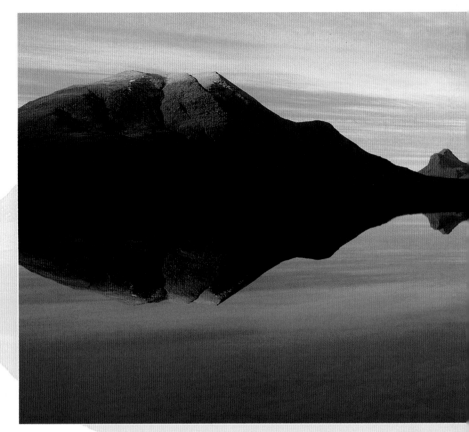

I am the wind which breathes upon the sea,

I am the wave of the ocean,

I am the murmur of the billows,

I am the ox of the seven combats,

I am the vulture upon the rocks,

I am a beam of the sun,

I am the fairest of plants,

I am a wild boar in valour,

I am a salmon in the water,

I am a lake in the plain,

I am a word of science,

I am the point of the lance in battle,

I am the God who created in the head the fire.

Who is it who throws light into the meeting on the mountain?

Who announces the ages of the moon?

Who teaches the place where couches the sun?

(If not I)

THE MYSTERY by Amergin, Irish

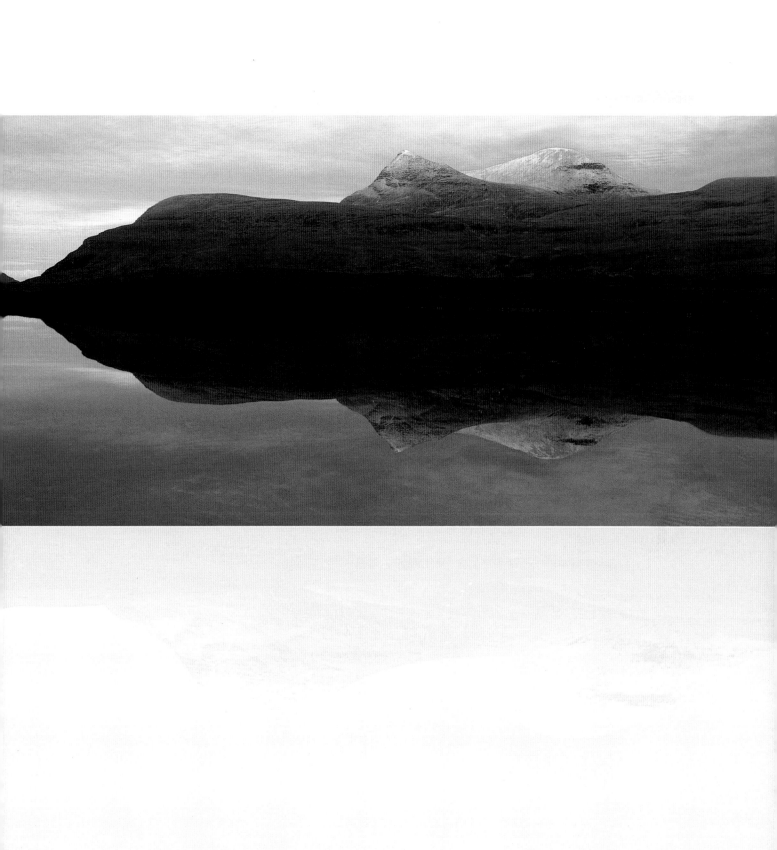

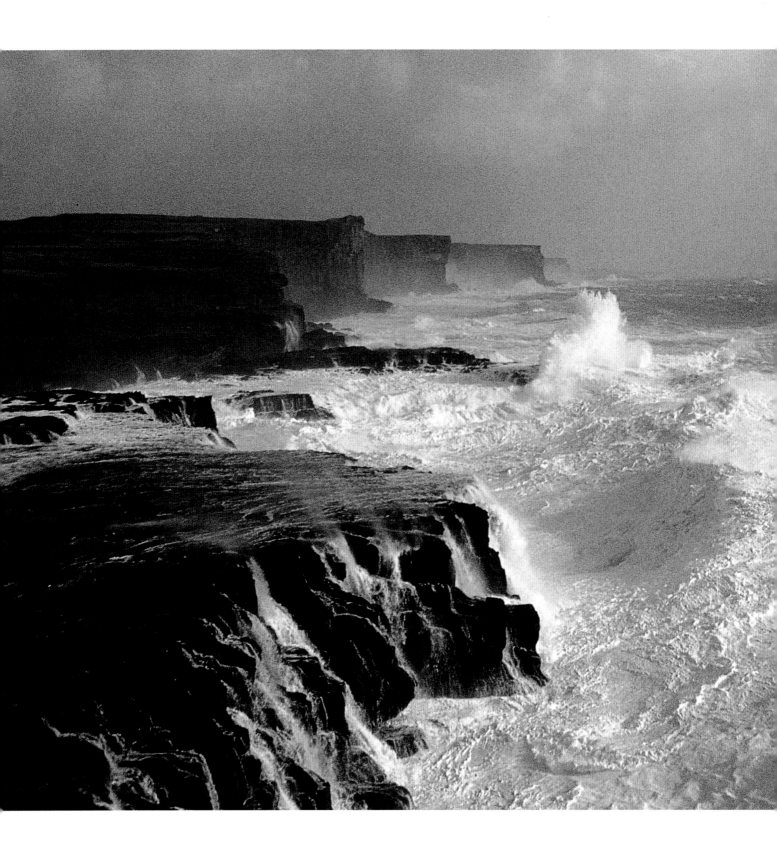

THE
CELTIC
QUEST

An Anthology from Merlin to Van Morrison

<small>EDITED BY JANE LAHR</small>

welcome
BOOKS
<small>NEW YORK & SAN FRANCISCO</small>

CONTENTS

THE SONG 17

THE SWORD 81

THE STAR 153

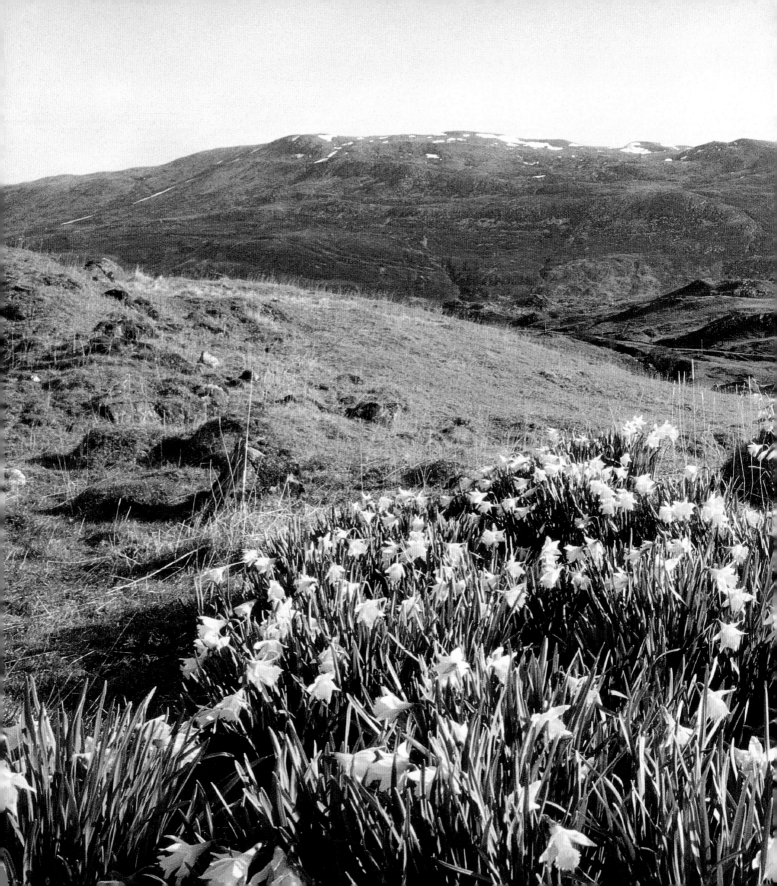

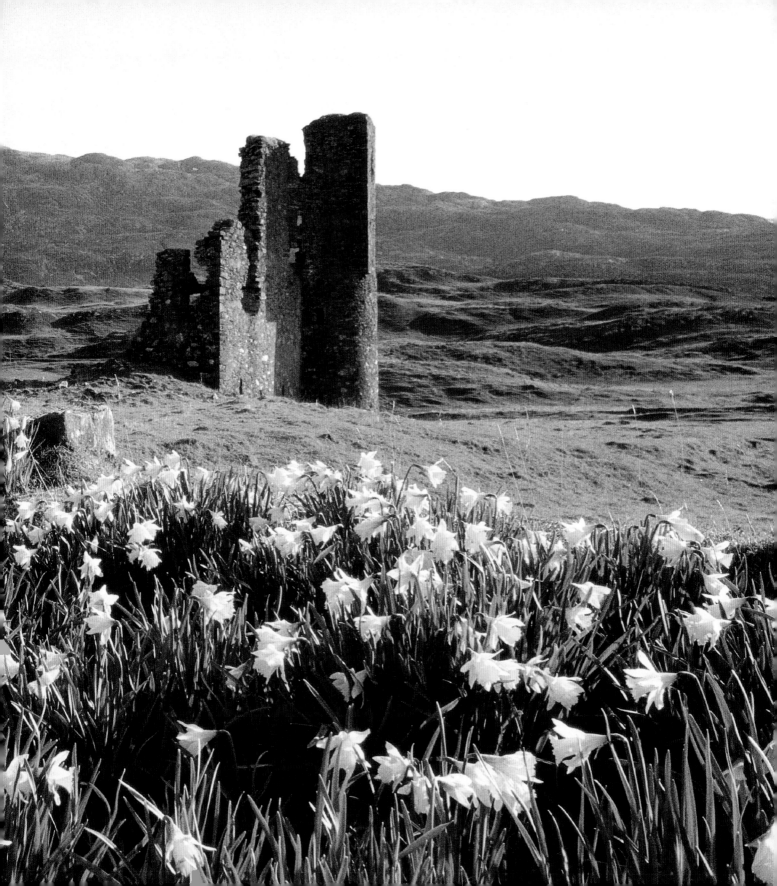

FOREWORD

I BEGAN MY JOURNEY INTO THE CELTIC REALM in 1960, when as a student at Dalton, a school in New York City, I started studying sculpture. My teacher, Rhys Caparn, possessed a remarkable presence, both physically and essentially. She stood over six feet tall and had a mane of white-gray hair. Educated at Bryn Mawr, as well as in Paris at the studios of Edouard Navellier and Alexander Archipenko, Rhys was intellectually aloof. She was a master animal artist, but her gifts were broader. Her work was based on capturing not merely the forms of the animals she was creating, but the power and essence of nature. In this way she strove to express the whole of nature. Her work had great poetic power and mystery, rendering visible that which lies beyond appearances. I studied with her throughout my high school years. She was my first *real* teacher. I came to learn about her Celtic heritage, her authority as a teacher, her wisdom.

In 1964 I found myself a student at the Slade School in London. My brother John was also in England completing his graduate degree at Oxford. To my great delight he had discovered the poetry of Dylan Thomas, regularly sharing his favorite poems with me. I read them all. They were revelations—what music! In that year I traveled to Scotland for the first time. Armed with my complete Robert Burns and a journal, I felt an extraordinary *déja vu* as I fell in love with the power and the beauty of the Scottish landscape.

In the 1970s, with a four-year-old daughter in tow, I visited the mile of great stones in Carnak, Brittany. I was now quite consciously searching out things Celtic. I found the small forest and stone circle known to Merlin and his consort. It was an unforgettable trip. In preparation for the adventure I read Joseph Bédier's great translation of *The Romance of Tristan and Iseult*, and reread the *Morte d'Arthur*.

The world has turned quite a few times since I was a student. Rhys died, a casualty of Alzheimer's. She told me that growing old meant "letting go of all the things that don't really matter." She called me "the good nurse" when I visited her for the last time— she had let go of the letters that formed my name. She retained her essential dignity and wonder, even when words had forsaken her.

The sacred animals, groves, landscapes, lakes, rivers and natural forms that Rhys deeply loved are also loosing their ability to communicate. They are in jeopardy—casualties of a belief system that places man and his possessions supreme over the birds and beasts. We begin to feel the limitations of this system that inhibits our true dreaming and spiritual growth. It is a system of thought which has had a disastrous effect on our environment—the land and animals are seen as subjects rather than revered and honored as guardians and teachers. The dream has lost its power. Poetry of the land has lost its music because we no longer listen.

I do feel some urgency in bringing together in one volume examples of the essential magic and power of Celtic ideas. I have endeavored to search out the richest Celtic literature and art— fusing together the ancient and modern. This volume represents my quest to recapture the dream and its power. It celebrates in word and image the yearning for star-songs and earth-songs, and for a deep visceral connection with nature.

Loosely structured around the Celtic lunar calendar, *The Celtic Quest in Art & Literature* contains three sections: *Song, Sword* and *Star*. *Song* celebrates the natural world as hallowed. It contains artistic visions that honor the spring-time rebirth of the land and the heart. *Sword* chronicles Celtic heroes from Cuchulainn and Fionn to Arthur and Gawain. Epic poetry and lore provide us with examples of courage and personal transformation. *Star* focuses on the philosophy of the Celtic priestly class, the druids. Cognizant of the natural rhythms of the trees, waters, stars and planets, the druids recognized that the apparent separateness of these bodies was illusory. They saw in star and stone the sacral and numinous.

Art and literature selections were chosen for their vibrant inner life and the skill of their execution. They are virtually all of Celtic origin. A very few exceptions were made for works that keenly express Celtic ideas. Dates ascribed to ancient literature refer to the century of transcription, not of origination.

It is my wish that this volume act as a talisman of Celtic sensibilities: pointing the way to a greater understanding of our universe as a multi-dimensional creative expression; lending credence to a non-local spirituality and bringing into balance our relationship to the earth and it's myriad creatures.

—Jane Lahr

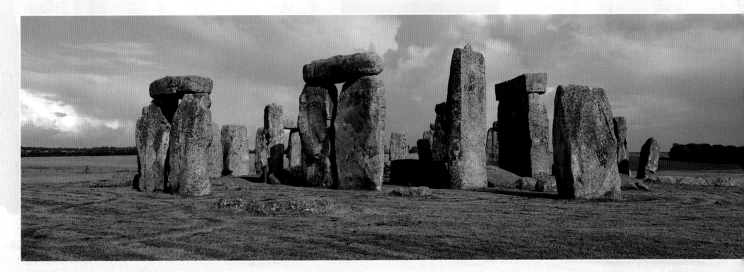

Stonehenge, Salisbury, England.

INTRODUCTION

THE EARTH-SHAPERS

Retold by Ella Young

Irish

In Tir-na-Moe, the Land of the Living Heart, Brigit was singing. Angus the Ever-Young, and Midyir the Red-Maned, and Ogma that is called Splendour of the Sun, and the Dagda and other lords of the people of Dana drew near to listen.

Brigit sang:

Now comes the hour foretold, a god-gift bringing
 A wonder-sight.
Is it a star new-born and splendid up springing
 Out of the night?
Is it a wave from the Fountain of Beauty upflinging
 Foam of delight?
Is it a glorious immortal bird that is winging
 Hither its flight?

It is a wave, high-crested, melodious, triumphant,
 Breaking in light.
It is a star, rose-hearted and joyous, a splendour
 Risen from night.
It is a flame from the world of the gods, and love runs before it,
 A quenchless delight.
Let the wave break, let the star rise, let the flame leap.
Ours, if our hearts are wise, to take and keep.

Brigit ceased to sing, and there was silence for a little space in Tir-na-Moe. Then Angus said:

"Strange are the words of your song, and strange the music: it swept me down steeps of air—down—down—always further down. Tir-na-Moe was like a dream half-remembered. I felt the breath of strange worlds on my face, and always your song grew

louder and louder, but you were not singing it. Who was singing it?"

"The Earth was singing it."

"The Earth!" said the Dagda. "Is not the Earth in the pit of chaos? Who has ever looked into that pit or stayed to listen where there is neither silence nor song?"

"O Shepherd of the Star-Flocks, I have stayed to listen. I have shuddered in the darkness that is round the Earth. I have seen the black hissing waters and the monsters that devour each other—I have looked into the groping writhing adder-pit of hell."

The light that pulsed about the De Danaan lords grew troubled at the thought of that pit, and they cried out: "Tell us no more about the Earth, O Flame of the Two Eternities, and let the thought of it slip from yourself as a dream slips from the memory."

"O Silver Branches that no Sorrow has Shaken," said Brigit, "hear one thing more! The Earth wails all night because it has dreamed of beauty."

"What dream, O Brigit?"

"The Earth has dreamed of the white stillness of dawn; of the star that goes before the sunrise; and of music like the music of my song."

"O Morning Star," said Angus, "would I had never heard your song, for now I cannot shake the thought of the Earth from me!"

"Why should you shake the thought from you, Angus the Subtle-Hearted? You have wrapped yourself in all the colours of the sunlight; are you not fain to look into the darkness and

listen to the thunder of abysmal waves; are you not fain to make gladness in the Abyss?"

Angus did not answer: he reached out his hand and gathered a blossom from a branch: he blew upon the blossom and tossed it into the air: it became a wonderful white bird, and circled about him singing.

Midyir the Haughty rose and shook out the bright tresses of his hair till he was clothed with radiance as with a Golden Fleece.

"I am fain to look into the darkness," he said. "I am fain to hear the thunder of the Abyss."

"Then come with me," said Brigit, "I am going to put my mantle round the Earth because it has dreamed of beauty."

"I will make clear a place for your mantle," said Midyir. "I will throw fire amongst the monsters."

"I will go with you too," said the Dagda, who is called the Green Harper.

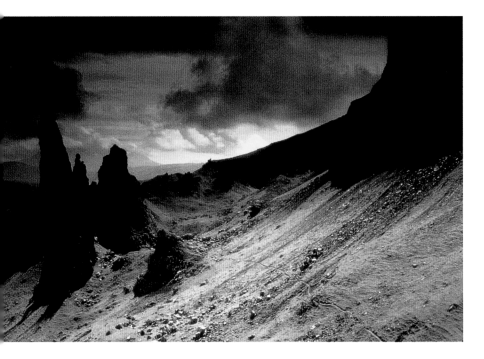

"And I," said Splendour of the Sun, whose other name is Ogma the Wise. "And I," said Nuada Wielder of the White Light. "And I," said Gobniu the Wonder-Smith, "we will remake the Earth!"

"Good luck to the adventure!" said Angus. "I would go myself if ye had the Sword of Light with you."

"We will take the Sword of Light," said Brigit, "and the Cauldron of Plenty and the Spear of Victory and the Stone of Destiny with us, for we will build power and wisdom and beauty and lavish-heartedness into the Earth."

"It is well said," cried all the Shining Ones. "We will take the Four Jewels."

Ogma brought the Sword of Light from Findrias the cloud-fair city that is in the east of the De Danaan world; Nuada brought the Spear of Victory from Gorias the flame-bright city that is in the south of the De Danaan world; the Dagda brought the Cauldron of Plenty from Murias the city that is builded in the west of the De Danaan world and has the stillness of deep waters; Midyir brought the Stone of Destiny from Falias the city that is builded in the north of the De Danaan world and has the steadfastness of adamant. Then Brigit and her companions set forth.

They fell like a rain of stars till they came to the blackness that surrounded the Earth, and looking down saw below them, as at the bottom of an abyss, the writhing, contorted, hideous life that swarmed and groped and devoured itself ceaselessly.

From the seething turmoil of that abyss all the Shining Ones drew back save Midyir. He grasped the Fiery Spear and descended like a flame.

His comrades looked down and saw him treading out the monstrous life as men tread grapes in a wine-press; they saw the blood and foam of that destruction rise about Midyir till he was crimson with it even to the crown of his head; they say him whirl the Spear till it became a wheel of fire and shot out sparks and tongues of flame; they saw the flame lick the darkness and turn back on itself and spread and blossom—murk-red—blood-red—rose-red at last!

Midyir drew himself out of the abyss, a Ruby Splendour, and said:

"I have made a place for Brigit's mantle. Throw down your mantle, Brigit, and bless the Earth!"

Brigit threw down her mantle and when it touched the Earth it spread itself, unrolling like silver flame. It took possession of the place Midyir had made as the sea takes possession, and it continued to spread itself because every-thing that was foul drew back from the little silver flame at the edge of it.

It is likely it would have spread itself over all the earth, only Angus, the youngest of the gods, had not patience to wait: he leaped down and stood with his two feet on the mantle. It ceased to be fire and became a silver mist about him. He ran through the mist laughing and calling on the others to follow. His laughter drew them and they followed. The drifting silver mist closed over them and round them, and through it they saw

each other like images in a dream—changed and fantastic. They laughed when they saw each other. The Dagda thrust both his hands into the Cauldron of Plenty.

"O Cauldron," he said, "you give to every one the gift that is meetest, give me now a gift meet for the Earth."

He drew forth his hands full of green fire and he scattered the greenness everywhere as a sower scatters seed. Angus stooped and lifted the greenness of the earth; he scooped hollows in it; he piled it in heaps; he played with it as a child plays with sand, and when it slipped through his fingers it changed colour and shone like star-dust—blue and purple and yellow and white and red.

Now, while the Dagda sowed emerald fire and Angus played with it, Mananaun was aware that the exiled monstrous life had lifted itself and was looking over the edge of Brigit's mantle. He saw the iron eyes of strange creatures jeering in the blackness and he drew the Sword of Light from its scabbard and advanced its gleaming edge against that chaos. The strange life fled in hissing spume, but the sea rose to greet the Sword in a great foaming thunderous wave.

Mananaun swung the Sword a second time, and the sea rose again in a wave that was green as a crysolite, murmurous, sweet-sounding, flecked at the edges with amythest and purple and blue-white foam.

A third time Mananaun swung the Sword, and the sea rose to greet it in a wave white as crystal, unbroken, continuous, silent as dawn.

The slow wave fell back into the sea, and Brigit lifted her mantle like a silver mist. The De Danaans saw everything clearly. They saw that they were in an island covered with green grass and full of heights and strange scooped-out hollows and winding ways. They saw too that the grass was full of flowers—blue and purple and yellow and white and red.

"Let us stay here," they said to each other, "and make beautiful things so that the Earth may be glad."

Brigit took the Stone of Destiny in her hands: it shone white like a crystal between her hands.

"I will lay the Stone in this place," she said, "that ye may have empire."

She laid the Stone on the green grass and it sank into the earth: a music rose about it as it sank, and suddenly all the scooped-out hollows and deep winding ways were filled with water—rivers of water that leaped and shone; lakes and deep pools of water trembling into stillness.

"It is the laughter of the Earth!" said Ogma the Wise.

Angus dipped his fingers in the water.

"I would like to see the blue and silver fishes that swim in Connla's Well swimming here," he said, "and trees growing in this land like those trees with blossomed branches that grow in the Land of the Silver Fleece."

"It is an idle wish, Angus the Young," said Ogma. "The fishes in Connla's Well are too bright for these waters and the blossoms that grow on silver branches would wither here. We must wait and learn the secret of the Earth, and slowly fashion dark strange trees, and fishes that are not like the fishes in Connla's Well."

"Yea," said Nuada, "we will fashion other trees, and under their branches shall go hounds that are not like the hound Failinis and deer that have not horns of gold. We will make ourselves the smiths and artificers of the world and beat the strange life out yonder into other shapes. We will make for ourselves islands to the north of this and islands to the west, and round them shall go also the three waves of Mananaun for we will fashion and re-fashion all things till there is nothing unbeautiful left in the whole earth."

"It is good work," cried all the De Danaans, "we will stay and do it, but Brigit must go to Moy Mell and Tir-na-Moe and Tir-nan-Oge and Tir-fo-Tonn, and all the other worlds, for she is the Flame of Delight in every one of them."

"Yes, I must go," said Brigit.

"O Brigit!" said Ogma, "before you go, tie a knot of remembrance in the fringe of your mantle so that you may always remember this place—and tell us, too, by what name we shall call this place."

"Ye shall call it the White Island," said Brigit, "and its other name shall be the Island of Destiny; and its other name shall be Ireland."

Then Ogma tied a knot of remembrance in the fringe of Brigit's mantle.

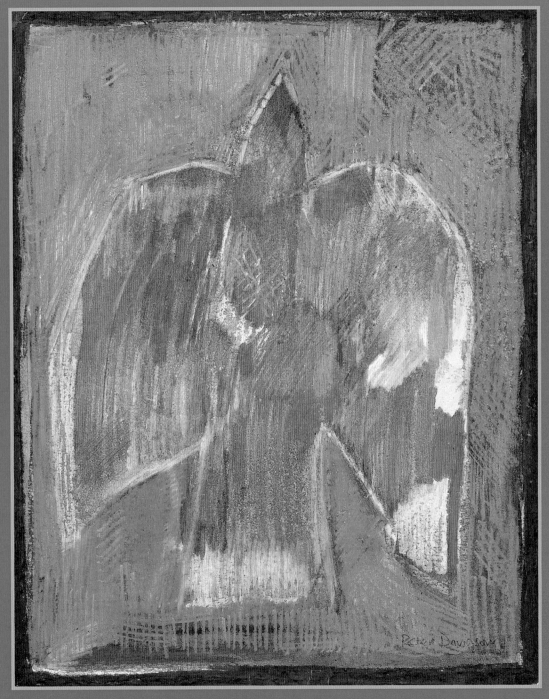

Rising Bird, Peter Davidson (living artist), Welsh. Oil pastel on paper, 1988.

> *"Among the Celts are honored poets called bards who to the music of harps (instruments like lyres) chant praise of some, satire of others. Also they have philosophers called druids whom they hold in high veneration."*
>
> —DIODORUS SISCULUS (CIRCA 60 B.C.E.)

SONG

DAN, THE GAELIC WORD FOR SONG OR POEM connotes both skill and that which is destined. The Celts believed that those skilled in the art of singing or writing poetry had the ability to change the course of certain events—poets could influence destiny.

Central to Celtic belief were the philosophies established by their priest class—the druids. The druids were the shamans and interpreters of the guiding signs that dwell in the land, stars and dreams. Their intellectual and spiritual power informed Celtic life and art. Students of the druids, the bards were also held in high esteem.

There seem to be degrees or grades of druidic education of which bards represent one class. The most famous description of the many "grades" of druidry comes from Julius Caesar. He writes of bards (poets, storytellers and musicians), vates (judges and seers) and druids (prophets, shamans, astrologers and astronomers). We know from Caesar's letters that the complete training from apprentice bard to fully-qualified druid lasted 20 years. This extensive mentoring period was necessary in large part because the Celtic literary tradition was passed on orally. An apprenticeship required each student to commit all tales, poems and teachings to memory.

In *Song* we celebrate ancient and contemporary bards. The three traditional skills necessary to become a bard were the ability to play the harp, a vast knowledge of ancient tales and a mastery of poetic power. Although some of the bards represented in this volume did not play musical instruments, their work is deeply musical and has great rhythmic power. Our bards include a historical Merlin, the great poet Dylan Thomas (whose tribute to spring and youth *Fern Hill* (page 20) stands out as one of the finest poems in the English language), and Robert Graves, who expresses the transformative power of the senses in his poem *The Gift Sight* (page 40). The magic of the Scottish poet Kathleen Raine and the lyrics of the musician Sting so deeply reflect Celtic material, I was compelled to include them in this volume.

The union of art and literature in *Song* attempts to reveal the Celts' reverence for nature and the power of love and its alchemical potential. The fierce energy of John Milne's *A Glimpse of the Firth* illuminates *Fern Hill*, the rich textures of John McKirdy Duncan's *Tristan and Isolde* complements Bédier's translation of an excerpt from *The Romance of Tristan and Iseult* (page 50), and the perfect sensuality of Sir Henry Raeburn's *Portrait of a Young Girl* informs Jonathan Swift's poem *Stella's Birthday, 1715* (page 76).

Song, with its themes of budding nature and love provides the opening note to this volume. It reflects the movement from youthful "just spring" to the beginning of summer. For the Celts, the culmination of this period is celebrated on May 1 with the spring festival of Beltane (BEEL-teen). The lyrical literature that comprises this section focuses on the rebirth of the land and the reawakening of emotions and senses within this first part of the year. The Celts understood that life must be experienced through the senses in order for growth to occur.

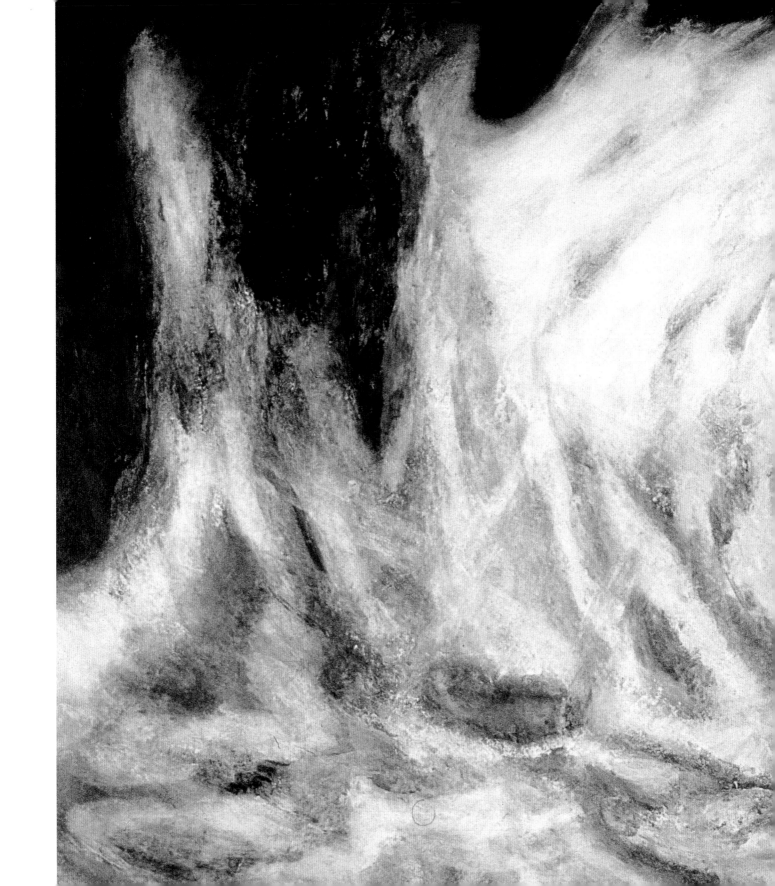

INVOCATION TO IRELAND

AMERGIN

Irish

I invoke the land of Ireland.
Much-coursed be the fertile sea,
Fertile be the fruit-strewn mountain,
Fruit-strewn be the showery wood,
Showery be the river of water-falls,
Of water-falls be the lake of deep pools,
Deep-pooled be the hill-top well,
A well of tribes be the assembly,
An assembly of kings be Tara,
Tara be the hill of the tribes,
The tribes of the sons of Mil,
Of Mil of the ships, the barks.
Let the lofty bark be Ireland,
Lofty Ireland, darkly sung,
An incantation of great cunning;
The great cunning of the wives of Bres,
The wives of Bres of Buaigne;
The great lady Ireland,
Eremon hath conquered her,
Ir, Eber have invoked for her.
I invoke the land of Ireland.

Aran Waves, Gwen O'Dowd
(living artist), Irish.
Oil on canvas, 1992.

FERN HILL

Dylan Thomas

Welsh

Now as I was young and easy under the apple boughs
About the lilting house and happy as the grass was green,
 The night above the dingle starry,
 Time let me hail and climb
 Golden in the heydays of his eyes,
And honoured among wagons I was prince of the apple towns
And once below a time I lordly had the trees and leaves
 Trail with daisies and barley
 Down the rivers of the windfall light.

And as I was green and carefree, famous among the barns
About the happy yard and singing as the farm was home,
 In the sun that is young once only,
 Time let me play and be
 Golden in the mercy of his means,
And green and golden I was huntsman and herdsman, the calves
Sang to my horn, the foxes on the hills barked clear and cold,
 And the sabbath rang slowly
 In the pebbles of the holy streams.

All the sun long it was running, it was lovely, the hay
Fields high as the house, the tunes from the chimneys, it was air
 And playing, lovely and watery
 And fire green as grass.
 And nightly under the simple stars
As I rode to sleep the owls were bearing the farm away,

All the moon long I heard, blessed among stables, the night-jars
 Flying with the ricks, and the horses
 Flashing into the dark.

And then to awake, and the farm, like a wanderer white
With the dew, come back, the cock on his shoulder: it was all
 Shining, it was Adam and maiden,
 The sky gathered again
 And the sun grew round that very day.
So it must have been after the birth of the simple light
In the first, spinning place, the spellbound horses walking warm
 Out of the whinnying green stable
 On to the fields of praise.

And honoured among foxes and pheasants by the gay house
Under the new made clouds and happy as the heart was long,
 In the sun born over and over,
 I ran my heedless ways,
 My wishes raced through the house high hay
And nothing I cared, at my sky blue trades, that time allows
In all his tuneful turning so few and such morning songs
 Before the children green and golden
 Follow him out of grace,
Nothing I cared, in the lamb white days, that time would take me
Up to the swallow thronged loft by the shadow of my hand,
 In the moon that is always rising,
 Nor that riding to sleep
 I should hear him fly with the high fields
And wake to the farm forever fled from the childless land.
Oh as I was young and easy in the mercy of his means,
 Time held me green and dying
 Though I sang in my chains like the sea.

Landscape with a Moth, Glyn
Morgan (living artist),
Welsh. Oil on canvas, 1986.

WHEN THE MOON HAS SET

John M. Synge

Irish

The worst vice is slight, compared with the guiltiness of a
man or woman who defies the central order of the world. . . .
The only truth a wave knows is that it is going to break.
The only truth a bud knows is that it is going to expand and
flower. The only truth we know is that we are a flood of
magnificent life, the fruit of some frenzy of the earth.

PRELUDE

John M. Synge

Irish

Still south I went and west and south again,

Through Wicklow from the morning till the night,

And far from cities, and the sites of men,

Lived with the sunshine and the moon's delight.

I knew the stars, the flowers, and the birds,

The grey and wintry sides of many glens,

And did but half remember human words,

In converse with the mountains, moors, and fens.

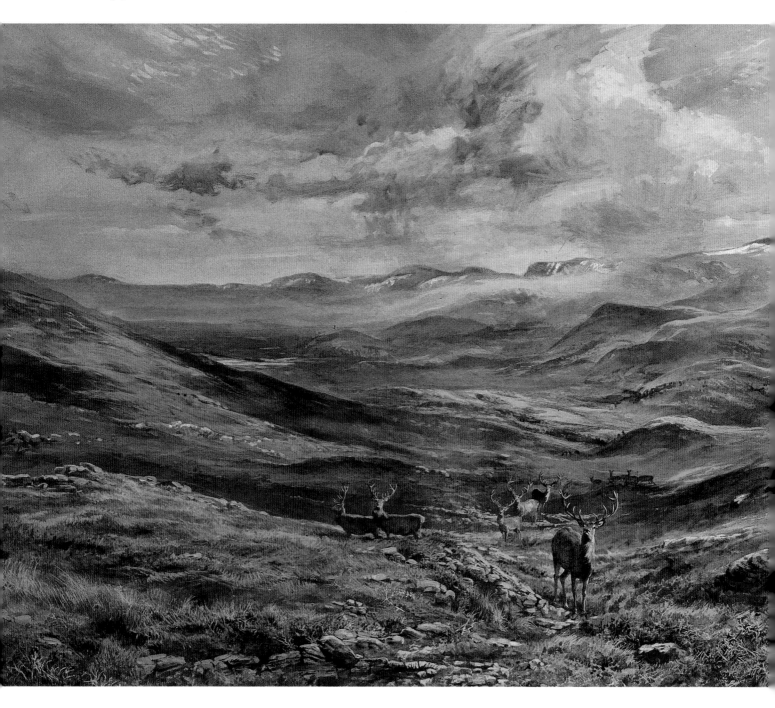

Cairngorms from Kinrara,
Tim Scott Bolton
(living artist), English.
Watercolor on paper, 1988.

Deirdre Remembers a Scottish Glen

Anonymous, 14th century

Irish, translated by Kenneth Hurlstone Jackson

Glen of fruit and fish and pools, its peaked hill of loveliest
wheat, it is distressful for me to think of it—
glen of bees, of long-horned wild oxen.

Glen of cuckoos and thrushes and blackbirds, precious is its
cover to every fox; glen of wild garlic and watercress,
of woods, of shamrock and flowers, leafy and twisting-crested.

Sweet are the cries of the brown-backed dappled deer under
the oak-wood above the bare hill-tops, gentle hinds that are
timid lying hidden in the great-treed glen.

Glen of the rowans with scarlet berries, with fruit fit for
every flock of birds; a slumbrous paradise for the badgers in
their quiet burrows with their young.

Glen of the blue-eyed vigorous hawks, glen abounding in
every harvest, glen of the ridged and pointed peaks, glen of
blackberries and sloes and apples.

Glen of the sleek brown round-faced otters that are pleasant
and active in fishing; many are the white-winged stately swans,
and salmon breeding along the rocky brink.

Glen of the tangled branching yews, dewy glen with level
lawn of kine; chalk-white starry sunny glen, glen of graceful
pearl-like high-bred women.

FROM *The Carmina Gadelica*
MILKING CROON

Alexander Carmichael

Scottish

Come, Brendan, from the ocean,

Come, Ternan, most potent of men,

Come, Michael valiant, down

And propitiate to me the cow of my joy.

> Ho my heifer, ho heifer of my love,
>
> Ho my heifer, ho heifer of my love.
>
> My beloved heifer, choice cow of every shieling,
>
> For the sake of the High King take to thy calf.

Come, beloved Colum of the fold,

Come, great Bride of the flocks,

Come, fair Mary from the cloud,

And propitiate to me the cow of my love.

> Ho my heifer, ho heifer of my love.

The stock-dove will come from the wood,

The tusk will come from the wave,

The fox will come but not with wiles,

To hail my cow of virtues.

> Ho my heifer, ho heifer of my love.

*The Cottesmore Prize Heifer
(After Henry Strafford),*
James William Giles
(1801–1870), Scottish.
Watercolor on paper, 1837.

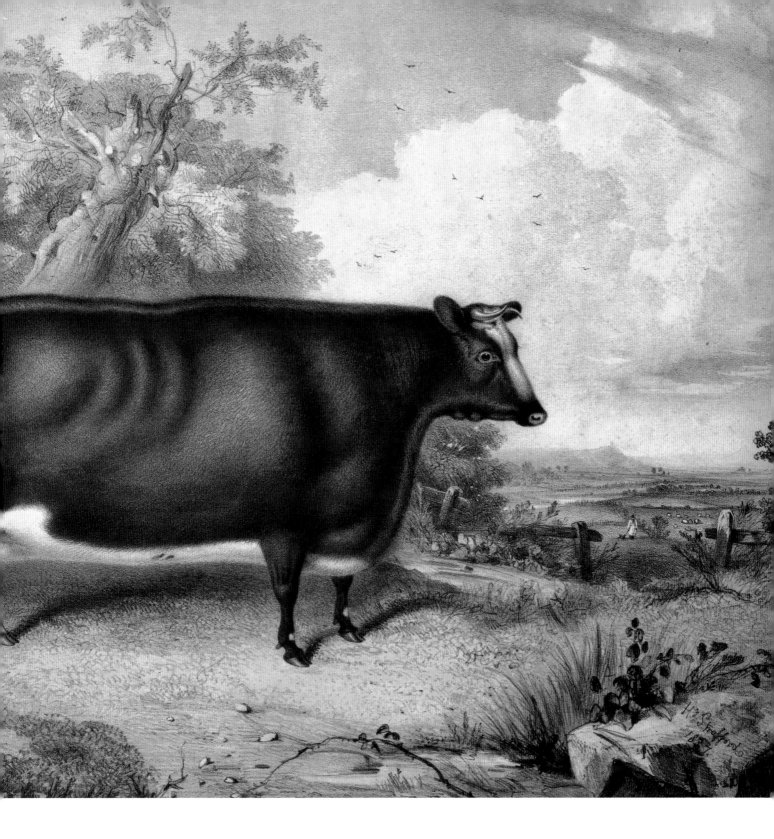

Detail of a bronze decoration
from a wooden pitcher found
at Brno-Malomerice, Monrovia,
Czech Republic, 3rd century B.C.E.

Suibhne
The Wild Man in the Forest

Anonymous, 12th century

Irish, translated by Kenneth Hurlstone Jackson

Little antlered one, little belling one, melodious little bleater, sweet I think the lowing that you make in the glen.

Home-sickness for my little dwelling has come upon my mind, the calves in the plain, the deer on the moor.

Oak, bushy, leafy, you are high above trees; hazel-bush, little branchy one, coffer of hazel-nuts.

Alder, you are not spiteful, lovely is your colour, you are not prickly where you are in the gap.

Blackthorn, little thorny one, black little sloe-bush; watercress, little green-topped one, on the brink of the blackbird's well.

Saxifrage of the pathway, you are the sweetest of herbs; cress, very green one; plant where the strawberry grows.

Apple-tree, little apple-tree, violently everyone shakes you; rowan, little berried one, lovely is your bloom.

Bramble, little humped one, you do not grant fair terms; you do not cease tearing me till you are sated with blood.

Yew, little yew, you are conspicuous in graveyards; ivy, little ivy, you are familiar in the dark wood.

Holly, little shelterer, door against the wind; ash-tree, baneful, weapon in the hand of a warrior.

Birch, smooth, blessed, proud, melodious, lovely is each entangled branch at the top of your crest.

Aspen as it trembles, from time to time I hear its leaves rustling, and think it is the foray . . .

If on my lonely journey I were to search the mountains of the dark earth, I would rather have the room for a single hut in great Glenn mBolcáin.

Good is its clear blue water, good its clean stern wind, good its cress-green watercress, better its deep brooklime.

Good its pure ivy, good its bright merry willow, good its yewy yew, better its melodious birch . . .

WINDHARP

John Montague

Irish

The sounds of Ireland,

that restless whispering

you never get away

from, seeping out of

low bushes and grass,

heatherbells and fern,

wrinkling bog pools,

scraping tree branches,

light hunting cloud,

sound hounding sight,

a hand ceaselessly

combing and stroking

the landscape, till

the valley gleams

like the pile upon

a mountain pony's coat.

The Ram's Horn

John Hewitt

Irish

I have turned to the landscape because men disappoint me:
the trunk of a tree is proud; when the woodmen fell it,
it still has a contained ionic solemnity:
it is a rounded event without the need to tell it.

I have never been compelled to turn away from the dawn
because it carries treason behind its wakened face:
even the horned ram, glowering over the bog hole,
though symbol of evil, will step through the blown grass with grace.

Animal, plant, or insect, stone or water,
are, every minute, themselves; they behave by law.
I am not required to discover motives for them,
or strip my heart to forgive the rat in the straw.

I live my best in the landscape, being at ease there;
the only trouble I find I have brought in my hand.
See, I let it fall with a rustle of stems in the nettles,
and never for a moment suppose that they understand.

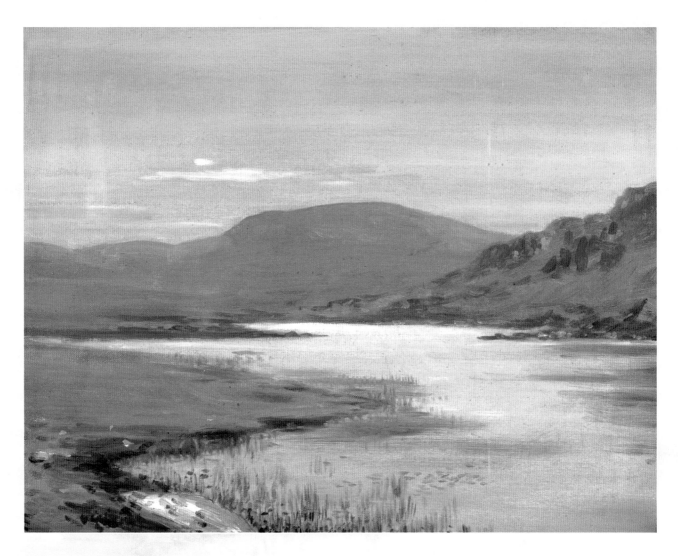

The Edge of the Lough,
George William Russell
(1867–1935), Irish.
Oil on canvas.

THE LAKE ISLE OF INNISFREE

William Butler Yeats

Irish

I will arise and go now, and go to Innisfree,

And a small cabin build there, of clay and wattles made:

Nine bean-rows will I have there, a hive for the honey-bee,

And live alone in the bee-loud glade.

And I shall have some peace there, for peace comes dropping slow,

Dropping from the veils of the morning to where the cricket sings;

There midnight's all a glimmer, and noon a purple glow,

And evening full of the linnet's wings.

I will arise and go now, for always night and day

I hear lake water lapping with low sounds by the shore;

While I stand on the roadway, or on the pavements grey,

I hear it in the deep heart's core.

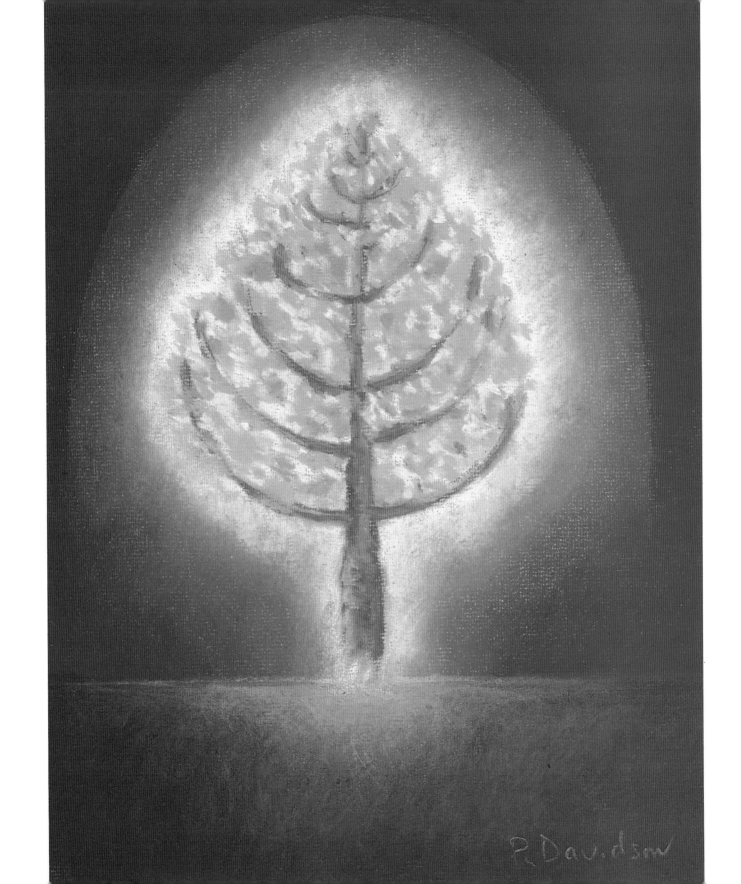
R. Davidson

I Was Brought to My Senses

STING

English

Alone with my thoughts this evening
I walked on the banks of Tyne
I wondered how I could win you
Or if I could make you mine
Or if I could make you mine

The wind it was so insistent
With tales of a stormy south
But when I spied two birds in a Sycamore tree
There came a dryness in my mouth
Came a dryness in my mouth

For then without rhyme or reason
The two birds did rise up to fly
And where the two birds were flying
I swear I saw you and I
I swear I saw you and I

I walked out this morning
It was like a veil had been removed from before my eyes
For the first time I saw the work of heaven
In the line where the hills had been married to the sky
And all around me every blade of singing grass
Was calling out your name and that our love would always last

Glowing Tree,
Peter Davidson
(living artist), Welsh.
Pastel on paper, 1996.

And inside every turning leaf
Is the pattern of an older tree
The shape of our future
The shape of all our history
And out of the confusion
Where the river meets the sea
Came things I'd never seen
Things I'd never seen

I was brought to my senses
I was blind but now that I can see
Every signpost in nature
Said you belong to me

I know it's true
It's written in a sky as blue
As blue as your eyes, as blue as your eyes
If nature's red in tooth and claw
Like winter's freeze and summer's thaw

The wounds she gave me
Were the wounds that would heal me
And we'd be like the moon and sun
And when our courtly dance had run
Its course across the sky
Then together we would lie
And out of the confusion
Where the river meets the sea
Something new would arrive
Something better would arrive

I was brought to my senses
I was blind but now that I can see
Every signpost in nature
Said you belong to me

Tangled Trunks,
William Gear (living
artist), Scottish. 1953.

GIFT OF SIGHT

ROBERT GRAVES

English

I had long known the diverse tastes of the wood,

Each leaf, each bark, rank earth from every hollow;

Knew the smells of bird's breath and of bat's wing;

Yet sight I lacked: until you stole upon me,

Touching my eyelids with light finger-tips.

The trees blazed out, their colours whirled together,

Nor ever before had I been aware of sky.

Ancient Celtic sanctuary
in Bibracte. Archaeological
Site, St-Leger-à-Beuvray,
France, 1st century B.C.E.

40

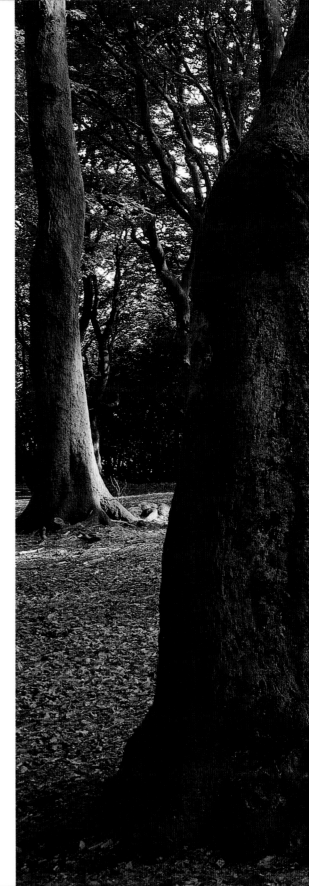

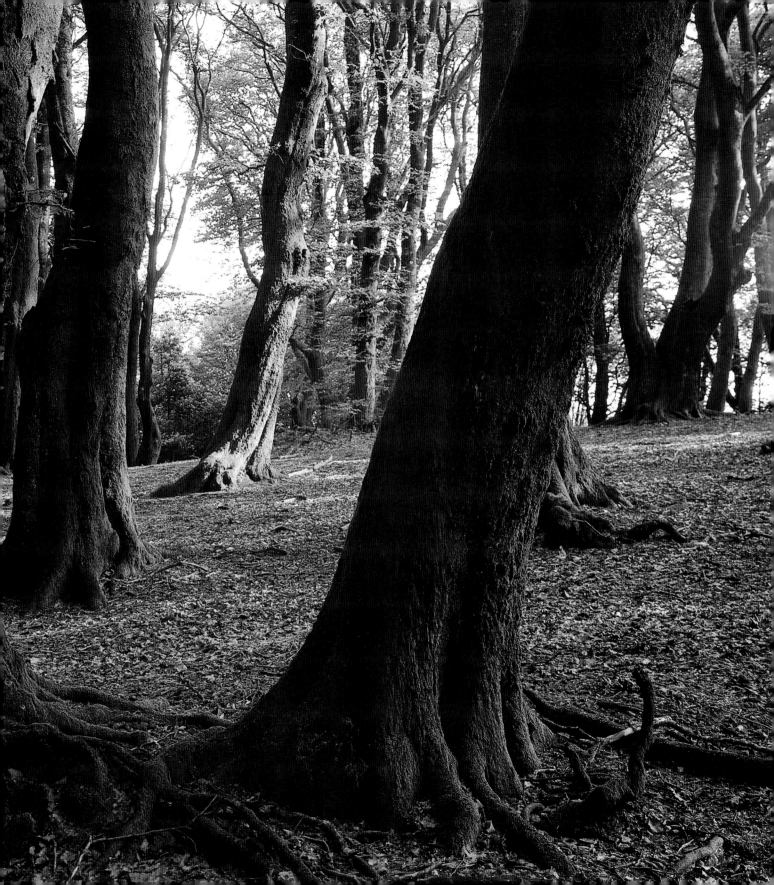

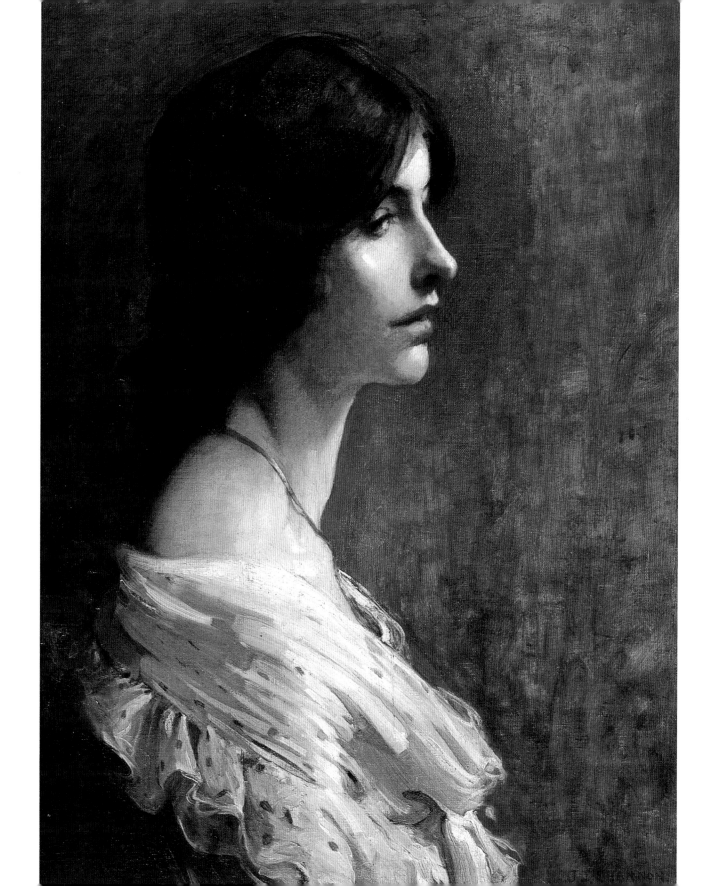

The Planter's Daughter

Austin Clarke

Irish

When night stirred at sea

And the fire brought a crowd in,

They say that her beauty

Was music in mouth

And few in the candlelight

Thought her too proud,

For the house of the planter

Is known by the trees.

Men that had seen her

Drank deep and were silent,

The women were speaking

Wherever she went—

As a bell that is rung

Or a wonder told shyly,

And O she was the Sunday

In every week.

Portrait of a Young Lady,
Sir James Jebusa Shannon
(1862–1923), Irish.
Oil on canvas, 1897.

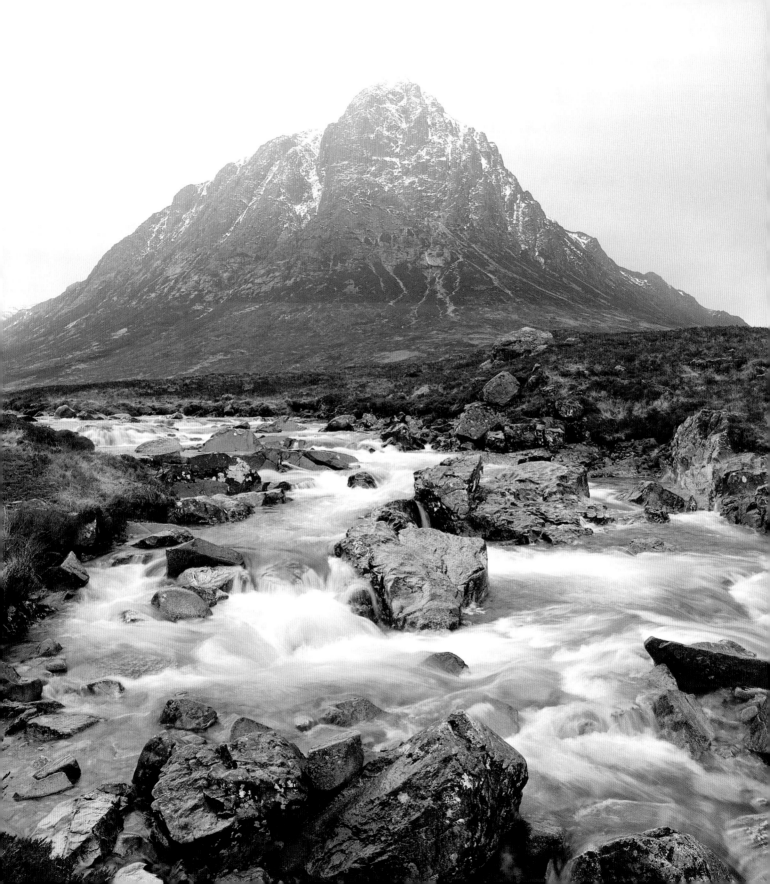

TO MY MOUNTAIN

Kathleen Raine

Scottish

Since I must love your north

of darkness, cold, and pain,

the snow, the lovely glen,

let me love true worth,

the strength of the hard rock,

the deafening stream of wind

that carries sense away

swifter than flowing blood.

Heather is harsh to tears

and the rough moors

give the buried face no peace

but make me rise,

and oh, the sweet scent, and purple skies!

Buchaille Etire Mòr, Scottish
Highlands Royal Forest.

TO ANYBODY
AT ALL

Margaret Tait

Scottish

I didn't want you cosy and neat and limited.

I didn't want you to be understandable,

Understood.

I wanted you to stay mad and limitless,

Neither bound to me nor bound to anyone else's or

 your own preconceived idea of yourself.

Portrait of Dylan Thomas,
Augustus John
(1878–1961), Welsh.
Oil on canvas.

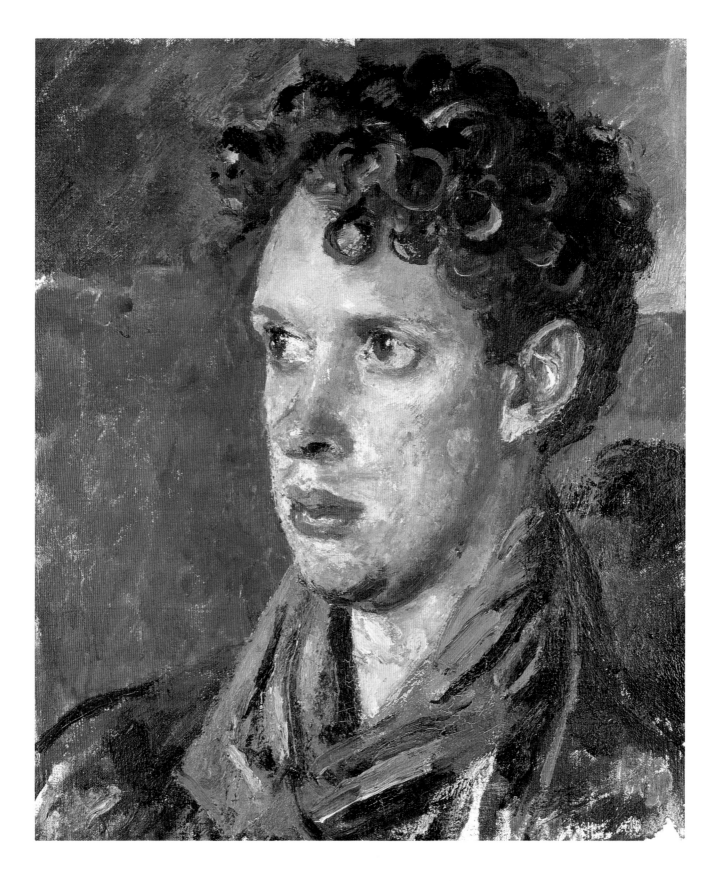

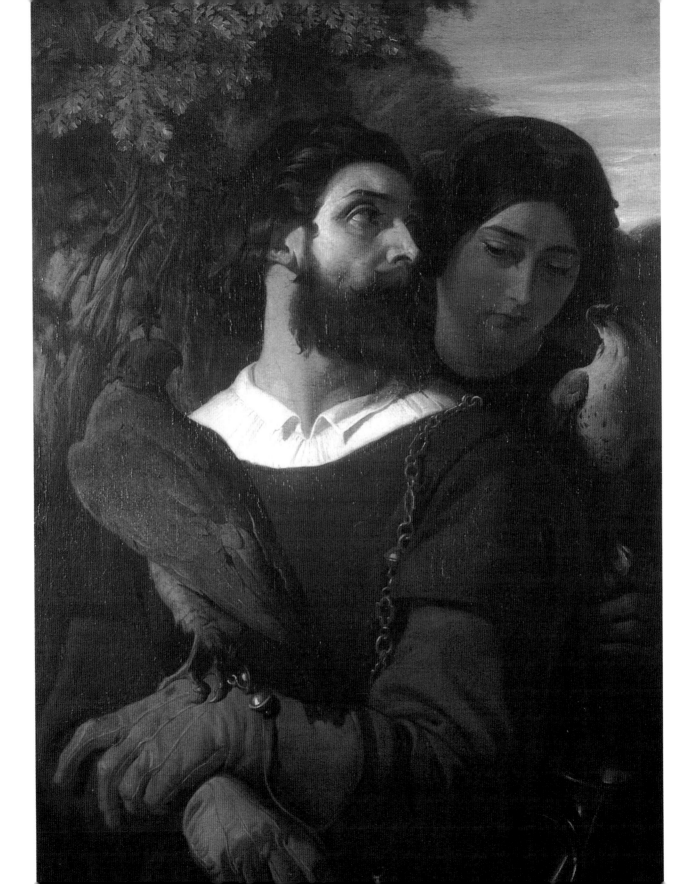

BLESSING FOR A LOVER

Alexander Carmichael

Scottish

You are the star of each night,

You are the brightness of every morning,

You are the story of each guest,

You are the report of every land.

No evil shall befall you, On hill nor bank,

In field or valley, On mountain or in glen.

Neither above nor below, Neither in sea

Nor on shore

In skies above, Nor in the depths.

You are the kernel of my heart,

You are the face of my sun,

You are the harp of my music,

You are the crown of my company.

The Falconer, Daniel Maclise
(1806–1870), Irish.
Oil on canvas, 1853.

Tristan and Isolde,
John McKirdy Duncan
(1866–1945), Irish.
Tempera on canvas, 1912.

"There are three trees that are good,

holly and ivy and yew;

they put forth leaves while they last,

And Tristan shall have me as long as he lives."

—Anonymous, Welsh, 15th–16th century C.E.

EXCERPT FROM *THE ROMANCE OF TRISTAN AND ISEULT*

THE PHILTRE

Retold by Joseph Bédier

Cornish

When the day of Iseult's livery to the lords of Cornwall drew near, her mother gathered herbs and flowers and roots and steeped them in wine, and brewed a potion of might, and having perfected it by science and magic, she poured it into a pitcher, and said apart to Brangien:

"Child, it is yours to go with Iseult to King Mark's country, for you love her with a faithful love. Take then this pitcher and remember well my words. Hide it so that no eye shall see nor no lip go near it: but when the wedding-night has come and that moment in which the wedded are left alone, pour this essenced wine into a cup and offer it to King Mark and to Iseult his queen. Oh! Take all care, my child, that they alone shall taste this brew. For this is its power: they who drink of it together love each other with their every single sense and with their every thought, forever, in life and in death."

And Brangien promised the Queen that she would do her bidding.

The ship, ploughing the deep waves, bore off Iseult. The farther it bore her from the soil of Ireland, the more sadly the young girl bewailed her lot. Seated under the tent in which she had secluded herself with Brangien her maid, she wept, remembering her land. Where were these strangers dragging her? Towards whom? Towards what fate? When Tristan approached her and sought to soothe her with soft words, she angered, repulsed him, and hate swelled her heart. He had come to Ireland, he the ravisher, he the murderer of the Morholt; with guile he had torn her from her mother and her land; he had not deigned to keep her for himself, and now he was carrying her away as his prey, over the waves, to the land of the enemy. "Accursed be the sea that bears me, for rather would I lie dead on the earth where I was born than live out there, beyond. . . ."

One day when the wind had fallen and the sails hung slack Tristan dropped anchor by an island and the hundred knights of Cornwall and the sailors, weary of the sea, landed all. Iseult alone remained aboard and a little serving maid, when Tristan came near the Queen to calm her sorrow. The sun was hot above them and they were athirst and, as they called, the little maid looked about for drink for them and found that pitcher which

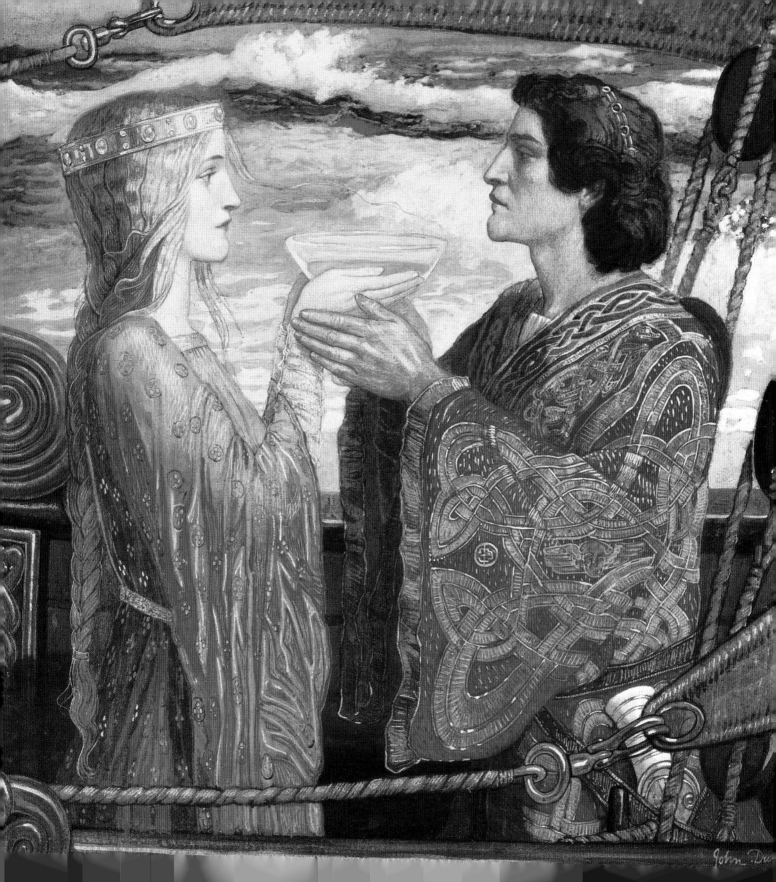

the mother of Iseult had given into Brangien's keeping. And when she came on it, the child cried "I have found you wine!" Now she had found not wine—but Passion and Joy most sharp, and Anguish without end, and Death.

The child filled a goblet and presented it to her mistress. The Queen drank deep of that draught and gave it to Tristan and he drank also long and emptied it all.

Brangien came in upon them; she saw them gazing at each other in silence as though ravished and apart; she saw the almost emptied pitcher standing there before them, and the goblet. She snatched up the pitcher and cast it into the shuddering sea and cried aloud: "Cursed be the day I was born and cursed the day that first I trod this deck. Iseult, my friend, and Tristan, you, you have drunk death together."

And once more the bark ran free for Tintagel. But it seemed to Tristan as though an ardent briar, sharp-thorned but with flower most sweet smelling drave roots into his blood and laced the lovely body of Iseult all round about it and bound it to his own and to his every thought and desire. And he thought: "Andret, Denoalen, Guenelon and Gondoïne, felons, that charged me with coveting King Mark's land, I have come lower by far, for it is not his land I covet. Fair uncle, who loved me orphaned ere ever you knew in me the blood of your sister Blanchefleur, you that wept as you bore me to that boat alone, why did you not drive out the boy that was to betray you? Ah! What thought was that! Iseult is yours and I am but your vassal; Iseult is yours and I am your son; Iseult is yours and may not love me."

But Iseult loved him, though she would have hated. Had he not basely disdained her? She could not hate, for a tenderness more sharp than hatred tore her.

And Brangien watched them in anguish, suffering more cruelly because she alone knew the depth of evil done.

Two days she watched them, seeing them refuse all food or comfort and seeking each other as blind men seek, wretched apart and together more wretched still, for then they trembled each for the first avowal.

On the third day, as Tristan neared the tent on deck where Iseult sat, she saw him coming and she said to him, very humbly, "Come in, my lord."

"Queen," said Tristan, "why do you call me lord? Am I not your liege and vassal, to revere and serve and cherish you as my lady and Queen?"

But Iseult answered, "No, you know that you are my lord and my master, and I your slave. Ah, why did I not sharpen those wounds of the wounded singer, or let die that dragon-slayer in the grasses of the marsh? Why did I not, while he lay helpless in the bath, plant on him the blow of the sword I brandished? But then I did not know what now I know!"

"And what is it that you know, Iseult? What is it that torments you?"

"Ah, all that I know torments me, and all that I see. This sky and this sea torment me, and my body and my life."

She laid her arm upon Tristan's shoulder, the light of her eyes was drowned and her lips trembled.

He repeated: "Friend, what is it that torments you?"

"The love of you," she said. Whereat he put his lips to hers.

But as they thus tasted their first joy, Brangien, that watched them, stretched her arms and cried at their feet in tears:

"Stay and return if still you can. . . . But oh! that path has no returning. For already Love and his strength drag you on and now henceforth forever never shall you know joy without pain again. The wine possesses you, the draught your mother gave me, the draught the King alone should have drunk with you: but that old Enemy has tricked us, all us three; it is you who have drained the goblet. Friend Tristan, Iseult my friend, for that bad ward I kept take here my body and my life for through me and in that cup, you have drunk not love alone, but love and death together."

The lovers held each other; life and desire trembled through their youth, and Tristan said, "Well then, come Death."

And as evening fell, upon the bark that heeled and ran to King Mark's land, they gave themselves up utterly to love.

Fretted bronze plaque with enameled decoration (part of a horse's harness). Found at Paillart, Oise. 1st–2nd century B.C.E.

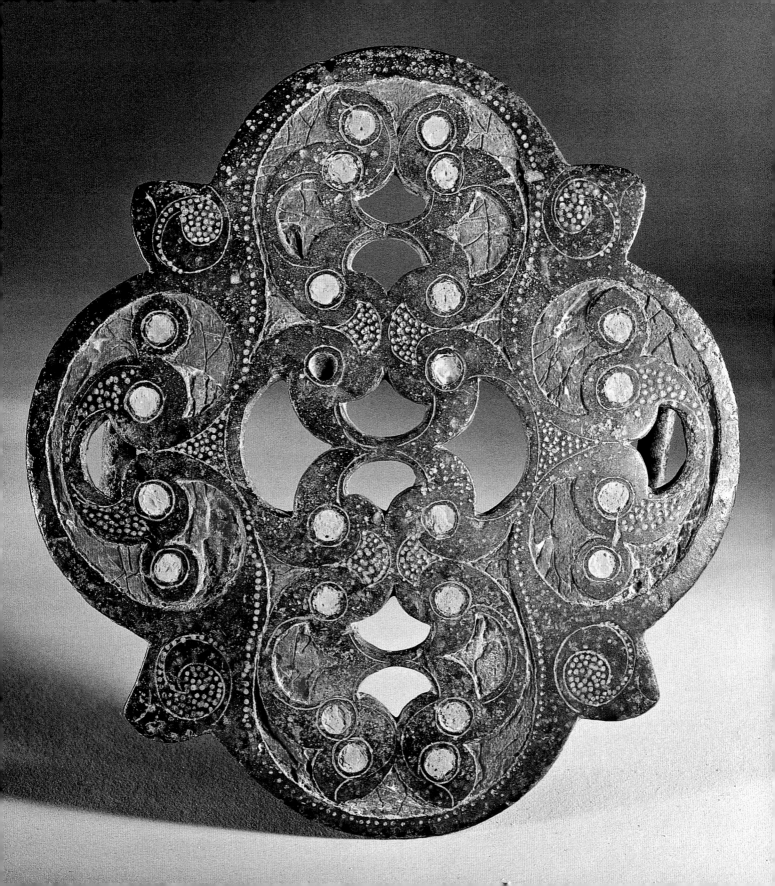

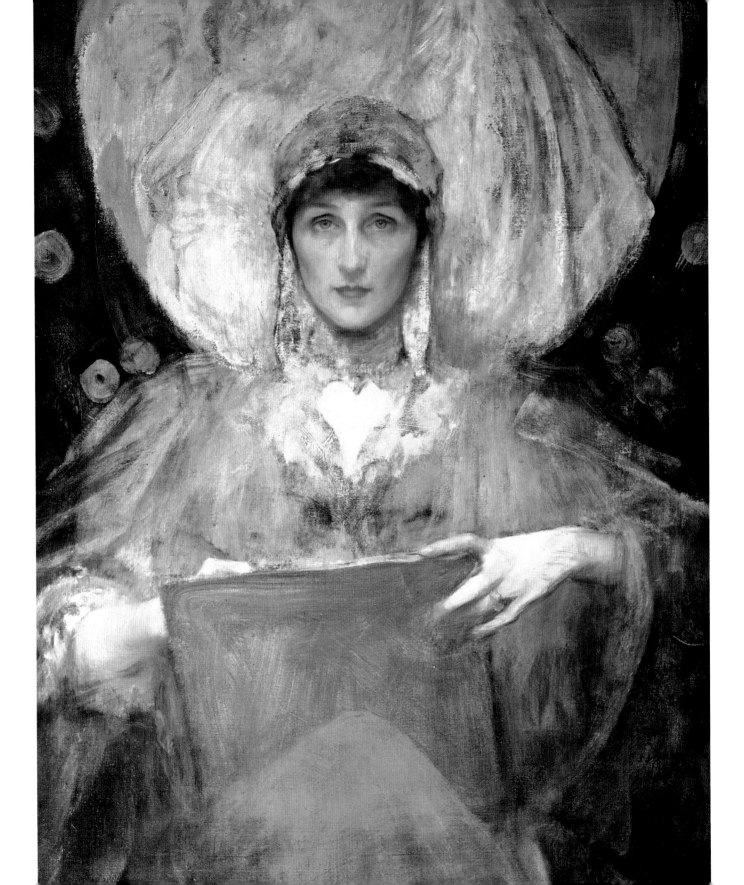

THE SONG OF BLODEUWEDD

Robert Graves

English

Not of father nor of mother

Was my blood, was my body.

I was spellbound by Gwydion,

Prime enchanter of the Britons,

When he formed me from nine blossoms,

 Nine buds of various kind:

From primrose of the mountain,

Broom, meadow-sweet and cockle,

 Together intertwined,

From the bean in its shade bearing

A white spectral army

 Of earth, of earthy kind,

From blossoms of the nettle,

Oak, thorn and bashful chestnut—

Nine powers of nine flowers,

 Nine powers in me combined,

 Nine buds of plant and tree.

Long and white are my fingers

 As the ninth wave of the sea.

Violet, Duchess of Rutland,
Sir James Jebusa Shannon
(1868–1928), Irish.

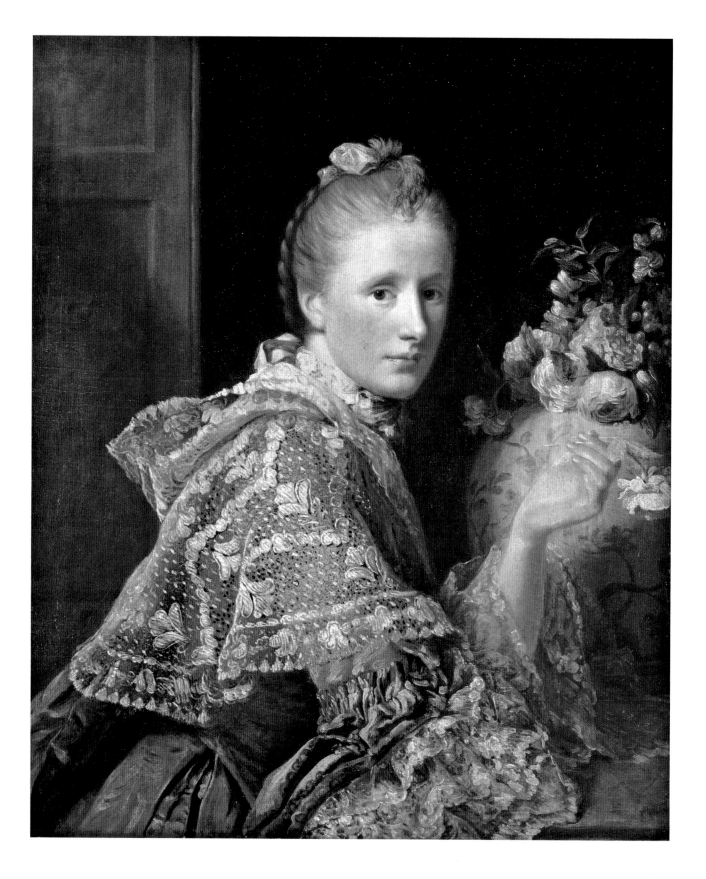

A RED, RED ROSE

Robert Burns

Scottish

O my luve's like a red, red rose,

That's newly sprung in June;

O my luve's like the melodie

That's sweetly played in tune.

As fair art thou, my bonnie lass,

So deep in luve am I;

And I will luve thee still, my dear,

Till a' the seas gang dry.

Till a' the seas gang dry, my dear,

And the rocks melt wi' the sun;

O I will love thee still, my dear,

While the sands o'life shall run.

And fare thee weel, my only luve,

And fare thee weel awile!

And I will come again, my luve,

Though it were ten thousand mile.

The Painter's Wife, Margaret Lindsay, Allan Ramsay (1713–1784), Scottish. Oil on canvas, 18th century.

Detail of bronze shield decorated with studs in red glass paste. Found in the River Thames, Britain. 1st–2nd century B.C.E.

THE CIRCLE

Alan Riddell

Scottish

A circle is my love, and all
my words along that line will tell
the radius my passions fill.

You lie within it. Gently there
you nestle in its humming care,
until its humming fills your ear.

Yes, I, who spin around you, make
a universe beyond the lake,
the silent lake which is your heart.

Its depth I am, circumference round,
and moving ripples when your hand
leans out to touch me on the ground.

And yet, and yet, it is, my dear,
your stillness, not my turning here,
that makes the circle true entire.

COUNTRY GIRL

George Mackay Brown

Scottish

I make seven circles, my love
For your good breaking.
I make the gray circle of bread
And the circle of ale
And I drive the butter round in a golden ring
And I dance when you fiddle
And I turn my face with the turning sun till your
 feet come in from the field.
My lamp throws a circle of light,
Then you lie for an hour in the hot unbroken
 circle of my arms.

I WILL MAKE YOU BROOCHES

Robert Louis Stevenson

Scottish

I will make you brooches and toys for your delight

Of bird-song at morning and star-shine at night.

I will make a palace fit for you and me

Of green days in forests and blue days at sea.

I will make my kitchen, and you shall keep your room,

Where white flows the river and bright blows the broom,

And you shall wash your linen and keep your body white

In rainfall at morning and dewfall at night.

And this shall be for music when no one else is near,

The fine song for singing, the rare song to hear!

That only I remember, that only you admire,

Of the broad road that stretches and the roadside fire.

The Purple Stocking,
Sir James Jebusa Shannon
(1862–1923), Irish. Oil
on canvas, 19th century.

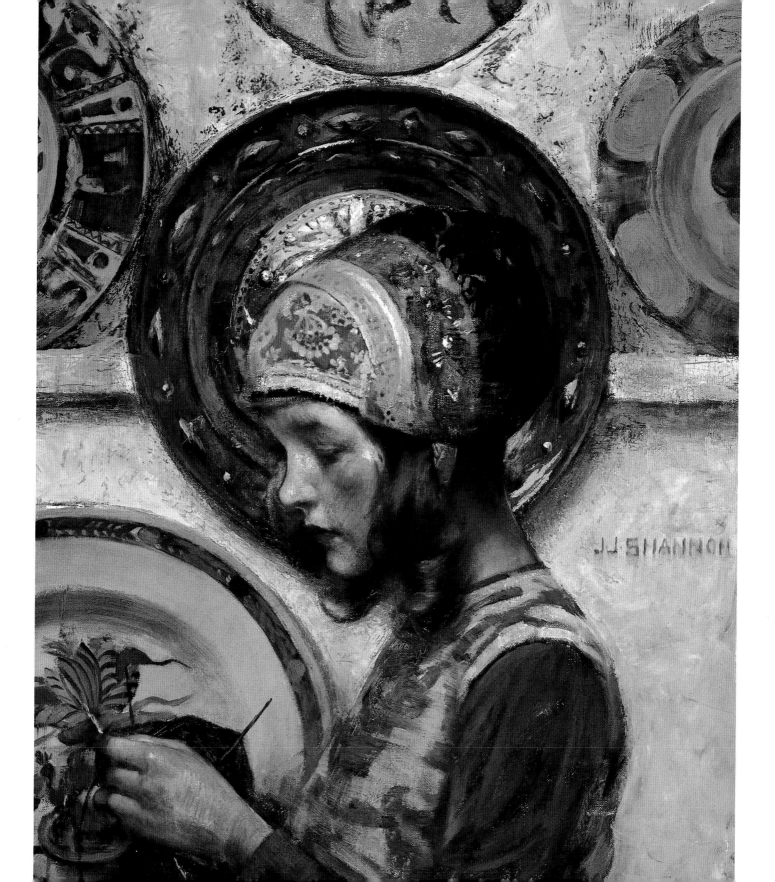

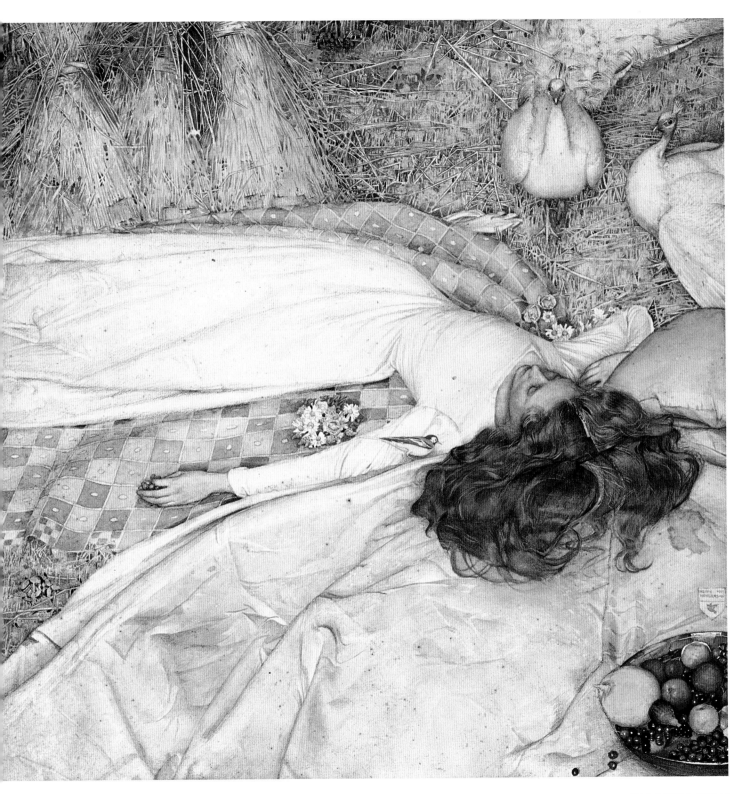

Ydelnesse, Keith Henderson
(1883–1982), Scottish. 1907.

THE WOOING OF ETAIN

Retold by Ann Moray

Irish

In the early days, when the Tuatha Dé Danann, the Fairy-gods, were defeated by the Sons of Mil, and they agreed to make their vast and beautiful dwelling places inside the mountains, and under the rivers and lakes of Ireland, their High King was the Dagda. He it was who, playing on his oaken harp, made the seasons to follow one another, and who commanded the winds and the rains, and the crops. His people called him "the Good God," and according to the ancient custom, he sent his young son, Angus mac Og, for fosterage to Midir, the proud Fairy King of Bri Leith.

Angus' companions were thrice-fifty of the noblest youths in Ireland, and thrice-fifty of the loveliest maidens, and for all their great number, they lived in one House. Their beds had columns and posts adorned with wrought gold that gleamed in the light of a precious stone of great size, brilliant in the roof at the centre of the House. Angus was leader of them all, for the beauty of his form and face, and for his gentleness. His days were spent in the Playing-field, in feasting and tale-telling, in harping and minstrelsy, and the reciting of poetry, and every youth was a chess player in the House of Midir of Bri Leith.

Angus stayed with his foster-father for nine years, then he returned to his own *sid*, Brugh on the Boyne.

After a year, to the day, Midir, lonely for his foster-son, decided to visit him. He put on his white silk, gold-embroidered tunic and his shoes of purple leather with silver-embroidered tips. He fastened his purple cloak of good fleece with the golden, gem-encrusted brooch of Bri Leith, that reached from shoulder to shoulder, in splendour, across his breast, and on the Eve of the autumn Feast of Samain, he came to the *sid* of Angus mac Og, at Brugh on the Boyne.

The Mac Og was standing on the Mound of the Brugh, watching two companies of his youths at play before him. The first company rode horses of purple-brown colour, and their bridles were of white bronze, decorated with gold, and the horses of the second company were blue as the summer sky at early morn, and they had bridles of silver. The battle sport was joyful, and the air was filled with the clash of arms, the clean ring of metal against metal and the lusty, clear-voiced challenging cries. Angus embraced his foster-father with delight, and they watched the play together, until, inadvertently, Midir was hurt in the eye by one of the youths. Though he was cured by the Dagda's Physician, he was angered, and demanded satisfaction. Angus readily agreed.

"If it is in my power," he said, "it is yours. What is your desire?"

"The hand of Etain, who is the gentlest and loveliest in all Ireland."

"And where is she to be found?" Angus asked.

"In Mag Inish, in the North East. She is daughter of the Fairy King Aylill."

"Then it shall be so," the Mac Og said, and at the end of the feasting he set out over the soft, cloud-bright fields of that many-hued Land, and came to Mag Inish, in the North East.

Aylill the Kind demanded a high bride-price. "I will not give my daughter to you except that you clear for me twelve plains in a single night," he said, "and furthermore, that you draw up out of this land twelve great rivers to water those plains."

Angus, knowing he could not himself accomplish these feats, went to his father, the Dagda, who, of his great power, caused twelve plains to be cleared in the Land of Aylill, and he caused twelve rivers to course towards the sea, and all in a single night. On the morrow, Angus mac Og came to Etain's father to claim her for Midir.

"You shall not have her till you purchase her," Aylill said.

"What do you require now?" Angus asked.

"I require the maiden's weight in gold and silver," Aylill answered, and the Mac Og said:

"It shall be done." And forthwith he placed the maiden in the centre of her father's House, measured the weight of her in gold and silver, and leaving the wealth piled up there on the floor, he returned to Brugh on the Boyne with Etain, and the ancient manuscript says, "Midir made that company welcome." Etain looked into Midir's eyes, and that night she became his bride.

They stayed together in the Brugh with Angus for a year and a day, sporting and playing chess for precious stones, drinking the choice wines and listening to the music of Angus' three half-brothers, the sons of Boann, his mother, who were called "the Fair and Melodious Three." Their names were Goltraiges, Gentraiges and Suantraiges, and the harps on which they played were of gold, and silver, and of white bronze, with figures of serpents and birds and hounds wrought upon them. When

Goltraiges played the Music of Weeping, twelve warriors of the household died of sadness, but when Gentraiges played the Music of Smiling, the Brugh was full of gladness and laughter, and when Suantraiges played the Music of Sleeping, there were gentleness and peace in the House, and in all Ireland the women whose time was upon them gave easy birth, and no animal was fierce in all the land. And so the days and the nights of the year passed, and sweet was the intimacy of Midir and Etain, and fond their espousal.

When the time came for them to return to Bri Leith, Angus, embracing them, said to Midir:

"Take care, Midir, of Etain, for your wife awaits you at Bri Leith, and Fuamnach is a dreadful and a cunning woman."

The warning of Angus was timely, for when the lovers returned, Fuamnach came out to meet them. With cleverness, she put them at their ease. She talked to Midir of his House and household, of his lands and herds, and of his people, but later, when Etain was in her chamber alone, combing her hair and waiting for Midir, Fuamnach came to her and struck her, as she sat, with a rod of scarlet quicken-tree. Etain, on the instant, became a shining pool of water in the centre of the room.

In triumph, Fuamnach went to Midir and told him what she had done, and moreover, swore that she would harm Etain for as long as she lived, and in whatever form she might be. Then she left Bri Leith and returned to the House of her foster-father, the wizard Bresal. Midir, without solace, and lonely, left his House to wander over the far lands of his kingdom.

Meanwhile the crystal pool that was Etain dried, rolled itself together and became a small worm, and because Etain was lovely and full of joy, the worm turned into a beautiful purple fly, of wondrous size, and "sweeter than pipes and horns was the sound of her voice, and the hum of her wings. Her eyes would shine like precious stones in the darkness, and the fragrance and bloom of her would turn away hunger and thirst from anyone around whom she would go, and the spray that fell from her wings would cure all sickness."

She longed for Midir, and when she had tried her wings and gathered strength, she flew to the far reaches of Bri Leith,

and when she came to him, Midir knew that the lovely purple fly was Etain. Everywhere he went, she attended him, and while she was there he took no other woman, and the sight of her nourished him, and the sweet sound of her humming would send him to sleep, and Midir would neither eat nor drink, nor dance, nor play the chess game, nor hear any other music, if he could not hear the music of her voice, and the sound of her wings, and he could not see her and smell the fragrance of her.

But soon Fuamnach discovered the happiness of Midir and Etain, and forthwith she came to where they were. Midir tried to protect his love, but the witch-power of Fuamnach prevailed, and straightway she began to chant a powerful incantation, and they could not see each other, and she raised and stirred up a great evil wind of assault, so strong and irresistible that in spite of their love, and of all the arts of Midir, Etain was taken up and swept away from the fair familiar mound of Bri Leith. Fuamnach put upon her further that she should not light on any hill or tree or bush in the whole of Ireland for seven years, but only on the sea rocks, and upon the waves themselves. Whenever Etain, faint and exhausted, tried to settle on a shrub or a land rock, the evil blast blew her upwards and away, and she had no respite and no rest until, seven years to the day, she alighted on the golden fringe of Angus mac Og's tunic as he stood on the Mound of the Brugh.

"Welcome," he said. "Welcome, Etain, weary and careworn, who has suffered great dangers through the evil of Fuamnach." And the Mac Og gathered the tired purple fly into the warm fleece of his cloak, and to his heart, and he brought her into his House. And Angus made a sun bower for Etain, with bright windows for passing in and out, and he filled it with flowers of every hue, and wondrous healing herbs, and the purple fly throve on the fragrance and the bloom of those goodly, precious plants. Angus slept in the sun bower with Etain, and comforted her, until gladness and colour came to her again, and wherever he went, he took the sun bower with him.

At the end of the seven years Fuamnach had begun her search for the purple fly, and when she found the sun bower, and

discovered the honour and the love the Mac Og bestowed upon Etain, her hatred deepened, and with cunning, she went to Midir.

"Let Angus come to visit you for a while," she said, "for the love between you is deep."

And Midir, in his loneliness, welcomed the thought, and sent messengers to bid the Mac Og come to Bri Leith.

Angus left the Brugh, and the sun bower with a heavy heart, and as soon as he had come to the Fair Mound of Bri Leith, and he and his foster-father were closeted together, Fuamnach, by devious and secret ways came to his House, and entering into the sun bower, she raised the same dread fury of wind and swept Etain with violence through the window and away from the Brugh, to be driven and buffeted, hither and yon, for seven more years, over the length and breadth of Ireland.

When Angus returned to the Brugh and found the crystal sun bower empty, he followed Fuamnach's tracks, and he came up with her at the House of the wizard Bresal, and he shore off her head.

Etain, seven years to the day of the second great wind of Fuamnach, tired and spent, small and pale, lit upon the roof of Etar's House. Etar was an Ulster warrior. There were feasting and celebration within, and as the wife of Etar was about to drink, Etain, exhausted, dropped from the roof and fell into the golden beaker, and the woman swallowed the purple fly with the wine that was in the goblet. And Etain was conceived in the womb of Etar's wife, and afterwards became her daughter.

When she was born, she became Etain, daughter of Etar, and it was one thousand and twelve years from the time of her first begetting by the Fairy King, Aylill, until her conception in the womb of the wife of Etar.

Eochaid, King of Ireland, in the year after his succession, commanded that the great Feast of Tara be held in order to assess the tribute and the taxes. But the people assembled and talked together, and they refused to pay tribute to a King who had no Queen, and they would not hold Festival at that time. So it was that Eochaid, without delay, sent envoys to the North and to the South, to the East and to the West, to seek the fairest maiden in Ireland to be his bride.

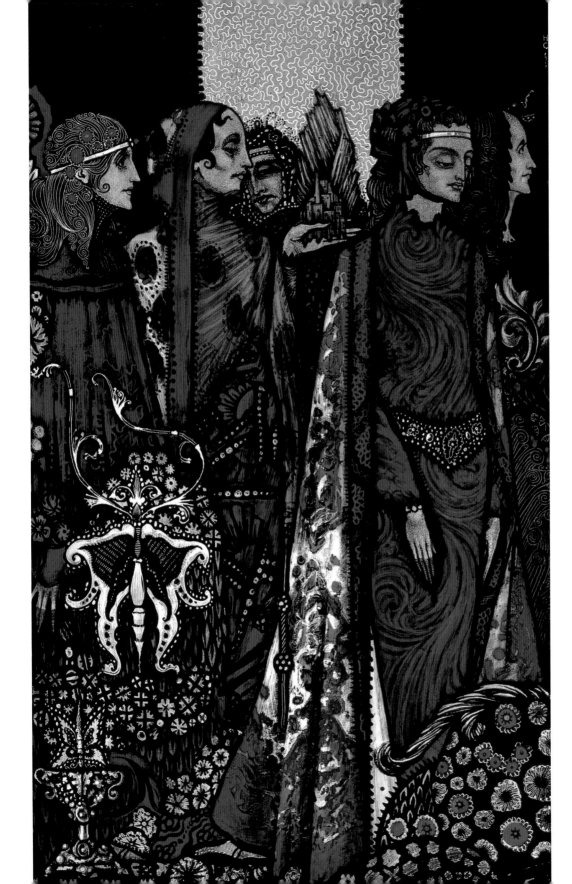

Etain, Helen, Maeve and Fand, Golden Deirdre's Tender Hand, Harry Clarke (1890–1931), Irish.

As the months passed and, one by one, the messengers returned to Tara, each had audience with the King. He listened to them and conferred with his men of wisdom, and his poets, but his heart did not leap within him until, late on an evening, he was alone on the terrace of Tara and a young envoy asked leave to speak with him. The Kind bade him draw near, and eagerly, the messenger spoke.

"Fifty beautiful maidens there were, O King, bathing in the estuary near to the house of Etar, in Ulster, and one more beautiful than all the others, at the edge of a spring, with a bright silver comb ornamented with gold, washing her hair in a silver bowl with four golden birds on it, and little flashing jewels of purple carbuncle on the rims of the bowl. . . . There were two golden yellow tresses on her head; each one was braided of four plaits, with a bead at the end of each plait. The colour of her hair seemed to them like the flower of the water-flag in summer, or red gold that has been polished.

"She was loosening her hair to wash it . . . her wrists were as white as the snow of one night and they were soft and straight; and her clear and lovely cheeks were red as the foxglove of the moor. Her eyebrows were black as a beetle's wing. . . . Her eyes were blue as the bugloss; her lips red as vermilion; her shoulders were high and smooth and soft and white. . . . Her slender long yielding smooth side, soft as wool, was white as the foam on the wave. . . . The bright blush of the moon was on her noble face. . . . She was the fairest and loveliest and most perfect of the women of the world that the eyes of men have ever seen."

"She is Etain," the messenger said, "daughter of Etar, and there is pride on her brow and radiance in her eyes, and it is said, 'All are fair till compared with Etain,' I thought her to be out of a Fairy Mound."

Eochaid, the King, wooed Etain, and married her, and she matched him in lineage, in youth and fame, and she brought joy and happiness to the King's House. The Great Feast of Tara was held with all splendour, and the people of Ireland rejoiced.

The King had two brothers, and Anguba, the younger of them, saw Etain at the Feast and he gazed on her continually, and such gazing is a sign of love. His heart reproached him, and he tried not to love his brother's wife, but to no avail, and that his honour should not be stained, he ate not food, fell into a decline, and was near to death.

It was the time of the Royal Circuit, and Eochaid, despite his grief and deep distress, was forced to leave Tara. He left his brother in the care of Etain, and bade her attend him, and if he should die, to see that his grave be dug, his lamentations made and his cattle slain.

Every day Etain came to the house where Anguba lay sick, and spoke with him, to comfort him, and his sickness was eased, for as long as she stayed with him, he would be gazing at her. Etain pondered on the matter, and one day she asked him the cause of his sickness.

"It is for love of you," Anguba said, and Etain answered:

"Pity, indeed, that you have been so long without telling it. Had we but known, you would have been healed a while ago."

"Even this day I could be whole again," Anguba said, "if you are willing."

"I am willing indeed," Etain replied, and every day she came to his house and she bathed his head, and carved his meat, and after thrice nine days Anguba was healed of his sickness and he said to Etain:

"And when shall I have from you what is still lacking to cure me?"

"Tomorrow," Etain said, "but not in the King's House shall he be shamed. Tomorrow, on the hill above the Court, I will wait for you." Etain kept the tryst, but at the hour of meeting a magic sleep overcame Anguba, and he did not waken till the third hour of the next day. When Etain returned to the House, she found the King's brother sorrowful and distraught.

"That I should have tryst with you, and then fall asleep," he said.

Twice they made tryst, and each time Anguba slept, and on the third night a man was waiting on the hill above the Court.

"Who are you?" Etain said. "It was not you I came to meet. My tryst with Anguba is not for sin or hurt, but that one who is worthy to be King should be healed of his sickness."

And the stranger revealed himself to her, and told her his name.

"I am Midir of Bri Leith, and I have loved you for a thousand years. You were daughter to Aylill, Fairy King of Mag Inish, and I was your lover and your husband. I paid a great bride-price for you."

He was tall and fair, and his purple mantle fell in five soft folds around him, and in it was the golden brooch of Bri Leith, that reached to his shoulder on either side. His bright yellow hair was held back from his brow by a fillet of gold, and the radiance of desire was in his eyes.

"Tell me," said Etain, "what parted us?"

"The sorcery of Fuamnach divided us, one from the other," said Midir, and approached her. "It was I who put love for you in Anguba's heart, so that he was sick with longing and near to dying. It was I who took from him all carnal desire and covered him with sleep, that your honour might not suffer."

Etain was silent, and turned away from him.

"Etain," he said, "will you come with me
to the wondrous land where harmony is,
hair is like the crown of the primrose there,
and the body smooth and white as snow.
There is neither mine nor thine,
white are teeth there, and dark the brows.
A delight to the eye is the number of our hosts."

But Etain would not look at him.

"A wondrous land is the land I tell of," Midir said.

"Warm sweet streams flow through the land,
the choice of mead and wine,
stately folk, without blemish,
conception is without sin, without lust,
We see everyone on every side,
and no one seeth us . . ."

But still she stood apart.

"Will you come with me if the King, your husband, bids you?"

"Willingly," Etain answered, and they looked into each other's eyes.

When she returned to the house she found Anguba and he was whole again, and healed of the cause of his sickness.

"We are well met," he said, "for now I am healed, and your honour has not suffered."

"It is well," said Etain, and they rejoiced together.

When Eochaid returned from his journeying, he gave thanks to Etain for her care of Anguba, his brother, and for all she had done to tend him. There was feasting in the great hall of Tara, and Etain poured the wine for Eochaid, her husband, and for Anguba, his brother, for it is written, "the pouring of wine was a special gift of hers."

On a day in midsummer Eochaid the King arose and went to the high terrace of Tara to look out over the Plain of Breg, shimmering in the haze of summer. He could hear the gentle humming of the bees in the flowers around him, and the cries of the nimble deer from the wooded slopes, and the lowing of heifers, white-backed, short-haired and merry in the soft fields. The cuckoo called with familiar voice, and the early blackbird sang the dawn, and as he looked about him at the fair land, suddenly he saw on the terrace before him a young warrior. He wore a purple cloak, and a golden brooch that reached from one shoulder to the other. He held a five-pointed spear in one hand, and in the other a white-bossed shield. It was richly encrusted with jewels and precious stones that gleamed in the morning sunlight, so that the King could not see the warrior clearly for the radiance of him. This warrior was not in Tara last night when the gates were locked, he thought, and the Courts have not yet been opened for the day. The visitor walked towards him.

"Welcome to you, Warrior. I do not know you," the King said.

"It is for that we have come," said the warrior.

"We do not know you," the King said again.

"Yet, in truth, I know you well," the stranger replied.

"Then, in truth, tell me your name."

"I am Midir of Bri Leith."

"It is of no matter."

"If you win my stake," the warrior said, "at the hour of terce tomorrow you shall have from me fifty dark grey steeds with dappled, blood-red heads, and pointed ears, broad-chested, with distended nostrils and slender limbs. Mighty, keen, huge, swift, steady, yet easily yoked with their fifty enamelled reins."

Eochaid agreed to the stake and the play began. The King won with ease, and the strange warrior left the terrace of Tara, taking his chessboard with him. But when the King arose on the morrow, his opponent was already waiting for him, and he wondered again how the warrior had entered the House before the Courts had been opened. Then he saw fifty darkly beautiful steeds on the Plain of Breg, each with its wrought enamelled bridle, and all other thoughts left his mind. He turned to his visitor.

"This is honourable, indeed," he said.

"What is promised is due," said Midir of Bri Leith, and he repeated his words "What is promised is due." They sat down again, to play. This time Eochaid asked what the stake should be.

"If you win my stake, you shall have from me fifty young boars, curly-mottled, grey-bellied, blue-backed, with horse's hoofs to them. . . . and further you shall have fifty gold-hilted swords, and again fifty red-eared cows," Midir said, "and fifty swords with ivory hilts."

"It is well," agreed the King, and again, he won, and the fruits of his winning were there at his House when he wakened. He was filled with wonder, and was counting his rich gains when his foster-father came upon him.

"From whence, Eochaid, is this great wealth?" he asked, surprised, and the King told him of the strange warrior to whom locked doors were no barrier, but who could not defeat him at the chess game. "Have a care, Eochaid," his foster-father said, "for this is a man of great magic power that has come to you. See that next time you lay heavy burden on him." And the King's foster-father bade him farewell, and left Tara for his own kingdom. The King went out to the terrace, and on the instant, Midir was there, and the chessboard ready. Remembering the advice he had been given, Eochaid made the stake, and he put on Midir the famous tasks that are remembered in Ireland to this day.

"If I take your stake," he said, "you must clear the rocks and stones from the hillocks of Great Meath, and the rushes from the land of Tethba. You must cut down the forest of Breg, and lay a causeway over the Great Bog of Tavrach, and all this you must accomplish in a single night."

"You lay too much upon me," Midir said.

"I do not indeed," the King replied.

"Then grant me this request," asked Midir. "That none shall be out of doors till the sun shall rise tomorrow."

"It shall be done," Eochaid agreed, and they began to play. The King won again, and when Midir left, Eochaid called his steward and commanded him to go to the Bog of Tavrach, forthwith, and to watch the efforts and the work of that night.

The steward went with all stealth from Tara, and as he watched, it seemed to him that all the men from all the Elf-mounds in the world were raising tumult there, and Midir, standing on a hill, urged on his Fairy Hosts. Then to his surprise, the King's man saw that the strong dark blue Fairy oxen were yoked by their shoulders so that the pull might be there, and not on their foreheads, as it had always been in Ireland. And as they worked, the hosts of the Elf-mounds sang:

"Heave here, pull there, excellent oxen,
In the hours after sundown,
And none shall know whose
Is the gain or the loss
From the Causeway of Tavrach."

And the causeway would have been the best in the world, had not the work of the Fairy Hosts been spied upon, but Midir was angry because of this and he left some defects in the work.

Meanwhile the steward returned to Tara, and told the King of the magic he had witnessed during the night, and he told him of the new way he had seen of yoking the oxen so that the pull might be upon their shoulders. When he heard this, Eochaid decreed that henceforth all the oxen in Ireland should be thus yoked, and for this decree he was called Eochaid Airem, "The Ploughman."

"There is not on the ridge of the world a magic power to surpass the magic I have seen this night," the steward said, and as he spoke, Midir appeared before them, his loins girt and an angry look on his face. Eochaid was afraid, but he made Midir welcome.

"It is cruel and unreasonable of you to lay such hardship and affliction on me and on my people, and then to spy on me," Midir said. "My mind is inflamed against you."

"I will not give wrath for your rage," the Kind said.

"Then," said the Fairy King, "let us play chess."

"What stake shall we set upon the game?" Eochaid asked.

"That the loser pays what the winner shall desire," said Midir of Bri Leith, and they sat down to play. Midir won with ease, and Eochaid's stake was forfeit.

"You have taken my stake," he said.

"Had I wished I could have taken it before now."

"What do you want of me?"

"My arms about Etain, and a kiss from her lips."

Eochaid was silent. Then he said:

"Come one month from today and it shall be given to you."

Midir left Tara for the Fair Mound of Bri Leith, and Eochaid, losing no time, called the flower of the warriors of his land, and the best war lords in all Ireland, and he mustered them around Tara, without and within, ring upon ring of the heroes of Ireland to guard the Hill of Tara, and the King and Queen were in the centre of the House; and the Courts were locked and guarded by the Men of Strength, and the Men of Hearing, against the Man of Magic who was to come.

Etain was serving wine to the King and the Lords in the midst of the Hall, and as she bent over towards the goblet in the King's hand, Midir, in the centre of the Royal House, came towards her. He was fair at all times, but on this night he was fairest, and the hosts of Tara were astonished at his beauty, and at the radiance of him. In the silence, the King made him welcome.

"What has been pledged to me, let it be given to me," Midir said.

"I have given the matter little thought," said the King.

"What is promised is due," Midir said.

Etain was silent, and her cheeks were red as the scarlet rowenberry, and then, by turn, as white as snow.

"Do not blush, Etain," Midir said to her. "I have been a year seeking you with gifts and treasures, the richest and most beautiful in Ireland. It is not by the dark magic that I have won you."

"I will not go with you, Midir, unless the King releases me to you," Etain replied.

"I will never release you," Eochaid said. "But as for this stake, I willingly allow this warrior to put his arms about you, and to kiss you, here in the middle of the Royal House, while the hosts of Tara look on."

"It shall be done," said Midir, and he took his weapons in his left hand, and with his right arm he held Etain round the waist, and as he kissed her, and kissed her again, he bore her away in his embrace, up through the skylight of the House.

The men of Ireland rose in shame about their King, and he led them out in hot pursuit. But Eochaid, High King of Ireland, and his hosts, saw only two snow-white swans in full flight over Tara.

And the Whole Day they Flew Onward, Harry Clarke (1890–1931), Irish.

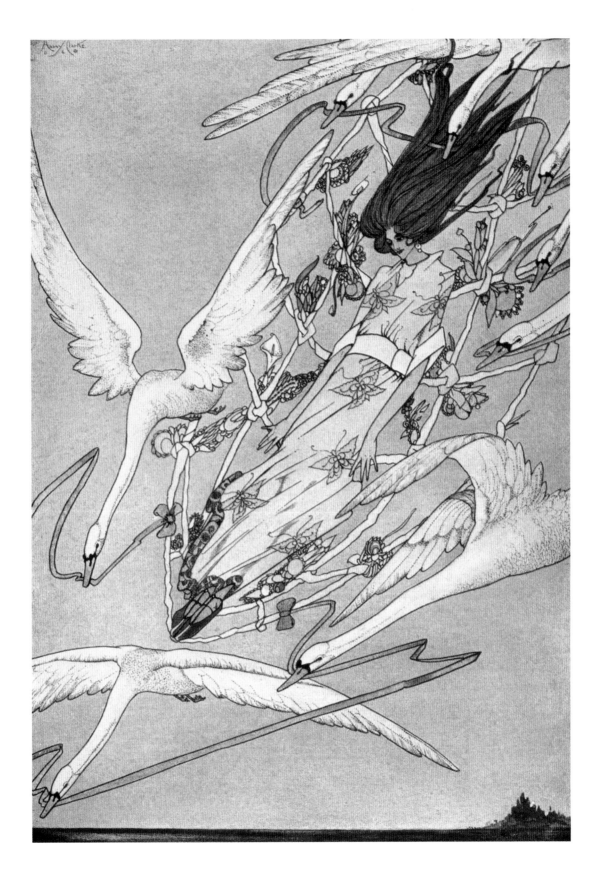

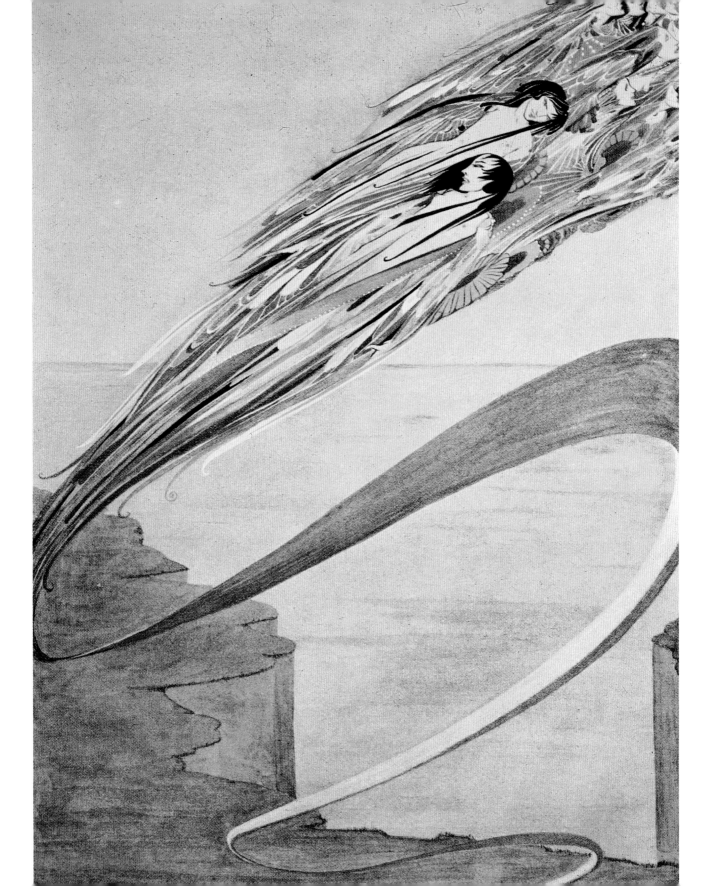

LOVE SPELL

Kathleen Raine

Scottish

By the travelling wind
By the restless clouds
By the space of the sky,

By the foam of the surf
By the curve of the wave
By the flowing of the tide,

By the way of the sun,
By the dazzle of light
By the path across the sea,
 Bring my lover.

By the way of the air,
By the hoodie crow's flight
By the eagle on the wind,

By the cormorant's cliff
By the seal's rock
By the raven's crag,

By the shells on the strand
By the ripples on the sand
By the brown sea-wrack,
 Bring my lover.

By the mist and the rain
By the waterfall
By the running burn,

By the clear spring
By the holy well
And the fern by the pool
 Bring my lover.

By the sheepwalks on the hills
By the rabbit's tracks
By the stones of the ford,
 Bring my lover.

By the long shadow
By the evening light
By the midsummer sun
 Bring my lover.

By the scent of the white rose
Of the bog myrtle
And the scent of the thyme
 Bring my lover.

By the lark's song
By the blackbird's note
By the raven's croak
 Bring my lover.

By the voices of the air
By the water's song
By the song of a woman
 Bring my lover.

By the sticks burning on the
 hearth
By the candle's flame
By the fire in the blood
 Bring my lover.

By the touch of hands
By the meeting of lips
By love's unrest
 Bring my lover.

By the quiet of the night
By the whiteness of my breast
By the peace of sleep
 Bring my lover.

By the blessing of the dark
By the beating of the heart
By my unborn child,
 Bring my lover.

I am born of a thousand storms, and grey with rushing rains, Harry Clarke (1890–1931), Irish.

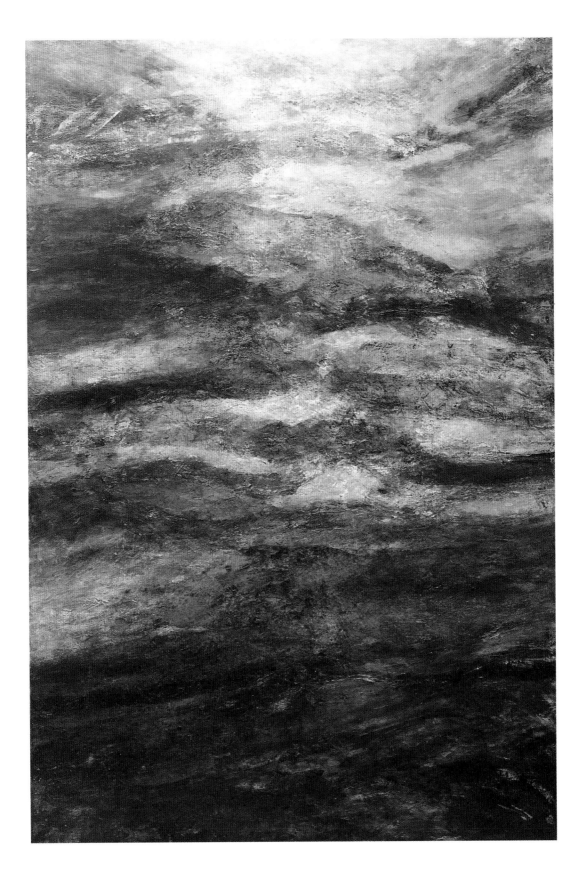

SPELL OF SLEEP

Kathleen Raine

Scottish

Let him be safe in sleep
As leaves folded together
As young birds under wings
As the unopened flower.

Let him be hidden in sleep
As islands under rain,
As mountains within their clouds,
As hills in the mantle of dusk.

Let him be free in sleep
As the flowing tides of the sea,
As the travelling wind on the moor,
As the journeying stars in space.

Let him be upheld in sleep
As a cloud at rest on the air,
As sea-wrack under the waves
When the flowing tide covers all
And the shells' delicate lives
Open on the sea-floor.

Let him be healed in sleep
In the quiet waters of night
In the mirroring pool of dreams
Where memory returns in peace,
Where the troubled spirit grows wise
And the heart is comforted.

An Ghoath Ar Muir (The Wind on the Sea), Gwen O'Dowd (living artist), Irish. Encaustic on canvas, 1989.

STELLA'S BIRTHDAY, 1715

Jonathan Swift

Irish

Stella this day is thirty-four,

(We shan't dispute a year or more)

However Stella, be not troubled,

Although thy size and years are doubled,

Since first I saw thee at sixteen

The brightest virgin on the green,

So little is thy form declined

Made up so largely in thy mind.

Oh, would it please the gods to split

Thy beauty, size, and years, and wit,

No age could furnish out a pair

Of nymphs so graceful, wise and fair

With half the luster of your eyes,

With half your wit, your years and size:

And then before it grew too late,

How should I beg of gentle Fate,

(That either nymph might have her swain,)

To split my worship too in twain.

Mrs. Scott Moncrieff,
Sir Henry Raeburn
(1756–1823), Scottish.
Oil on canvas, 1814.

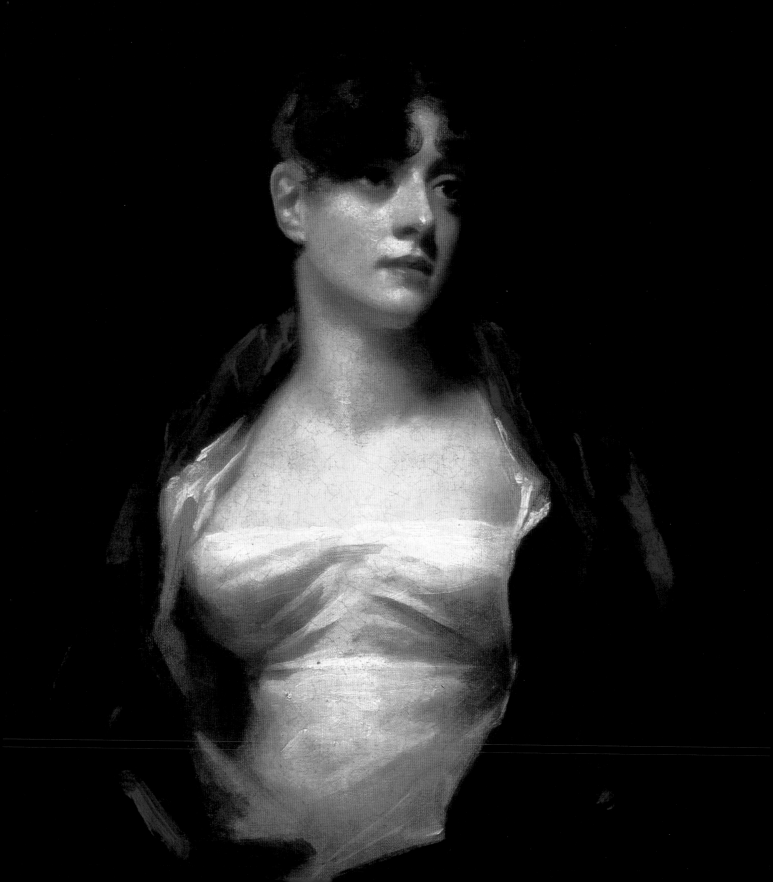

BLESSING OF THE MOON

F. MARIAN MacNEIL

Irish

When I see the new moon,

It becomes me to lift mine eye,

It becomes me to bend my knee,

It becomes me to bow my head.

Giving thee praise, thou moon of guidance,

That I have seen thee again,

That I have seen the new moon,

The lovely leader of the way.

Many a one has passed beyond

In the time between the two moons,

Though I am still enjoying earth,

Thou moon of moons and of blessings.

King Arthur in Combat, Robert de Barron, French. Illuminated manuscript page from *L'Estoire de Merlin*, 14th century.

"Bring me my bow of burning gold,
Bring me my arrow of desire,
Bring me my spear, O clouds unfold!
Bring me my chariot of fire."

—WILLIAM BLAKE

SWORD

TALES OF ADVENTURE, ROMANCE AND MAGIC are the main body of Celtic literature. *Sword* features a rich selection of tales and poetry which brings into high relief the many qualities of the Celtic Hero. The heroes and heroines you will find in these pages are not merely strong and courageous, they have many other extraordinary qualities. Always astonishingly beautiful, they are also keenly intelligent with the ability to intuit and understand.

Perhaps the most famous of these heroes is the Irish warrior Cuchulainn (Coo-HOOL-lyn). Naturally, he possesses great physical power, yet his greatest strength is his ability to avail himself of the powers that surround him. Whether it is the druids with their great wisdom or the animals with their magical power, Cuchulainn looks to these exterior forces to protect, guide and inform him. He wields mystical weapons—his sword and his spear. He is larger than life and usually is defined in single combat against great odds.

Trained on the Isle of Skye by the woman warrior, Scathach, Cuchulainn's intense concentration allows him to go into battle in an altered consciousness—a warp frenzy that renders him unconquerable.

Even though the Celtic hero is singular, he does not stand alone—he is connected to both his family and the tribe of warriors he leads. The literary selections in *Sword* reveal such deep loyalties and friendships.

It is worth noting that much of the heroic literature carries an elegiac tone. Some of the melancholy is simply a consequence of the pain and death incurred in a warrior's life. Some of the selections included here are remembrances and laments. But there is also the sense that the heroic age of the Celts is over by the time oral tradition gives way to written language. Even in the earliest tales of the God Dagda and his son Angus Og there is a longing for the time before the terrible race of Fomorians stole the paradise Dagda had created (see page 91, *A Good Action*).

The spread of Christianity and the destruction of the native Celtic languages ripped the Celtic tradition out of people's lives. Stories were kept alive in folktales and songs from generation to generation. The elegiac sense so vivid in Yeats and Joyce has a long, inspired tradition. This section ends with a poem by Mary Ann Larkin that eloquently makes this point.

Cuchulainn, Arthur and Fionn all have magical births, become great warriors and die in battle. They share chivalrous qualities—each exceptionally skilled warriors. These heroes all have important loves in their lives. They are all lovers to varying degrees. In *Sword* you see a coming into maturity, into adulthood in the mid-summer of life. The festival of Lughnasadh (Loo-NAHS-ah) on August 1st or 2nd for the Irish sun-god Lugh (also Cuchulainn's father) is a harvest celebration. This season reflects the maturity that we ripen into and the fruits born of our struggles.

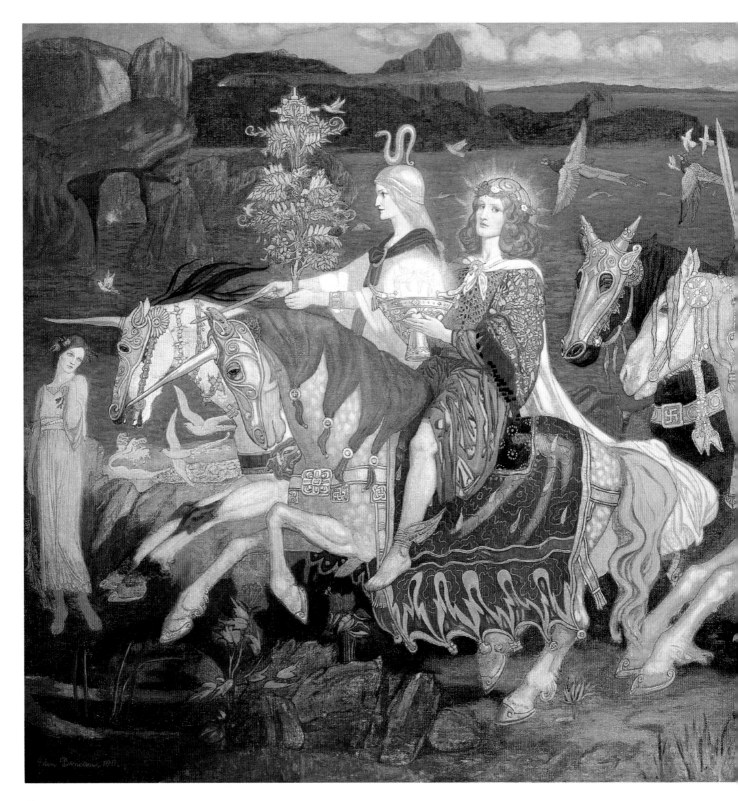

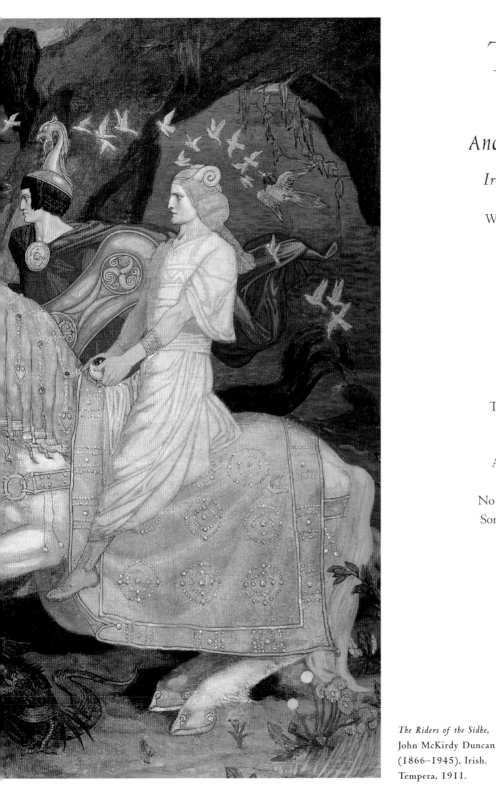

THE HOSTS OF FAERY

Anonymous, 12th century

Irish, translated by Kuno Meyer

White shields they carry in their hands,
With emblems of pale silver;
With glittering blue swords,
With mighty stout horns.

In well-devised battle array,
Ahead of their fair chieftain
They march amid blue spears,
Pale-visaged, curly-headed bands.

They scatter the battalions of the foe,
They ravage every land they attack,
Splendidly they march to combat,
A swift, distinguished, avenging host!

No wonder though their strength be great:
Sons of queens and kings are one and all;
On their heads are
Beautiful golden-yellow manes.

With smooth comely bodies,
With bright blue-starred eyes,
With pure crystal teeth,
With thin red lips.

Good they are at man-slaying,
Melodious in the ale-house,
Masterly at making songs,
Skilled at playing chess.

The Riders of the Sidhe,
John McKirdy Duncan
(1866–1945), Irish.
Tempera, 1911.

Detail of Gundestrup cauldron, inner plate. Warriors with lurs (Celtic wind instruments), Irish. Embossed silver, gilded, 1st–2nd century B.C.E.

EXCERPT FROM

PORTRAIT OF THE ARTIST AS A YOUNG MAN

James Joyce

Irish

16 *April:* Away! Away!

 The spell of arms and voices: the white arms of roads, their promise of close embraces and the black arms of tall ships that stand against the moon, their tale of distant nations. They are held out to say: We are alone. Come. And the voices say with them: We are your kinsmen. And the air is thick with their company as they call to me, their kinsman, making ready to go, shaking the wings of their exultant and terrible youth.

The Broighter Ship. May have been a votive offering to Mannannan mac Lir. Found at Broighter, County Derry, Ireland. Gold, 1st century B.C.E.–early 1st century.

THE ADVENTURE OF CONLE

Anonymous, 8th century

Irish, edited by Miles Dillon

Titania, Margaret Macdonald Mackintosh, (1865–1933), English. 1909.

'One day Conle the Red, son of Conn of the Hundred Battles, was beside his father on the hill of Usnech. He saw a woman in wonderful attire approach him. Conle said,

'"Where do you come from, woman?"

'"I come," said the woman, "from The Land of the Living, a place in which there is neither death nor sin nor transgression. We enjoy lasting feasts without preparing them and pleasant company without strife. We live in great peace. From that we are named the People of Peace."

'"With whom do you speak, boy?" said Conn to his son, for none saw the woman save Conle alone. The woman answered:

"He speaks to a beautiful young woman of noble race whom neither death threatens nor old age. I love Conle the Red, I call him to the Plain of Delight, where reigns a king victorious and immortal, a king without weeping or sorrow in his land since he became king.

Come with me, Conle the Red of the jewelled neck, red as flame. Your hair is yellow over the bright noble face of your royal form. If you come with me, your beauty will not lose its youth or its fairness forever."

'Conn said to his druid, Corán was his name, for they all heard what the woman said, although they did not see her:

'"I pray you, Corán of the many songs and many talents, trouble has come to me which defeats my counsel, which defeats my power, a strength which I have not known since I became king, that I should meet an invisible form which strives against me to steal away my fair son by magic spells. He is being lured away from me, the king, by women's wiles."

'Then the druid sang against the woman's voice so that no one heard the voice of the woman and so that Conle did not see the woman after that; but when the woman went away at the loud chanting of the druid, she threw an apple to Conle. Conle was for a month without drink, without food. He cared not to eat any other food but his apple, and his apple did not diminish for what he used to eat of it, but was still whole. A longing then came upon Conle for the woman he had seen. A month from that day Conle was beside his father in the plain of Archommin, and he saw the same woman approach him, and she said to him:

"There above sits Conle among lifeless mortals waiting for gloomy death. Living immortals invite you. You are a hero for the people of Tethra who see you every day in the assemblies of your fatherland among your dear companions."

'When Conn heard the woman's voice he said to his people: "Call me the druid. I see that her tongue has been loosened today." The woman said then:

"Conn of the Hundred Battles, do not love druidry for it is small. A just man comes to give judgment at the wide strand with many companions, many and wonderful. Soon shall his judgment reach you, and it will scatter the spells of the druids in the sight of the devil, the Black Magician."

'Conn thought it strange that Conle spoke with no one once the woman had come.

'"Did you understand what the woman says, O Conle?" said Conn.

'"It is not easy for me, for I love my people, but a longing for the woman has come upon me."

'The woman answered then and said this:

"You have a longing greater than all other desires to go from them over the sea, so that we may come in my ship of glass to the dwelling of Boadach, if we can reach it.

"There is another country where also you could go. I see the sun sets. Though it is far away, we shall reach it before night.

"It is the country which delights the mind of anyone who goes there. There are no people there save only women and girls."

'When the maiden had finished speaking Conle sprang away from them so that he was in the ship of glass, that is, in the firm crystal coracle. They looked out farther and farther, as far as their eyes could see. They rowed then over the sea away from them, and they were not seen since, and it is not known where they went.'

THE SHADOW HOUSE OF LUGH

Anonymous, 8th century

Irish, translated by Ethna Carbery

Dream-fair, beside dream waters, it stands alone:
A winged thought of Lugh made its corner stone:
A desire of his heart raised its walls on high,
And set its crystal windows to flaunt the sky.

Its doors of the white bronze are many and bright,
With wonderous carven pillars for his Love's delight,
And its roof of the blue wings, the speckled red,
Is a flaming arc of beauty above her head.

Like a mountain through mist Lugh towers high,
The fiery-forked lightning is the glance of his eye,
His countenance is noble as the Sun-god's face—
The proudest chieftain he of a proud De Danaan race.

He bides there in peace now, his wars are all done—
He gave his hand to Balor when the death gate was won,
And for the strife-scarred heroes who wander in the shade,
His door lieth open, and the rich feast is laid.

He hath no vexing memory of blood in slanting rain,
Of green spears in hedges on a battle plain;
But through the haunted quiet his Love's silver words
Blow round him swift as wing-beats of enchanted birds.

A grey haunted wind is blowing in the hall,
And stirring through the shadowy spears upon the wall,
The drinking-horn goes round from shadowy lip to lip—
And about the golden methers shadowy fingers slip.

The Star of Beauty, she who queens it there;
Diademed, and wondrous long, her yellow hair.
Her eyes are twin-moons in a rose-sweet face,
And the fragrance of her presence fills all the place.

He plays for her pleasure on his harp's gold wire
The laughter-tune that leaps along in trills of fire;
She hears the dancing feet of *Sidhe* where a white moon gleams,
And all her world is joy in the House of Dreams.

He plays for her soothing the Slumber-song:
Fine and faint as any dream it glides along:
She sleeps until the magic of his kiss shall rouse;
And all her world is quiet in the Shadow-house.

His days glide to night, and his nights glide to day:
With circling of the amber mead, and feasting gay;
In the yellow of her hair his dreams lie curled,
And her arms make the rim of his rainbow world.

Opera of the Seas, Margaret Macdonald Mackintosh,
(1865–1933), English. Gesso panel, 1903.

Detail of Gundestrup
cauldron, outer plate, Irish.
Embossed silver, gilded,
1st–2nd century B.C.E.

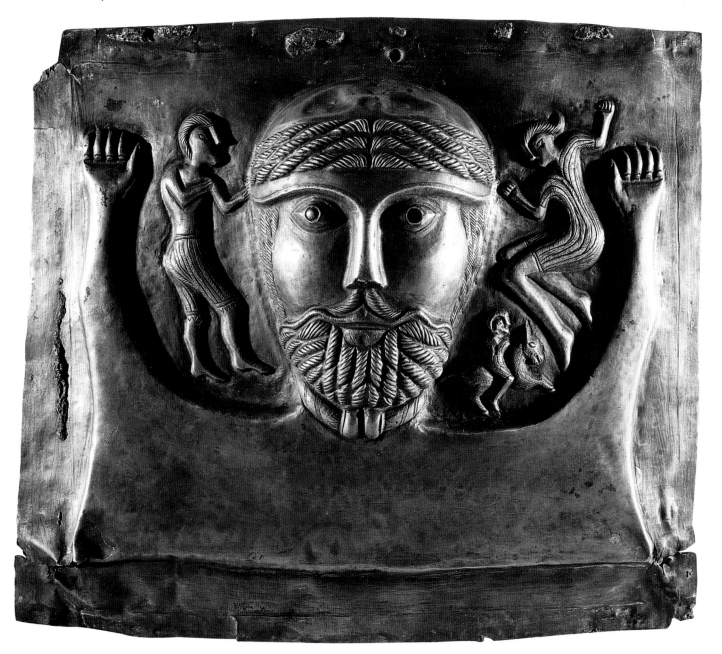

A Good Action

Retold by Ella Young

Irish

The Dagda sat with his back to an oak tree. He looked like a workman, and his hands were as hard as the hands of a mason, but his hair was braided like the hair of a king. He had on a green cloak with nine capes, and along the border of every cape there was a running pattern embroidered in gold and silver and purple thread. Opposite the Dagda sat his son, Angus Og, with his hands clasped about his knees. He was in rags, and his hair was matted like the hair of a beggar: a bramble had scratched his nose, but his eyes were smiling.

"If you only knew how ridiculous you look in that cloak," he was saying to the Dagda, "you would not wear it."

"My son," said the Dagda, with dignity, "it is the only cloak the people of the Fomor have left me, and the evening is cold."

"Why don't you keep yourself warm by working?" said Angus. "It's what I would do myself if you had brought me up to a trade."

"Angus," said his father, "remember I am one of the gods: it is not necessary to talk sense to me."

"O dear!" said Angus, "a bramble scratched me on the nose this morning—it's all because you have lost your Magic Harp and the Cauldron of Plenty! Soon even the snails will make faces at me. I can't go wandering round Ireland in comfort any more. I'll change myself into a salmon and swim in the sea."

"The salmon must come up the rivers once a year, and when you come the Fomorians will take you in their net, and it is likely Balor, their king, will eat you."

"'Ochone a rie!' I must be something else! I'll be an eagle."

"You will shiver in the icy grip of the wind that goes before the Fomor—the black bitter wind that blows them hither to darken the sun for us."

"'Ochone, Ochone, my Grief and my Trouble!' I must think of something else. I'll be a good action. The Fomor never meddle with a good action."

While Angus was talking a Pooka came out from between the trees. It looked like a little snow-white kid with golden horns and silver hoofs, but it could take any shape it had a fancy for. When it saw Angus it smiled and made one jump on to his shoulder.

"Look at this!" said Angus. "I never can say anything important without being interrupted!"

"What do you want?" he said to the Pooka, pretending to be cross.

"O nothing at all, only to listen to your wise talk; it does me good," said the Pooka, prancing on Angus' shoulder.

"Well, keep quiet if you want to listen!" said Angus. "I was saying," he continued to the Dagda, "I will be a good action."

Just at that moment an ugly deformed animal, with a head like the head of a pig and a hound's body, came tearing through the wood; behind it was a young boy of the Fomor. He was ugly and deformed, but he had a rich cloak and a gold circle on his head. The moment he saw the Pooka he threw a fire-ball at it. The Pooka jumped behind Angus, and Angus caught the fire-ball. It went out in his hand.

"I am a Prince of the Fomor," said the boy, trying to look big.

"I was thinking as much," said Angus; "you have princely manners."

"I am Balor's own son. I have come out to look for treasure, and if you have anything I command you to give it to me at once."

"What would you like?" said Angus.

"I would like the white horse of Mananaun; or three golden apples; or a hound out of Tir-nan-Oge."

"They say it's lucky to be good to poor folk," said Angus. "If you are good to us, perhaps you may find a treasure."

"If you do not get up at once and hunt about for a treasure for me I will tell my father, Balor, and he will wither you off the face of the earth!"

"O give me a little time," said Angus, "and I'll look for something."

The Pooka, who had been listening to everything, now skipped out from his hiding-place with a turnip in his mouth— he was holding it by the green leaves.

"The very thing!" said Angus. "Here is a treasure!" He took the turnip in his hands and passed his fingers over it. The turnip became a great white egg, and the leaves turned into gold and crimson spots and spread themselves over the egg.

"Now, look at this!" said Angus. "It is an enchanted egg. You have only to keep it till you do three Good Actions, and then it will hatch out into something splendid."

"Will it hatch into Mananaun's white horse?" said the boy.

"It depends on the Good Actions you do; everything depends on that."

"What is a Good Action?"

"Well, if you were to go quietly away, and never tell any one you had seen us, it would be a Good Action."

"I'll go," said the boy. He took the egg in his hands, kicked up a toe-full of earth at the Pooka, and went.

He hadn't gone far when he heard a bird singing. He looked and saw a little bird on a furze-bush.

"Stop that noise!" he said.

The bird went on singing. The boy flung the egg at it. The egg turned into a turnip and struck a hare. The hare jumped out of the furze-bush.

"My curse on you," said the boy, "for a brittle egg! What came over you to hatch into nothing better than a hare! My Grief and my Trouble! What came over you to hatch out at all when this is only my second Good Action?"

He set his hound after the hare, but the hare had touched the enchanted turnip and got some of the magic, so the hound could not chase it. He came back with the turnip. The boy hit him over the head with it many times and the dog howled. His

howling soothed Balor's son, and after a while he left off beating the dog and turned to go back to his own country. At first he walked with big steps puffing his cheeks vaingloriously, but little by little a sense of loss overcame him, and as he thought how nearly he had earned the white horse of Mananaun, or three golden apples, or some greater treasure, two tears slowly rolled down his snub nose: they were the first tears he had shed in his life.

Angus and the Dagda and the Pooka were still in the little clearing when Balor's son passed back through it. The moment he came in sight the Pooka changed himself into a squirrel and ran up the oak tree; Angus changed himself into a turnip and lay at the Dagda's feet; but the Dagda, who had not time to think of a suitable transformation, sat quite still and looked at the young Fomorian.

"Sshh! Sshh! Hii! Tear him, dog!" said Balor's son.

The pig-headed creature rushed at the Dagda, but when he came to the turnip he ran back howling. The Dagda smiled and picked up the turnip. He pressed his hands over it and it became a great golden egg with green and purple spots on it.

"Give it to me! Give it to me!" yelled Balor's son, "it's better than the first egg, and the first egg is broken. Give it to me."

"This egg is too precious for you," said the Dagda. "I must keep it in my own hands."

"Then I will blast you and all the forest and every living thing! I have only to roar three times, and three armies of my people will come to help me. Give me the egg or I will roar."

"I will keep this egg in my own hands," said the Dagda.

Balor's son shut his eyes tight and opened his mouth very wide to let out a great roar, and it is likely he would have been heard at the other end of the world if the Pooka hadn't dropped a handful of acorns into his mouth. The roar never came out. Balor's son choked and spluttered, and the Dagda patted him on the back and shook him. He shook him very hard, and while he shook him Angus turned into a good action and slipped into the boy's mind. Balor's son got his breath then, he said:

"I will not blast you this time; I will do a Good Action. I will let you carry the egg, and you can be my slave and treasure-finder."

"Thank you," said the Dagda; but the words were scarcely out of his mouth when a terrible icy wind swept through the wood. The earth shook and the trees bent and twisted with terror. The Pooka instantly turned himself into a dead leaf and dropped into a fold of the Dagda's cloak; the Dagda hid the leaf in his bosom and turned his cloak so that the nine capes were inside. He did it all in a moment, and the next moment the wood was full of Fomorians—ugly mis-shapen beings with twisted mouths and squinting eyes. They shouted with joy when they saw Balor's son, but they knew the Dagda was one of the De Danaans and rushed at him with their weapons.

"Stop!" roared Balor's son. "Keep back from my Treasure-Finder! He must follow me wherever I go."

The Fomor stood back from the Dagda, and their captain bowed himself before Balor's son.

"O Prince," he said, "whose mouth drops honey and wisdom, the thing shall be as you command, and, O Light of our Countenance, come with us now, for the Harp-feast is beginning and Balor has sent us into the four quarters of the world to find you."

"What feast are you talking about?"

"O Pearl of Goodness, the feast your father is giving so that all his lords may see the great harp that was taken from the Dagda."

"I know all about that harp! I have seen it; no one can play on it—I will not go with you!"

"O Fount of Generosity, we are all as good as dead if we return without you."

Balor's son turned away and took two steps into the wood; then he stopped and balanced himself, first on one foot then on the other; then he turned round and gave a great sigh.

"I will go with you," he said, "it is my twenty-first Good Action!"

The terrible icy wind swept through the wood again and the Fomorians rose into it as dust rises in a whirlwind; the Dagda rose too, and the wind swept the whole company into Balor's country.

It was a country as hard as iron with never a flower or a blade of grass to be seen and a sky over it where the sun and moon never showed themselves. The place of feasting was a great plain and the hosts of the Fomor were gathered thick upon it. Balor of the Evil Eye was in the midst and beside him the great harp. Every string of the harp shone with the colours of the rainbow and a golden flame moved about it. No one of the Fomor had power to play on it.

As soon as the Dagda saw the harp he turned his cloak in the twinkling of an eye so that the nine capes were outmost and he stretched his hands and cried:

> "Ϲᴀɪɲ Ɗᴀuɲ-ᴅᴀbᴌᴀo,
> Ϲᴀɪɲ Ϲoɪɲ cecһᴀɲcһuɪɲ,
> Ϲᴀɪɲ ɲᴀm, cᴀɪɲ ɡᴀm,
> Ɓᴇoᴌᴀ cɲoc ocuɲ boᴌɡ ocuɲ buɪɲɲᴇ."

The great harp gave a leap to him. It went through the hosts of the Fomor like lightning through clouds, and they perished before it like stubble before flame. The Dagda struck one note on it, and all the Fomor lost the power to move or speak. Then he began to play, and through that iron country grass and flowers came up, slender apple-trees grew and blossomed, and over them the sky was blue without a cloud. The Pooka turned himself into a spotted fawn and danced between the trees. Angus drew himself out of the mind of Balor's son and stood beside the Dagda. He did not look like a beggar-man. He had a golden light round his head and a purple cloak like a purple cloud, and all about him circled beautiful white birds. The wind from the birds' wings blew the blossoms from the apple trees and the petals drifted with sleepy magic into the minds of the Fomorians, so that each one bowed his head and slept. When the Dagda saw that, he changed the tune he was playing, and the grass and flowers became a dust of stars and vanished. The apple trees vanished one by one till there was only one left. It was covered over with big yellow apples—sweeter than the sweetest apples any one ever ate. It moved, and Angus saw it was going to vanish. He put his hand on the Dagda's wrist to stop the music and said:

"Do not play away that apple tree. Leave it for Balor's son when he wakens—after all, he did one Good Action."

The Dagda smiled and stopped playing.

THE APPLE TREES

Merlin

Scottish

Sweet apple tree of lush foliage,

I have fought beneath you to please a maiden,

shield on shoulder and sword on hip.

I have slept alone in the forest of Kelyddon.

Listen, little pig, why do you think of sleep?

Lend your ear to the sweet song of birds.

Kings will come across the sea on Monday

and the Kymry will be blessed.

Sweet apple tree that grows in the clearing,

the nobles of Rydderch's court do not see you

though they trample the earth at your feet.

To their eyes the faces of heroes are terrible.

Gwendydd no longer loves me and comes no more to see me.

I am hateful to Gwassawg, one of Rydderch's faithful,

for I have slain his son and his daughter

May merciless death come to me. . . .

Since Gwenddoleu, no prince does me honor.

I have neither joy nor a woman's company.

At the battle of Arderyd I received a gold torque,

and now she who is white as a swan scorns me.

A POISON TREE

William Blake

English

I was angry with my friend:
I told my wrath, my wrath did end.
I was angry with my foe:
I told it not, my wrath did grow.

And I waterd it in fears,
Night & morning with my tears;
And I sunnéd it with smiles,
And with soft deceitful wiles.

And it grew both day and night,
Till it bore an apple bright.
And my foe beheld it shine,
And he knew that it was mine,

And into my garden stole,
When the night had veild the pole;
In the morning, glad I see
My foe outstretchd beneath the tree.

Apple, Walberswick,
Charles Rennie Mackintosh
(1868–1928), Scottish.
Pencil and watercolor, 1915.

THE HILLS OF CUALANN

Anonymous, 8th century

Irish, translated by Joseph Campbell

In the youth of summer

The hills of Cualann

Are two golden horns,

Two breasts of childing,

Two tents of light

In the ancient winter

They are two rusted swords,

Two waves of darkness,

Two moons of ice.

Detail of an enameled bronze
shield found in the Thames
at Battersea, England.
6th–1st century B.C.E.

THE WEAKNESS OF THE ULSTERMEN

Anonymous, 12th century

Irish, translated by Joseph Campbell

Crunnchu was wealthy and prosperous, living in the lonely hills with his wife and four sons. His wife died, and for years he and his sons lived without a woman in the house. One day a young woman, dignified and beautiful, came to the house and sat down by the fire. She said nothing, and Crunnchu watched her, silent also, as she rose again and set about the duties of a housewife, preparing food, milking the cows, directing the servants.

When night came she went to Crunnchu and he spoke to her then:

"Will you be my wife?"

"On condition that you speak my name to no one nor tell aught to anyone about me," she replied. And so it was agreed between them. They lived happily together, and with her his prosperity increased.

One day he told her that he was going to one of the great assemblies of the men of Ulster, where there would be races and games and entertainments and combats. She begged him not to go.

"You may by accident speak of me," she said, "and I am very happy here with you, and would not like to leave. But our union is at an end if you speak of me to anyone."

He would not heed her; but assured her vehemently that he would not endanger their union by one word. And it was a glorious day of entertainment. In all the contests of chariot-racing the horses of the king were victorious, and the mouths of all the people were full of praise for them. And the poets sang the praises of the king and his wife. And they praised the horses, saying:

"No two such horses have ever been seen. Their speed could not be matched anywhere."

But Crunnchu, provoked by all the praise, and forgetting his promise, shouted:

"My wife could run faster than the horses you praise."

The king was enraged and cried out:

"Seize the man who said that."

The attendants seized Crunnchu and brought him to the king.

"Now," said the king, "you will prove that boast or pay for it." And he sent messengers to bring the man's wife at once to the assembly. Meanwhile Crunnchu was kept in bonds until his wife should be brought.

The messengers went to his house, where they were welcomed by the woman. When she inquired why they had come to her they said:

"Your husband has boasted to the king, in the presence of the whole assembly, that you can run more swiftly than the

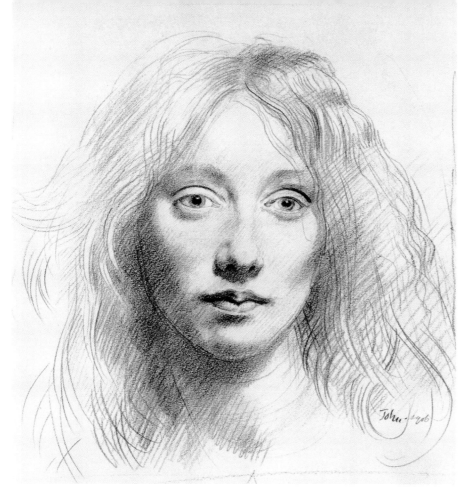

Portrait of Alexandra,
Augustus John
(1878–1961), Welsh.
Pencil on paper, 1906.

She cried out in great distress: "Will no one help me?" She looked round the mob: "A mother bore each one of you. Have you no pity for me?" She turned to the king and begged him: "Give me but a short respite, until my deliverance is come, and I will do what you ask me."

"You run now, or your husband dies," he replied.

"For this shame you put upon me," she cried, "you and all your people will pay, in years to come."

The king ignored this, but ordered her to tell her name, before the race began.

"My name, and my offspring's name," she said, "will be on this place of assembly to mark the great shame of your deed today. I am Macha. And my descent is from Ocean."

She called for the horses to be brought, and she outran them to the end of the course; and her time came; and her twins were born. So the name Emain Macha.

All who were there felt a strange weakness on them, a weakness like hers in her pain. And she spoke to them a prophecy:

"The shame you have put upon me will be punished in each man of you. When crisis or danger is nigh to you, this weakness you feel now will come upon you, and upon your children to the ninth generation."

Her word was true. For though the weakness came upon the men it did not affect the women or children of Ulster, nor did it affect any men but those of Ulster, nor did it affect Cuchulainn, who was begotten of Lu. And that is why Cuchulainn stood alone against the warriors of Maeve, because of the weakness put upon the men of Ulster by Macha.

horses of the king. And he will not be released until you come to the assembly."

"My husband," said she, "spoke rashly. I am unwell. I am expecting a child."

"Your husband will pay with his life for his boast," said they, "if you do not come."

She demurred no more, but went with them. The great crowds in the assembly gathered round her and gazed at her. She was humiliated and embarrassed before them all and protested:

"It is not fitting that one such as I should be before all men's gaze. Say quickly what it is you wish of me."

"To race against the horses of the king," they all shouted; and there were cries of mockery and jeering.

She drew back. "But my time is near," she said. "I cannot do this."

"Very well," said the king. "Your husband dies." And he ordered his attendants to draw their swords.

THE HOUND OF CULANN

Anonymous, 12th century

Irish, translated by Joseph Campbell

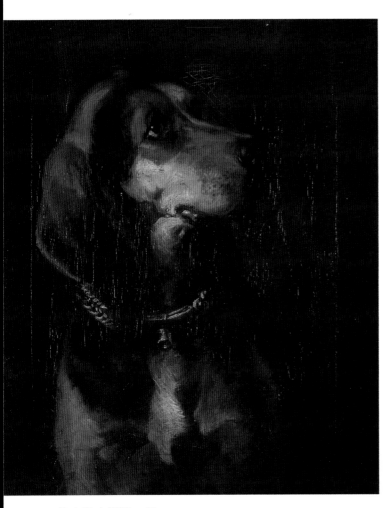

Dog's Head, William Simson
(1800–1847), Scottish.
Oil on canvas, 19th century.

The following year the smith Culann invited Conor to a banquet, and asked him to bring only a few of his companions, as he had neither the space nor the means for a grand entertainment. Conor accepted, and, before he set out, he went as was his custom to see and say farewell to the boys of the corps.

He watched them at four games. In the first, Setanta kept goal against all the three fifties, and they could not score; yet when they all kept goal together he scored against them as he wished. In the second, Setanta guarded the hole, and though each of the hundred and fifty balls came to the edge of the hole, not one did he let in; yet when they all guarded together he had no difficulty in getting the ball past them into the hole. The third game was the tearing-off of mantles: Setanta tore all the hundred and fifty mantles off in a trice; they could not as much as touch his brooch. In the fourth game they wrestled, and with all the corps against him Setanta stood firm on his feet, yet when he turned to the attack he left not one standing.

Conor said to Fergus, who stood with him:

"If that lad's deeds when he is full-grown are in keeping with his deeds today, we are a lucky land to have him."

"Is there any reason to believe," said Fergus, "that his prowess, alone of all, will not increase with the years?"

But Conor said: "Let him come with us to Culann's feast. He is worthy."

"I cannot go just yet," said Setanta.

The king was surprised that the boy did not at once leave everything for the opportunity of going to a banquet with the select royal party.

"Why so?" he asked.

"Because the boys are not finished playing," said Setanta,

"and I cannot leave until the games are finished."

"We cannot wait so long," said Conor.

"You need not wait. I shall follow you."

"You do not know the way."

"I shall follow the tracks of your chariots."

That was agreed. And Conor's party arrived at Culann's house, where they were welcomed to the feast which was ready laid for them. Culann said to Conor when the company were settling to the feast:

"Before we begin, tell me, is this all the company? There is none to follow?"

"None," said Conor: "all are here." He had already forgotten about Setanta.

"The reason I ask," said Culann, "is that I have a magnificent hound, which is my watchdog, and only myself can handle him or exact obedience from him; and none dare approach the neighbourhood when I loose him to guard the house. And I should like to loose him now before we begin."

"You may loose the hound," said Conor. The hound was loosed, and he made a circuit of the place and sat down with his head on his paws, a huge, fearsome guard.

Meanwhile the six-year-old boy had left his fellows of the boy-corps of Emain Macha, and was on his way to the house of Culann, the smith. He had no arms of defence, but passed the time of the journey with his hurling stick and ball. The hound bayed a fearsome challenge as he came to the house, but the boy continued his play until the hound sprang at him. Then he hurled the ball so that with terrific force it went right down the hound's throat, past the great open jaws and teeth, and as the hound reared back with the force of the blow and the pain, he grasped it by the hind legs and smashed its head to pulp on the stones of the yard.

At the sound of the hound's baying Conor had leaped to his feet remembering the boy. They all rushed out, certain Setanta was being torn by the hound, and were overjoyed to see him alive—all except Culann, who was filled with sorrow as he gazed on the hound.

"It was an unlucky day I made a banquet for Conor," he said. He turned to the boy. "You are welcome, boy, for your father's and mother's sake but not for your own. You have slain the only guard and protector of my house and my substance, of my flocks and my herds."

"Do not grieve," said the boy. "I shall see you are none the worse for what has happened."

"How can that be?" asked Culann, looking at the six-year-old boy.

"If there is a whelp of that dog's siring in all Ireland," said Setanta, "I shall rear and train it until it is able to guard and protect you as well as its sire; and until then I myself will guard your house and your property, even as your hound did."

"That is fair," said Conor.

"And you will be Cu Chulainn, the Hound of Culann, in the meantime," said Cathbhad the druid. "And that shall be your name, Cuchulainn."

"Indeed, I prefer my own name, Setanta, son of Sualtam," said the boy.

"But the name Cuchulainn will be on the lips of all the men of Ireland and the world, and their mouths will be full of its praise," said the druid.

"For that I would accept any name," said the boy; and from that time he was known as Cuchulainn.

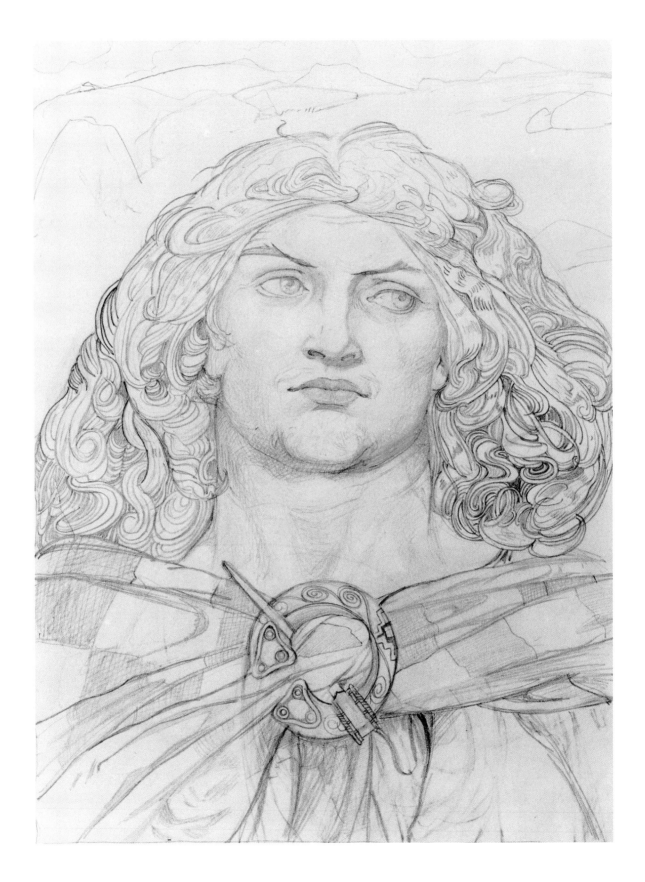

EXCERPT FROM *THE CATTLE RAID OF COOLEY*

THE COMBAT AT THE FORD

Anonymous, 12th century

Irish, translated by Joseph Dunn

"To what weapons shall we resort on this day, O Ferdiad?" asked Cu Chulainn.

"Thine is the choosing of weapons till night-time," Ferdiad made answer, "because it was I had my choice of weapons yesterday."

"Let us take, then," said Cu Chulainn, "to our great, well-tempered lances to-day, for we think that the thrusting will bring nearer the decisive battle to-day than did the casting of yesterday. Let our horses be brought to us and our chariots yoked, to the end that we engage in combat over our horses and chariots on this day."

"Good, let us do so," Ferdiad assented.

Thereupon they took full-firm broad-shields on them for that day. They took to their great, well-tempered lances on that day. Either of them began to pierce and to drive, to throw and to press down the other, from early morning's twilight till the hour of evening's close. And when the hour of evening's close was come, their horses were spent and the drivers were wearied, and they themselves, the hero warriors of valor, were exhausted.

"Let us give over now, O Ferdiad," said Cu Chulainn, "for our horses are spent and our drivers tired, and when they are exhausted, why should we too not be exhausted?" And in this manner he spoke, and uttered these words at that place:

> We need not our chariots break—
> This, a struggle fit for giants.
> Place the hobbles on the steeds,
> Now that the din of arms is over!

"Yea, we will cease, if the time has come," replied Ferdiad. They ceased then. They threw their arms away from them into the hands of their charioteers. Each of them came towards his fellow. Each laid his hand on the other's neck and gave him three kisses. Their horses were in one pen that night, and their charioteers at one fire.

They abode there that night. Early on the morrow they arose and repaired to the ford of combat. Cu Chulainn marked an evil mien and a dark mood that day beyond every other on Ferdiad.

"It is evil though appeareast to-day," said Cu Chulainn.

"How much soever thou findest fault with me to-day," said Ferdiad, "for my ill-boding mien and evil doing, it will be as as an offset to my prowess." And then he said, "To what weapons shall we resort to-day?"

"With thyself is the choice of weapons to-day until night-time come," replied Cu Chulainn, "for it was I that chose on the day gone by."

"Let us resort, then," said Ferdiad, "to our heavy, hard-smiting swords this day, for we trust that the smiting each other will bring us nearer to the decision of battle to-day than did our piercing each other yesterday."

Then they took two full-great long-shields upon them for that day. They turned to their heavy, hard-smiting swords. Each of them fell to strike and to hew, to lay low and cut down, to slay and undo his fellow, till as large as the head of a month-old child was each lump and each cut, each clutter and each clot of gore that each of them took from the shoulders and thighs and shoulderblades of the other.

Each of them was engaged in smiting the other in this way from the twilight of the early morning till the hour of evening's close. "Let us leave off from this now!" said Ferdiad.

Hammered-bronze disc,
Irish. 1st century.

"Aye, let us leave off if the hour is come," said Cu Chulainn.

They parted then, and threw their arms away from them into the hands of their charioteers. Though in comparison it had been the meeting of two happy, blithe, cheerful, joyful men, their parting that night was of two that were sad, sorrowful, and full of suffering. They parted without a kiss, a blessing, or any other sign of friendship, and their servants disarmed the steeds and the heroes; no healing nor curing herbs were sent from Cu Chulainn to Ferdiad that night, and no food nor drink was brought from Ferdiad to him. Their horses were not in the same paddock that night. Their charioteers were not at the same fire.

"What weapons shall we resort to to-day?" asked Cu Chulainn the next morning.

"With thee is the choice of weapons till night-time," Ferdiad responded.

"Let us go to the Feat of the Ford, then," said Cu Chulainn.

"Aye, let us do so," answered Ferdiad. Albeit Ferdiad spoke that, he deemed it the most grievous thing whereto he could go, for he knew that Cu Chulainn used to destroy every hero and every battle-soldier who fought with him in the Feat of the Ford.

Great indeed was the deed that was done on the ford that day. Each of them was busy hurling at the other in those deeds of arms from early morning's gloaming till the middle of noon. When mid-day came, the rage of the men became wild, and each drew nearer to the other.

Thereupon Cu Chulainn gave one spring from the bank of the ford till he stood upon the boss of Ferdiad's shield, seeking to reach his head and to strike it from above over the rim of the shield. Straightway Ferdiad gave the shield a blow with his left elbow, so that Cu Chulainn went from him like a bird onto the brink of the ford. He again sprang from the brink of the ford, so that he lighted upon the boss of Ferdiad's shield. Ferdiad gave the shield a thrust with his left knee, so that Cu Chulainn went from him like an infant onto the bank of the ford.

Thereat for the third time Cu Chulainn arose with the speed of the wind, and the swiftness of a swallow, and the dash of a dragon, and the strength of a lion into the clouds of the air, till he alighted on the boss of the shield of Ferdiad son of Daman, so as to reach his head that he might strike it from above over the rim of his shield. Then it was that the warrior gave the shield a violent powerful shake, so that Cu Chulainn flew from it into the middle of the ford, the same as if he had not sprung at all.

It was then the first distortion of Cu Chulainn took place, so that a swelling and inflation filled him like breath in a bladder, until he made a dreadful, many-colored, wonderful bow of himself, so that as big as a giant or a sea-man was the hugely-brave warrior towering directly over Ferdiad.

Such was the closeness of the combat they made, that their heads encountered above and their feet below and their hands in the middle over the rims and the bosses of their shields.

Such was the closeness of the combat they made, that their shields burst and split from their rims to their centers

Such was the closeness of the combat they made, that their spears bent and turned and shivered from their tips to their rivets.

Such was the closeness of the combat they made, that the puck-faced sprites and the white-faced sprites and the spirits of the glens and the uncanny beings of the air screamed from the rims of their shields and from the guards of their swords and from the tips of their spears.

Such was the closeness of the combat they made, that the steeds of the Gael broke loose affrighted and plunging with madness and fury, so that their chains and their shackles, their traces and their tethers snapped, and the women and children and the undersized, the weak and the madmen among the men of Erin broke out through the camp southwestward.

At that time they were at the edge-feat of the swords. It was then Ferdiad caught Cu Chulainn in an unguarded moment, and he gave him a thrust with his tuck-hilted blade, so that he buried it in his breast, and his blood fell into his belt, till the ford became crimsoned with the clotted blood from the battle-warrior's body. Cu Chulainn endured it not under Ferdiad's attack, with his death-bringing, heavy blows, and his long strokes and his mighty middle slashes at him.

Cu Chulainn gripped the short spear that was in his hand, cast it off the palm of his hand over the rim of the shield and over the edge of the corselet and hornskin, so that its farther half was visible after piercing Ferdiad's heart in his bosom. Ferdiad gave a thrust of his shield upwards to protect the upper part of his body, though it was help that came too late. Cu Chulainn threw a *gae bulga* as far as he could cast underneath at Ferdiad, so that it passed through the strong thick, iron apron of wrought iron, and brake in three parts the huge, goodly stone the size of a millstone, so that it cut its way through the body's protection into him, till every joint and every limb was filled with its barbs.

"Ah, that blow suffices," sighed Ferdiad. "I am fallen of that! But, yet one thing more: mightily didst thou drive with thy right *foot*. And it was not fair of thee for me not to fall by thy *hand*."

Thereupon Cu Chulainn hastened towards Ferdiad and clasped his two arms about him, and bore him with all his arms and his armor and his dress northwards over the ford, so that it would be with his face to the north of the ford, in Ulster, the triumph took place and not to the west of the ford with the men of Erin. Cu Chulainn laid Ferdiad there on the ground, and a cloud and a faint and a swoon came over Cu Chulainn there by the head of Ferdiad. "Ah, Ferdiad," said Cu Chulainn, "greatly have the men of Erin deceived and abandoned thee, to bring thee to contend and do battle with me. For no easy thing is to contend and do battle with me on the Cattle-Raid of Cooley!"

Enameled iron and bronze bolt from a chariot found at King's Langley, Hertfordshire, England. 6th–1st century B.C.E.

LOCHINVAR

SIR WALTER SCOTT

Scottish

The Meeting on the Turret Stairs,
Sir Frederick William Burton
(1816–1900), Irish.
Watercolor, 1864.

O young Lochinvar is come out of the west,
Through all the wide Border his steed was the best;
And save his good broadsword he weapons had none,
He rode all unarm'd, and he rode all alone.
So faithful in love, and so dauntless in war,
There never was knight like the young Lochinvar.

He staid not for brake, and he stopp'd not for stone,
He swam the Eske river where ford there was none;
But ere he alighted at Netherby gate,
The bride had consented, the gallant came late:
For a laggard in love, and a dastard in war,
Was to wed the fair Ellen of brave Lochinvar.

So boldly he enter'd the Netherby Hall,
Among bride's-men, and kinsmen, and brothers and all:
Then spoke the bride's father, his hand on his sword,
(For the poor craven bridegroom said never a word,)
'O come ye in peace here, or come ye in war,
Or to dance at our bridal, young Lord Lochinvar?'

'I long woo'd your daughter, my suit you denied;—
Love swells like the Solway, but ebbs like its tide—
And now I am come, with this lost love of mine,
To lead but one measure, drink one cup of wine.
There are maidens in Scotland more lovely by far,
That would gladly be bride to the young Lochinvar.'

The bride kiss'd the goblet: the knight took it up,
He quaff'd off the wine, and he threw down the cup.
She look'd down to blush, and she look'd up to sigh,
With a smile on her lips and a tear in her eye.
He took her soft hand, ere her mother could bar,—
'Now tread we a measure!' said young Lochinvar.

So stately his form, and so lovely her face,
That never a hall such a galliard did grace;
While her mother did fret, and her father did fume,
And the bridegroom stood dangling his bonnet and plume;
And the bride-maidens whisper'd, 't'were better by far
To have match'd our fair cousin with young Lochinvar.'

One touch to her hand, and one word in her ear,
When they reach'd the hall-door, and the charger stood near;
So light to the croupe the fair lady he swung,
So light to the saddle before her he sprung!
'She is won! we are gone, over bank, bush, and scaur;
They'll have fleet steeds that follow,' quoth young Lochinvar.

There was mounting 'mong Graemes of the Netherby clan;
Forsters, Fenwicks, and Musgraves, they rode and they ran:
There was racing and chasing on Cannobie Lee,
But the lost bride of Netherby ne'er did they see.
So daring in love, and so dauntless in war,
Have ye e'er heard of gallant like young Lochinvar?

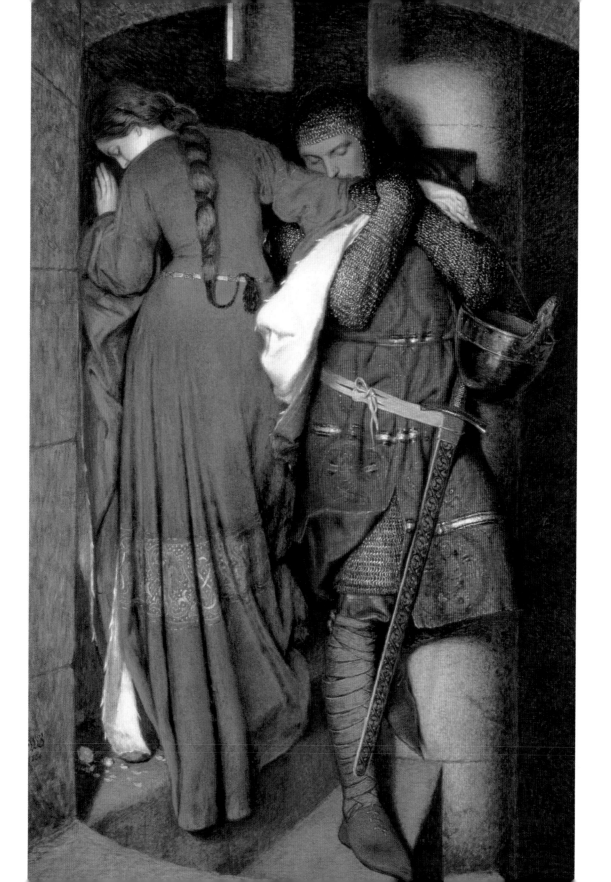

EXCERPT FROM

SIR GAWAIN AND THE GREEN KNIGHT

Anonymous, 14th century

English, translated by Theodore Howard Banks

This hero in green was habited gaily,
And likewise the hair on the head of his good horse;
Fair, flowing tresses enfolded his shoulders,
And big as a bush a beard hung on his breast.
This, and the hair from his head hanging splendid,
Was clipped off evenly over his elbows,
In cut like a king's hood, covering the neck,
So that half of his arms were held underneath it.
The mane of the mighty horse much this resembled,
Well curled and combed, and with many knots covered,
Braided with gold threads about the fair green,
Now a strand made of hair, now a second of gold.
The foreclock and tail were twined in this fashion,
And both of them bound with a band of bright green.
For the dock's length the tail was decked with stones dearly,
And then was tied with a thong in a tight knot,
Where many bright bells of burnished gold rang.
In the hall not one single man's seen before this
Such a horse here on earth. such a hero as on him
 Goes.
 That his look was lightning bright
 Right certain were all those
 Who saw. It seemed none might
 Endure beneath his blows.

Gawain from detail
of page from *Le Roman de
Lancelot du Lac*. Northern
France, 14th century.

Yet the hero carried not helmet nor hauberk,
But bare was of armor, breastplate or gorget,
Spear-shaft or shield, to thrust or to smite.
But in one hand he bore a bough of bright holly,
That grows most greenly when bare are the groves,
In the other an ax, gigantic, awful.
A terrible weapon, wondrous to tell of.
Large was the head, in length a whole ell-yard.
The blade of green steel and beaten gold both;
The bit had a broad edge, and brightly was burnished,
As suitably shaped as sharp razors for shearing.
This steel by its strong shaft the stern hero gripped:
With iron it was wound to the end of the wood,
And in work green and graceful was everywhere graven.
About it a fair thong was folded, made fast
At the head, and oft looped down the length of the handle.
To this were attached many splendid tassels,
On buttons of bright green richly embroidered.
Thus into the hall came the hero, and hastened
Direct to the dais, fearing no danger.
He gave no one greeting, but haughtily gazed.
And his first words were, "Where can I find him who governs
This goodly assemblage? for gladly that man
I would see and have speech with." So saying, from toe
 To crown
 On the knights his look he threw,
 And rolled it up and down:
 He stopped to take note who
 Had there the most renown.

There sat all the lords, looking long at the stranger,
Each man of them marveling what it might mean
For a horse and a hero to have such a hue.
It seemed to them green as the grown grass, or greener,
Gleaming more bright than on gold green enamel.
The nobles who stood there, astonished, drew nearer,
And deeply they wondered what deed he would do.
Since never a marvel they'd met with like this one,
The folk all felt it was magic or phantasy.
Many great lords then were loath to give answer,
And sat stone-still, at his speaking astounded,
In swooning silence that spread through the hall.
As their speech on a sudden was stilled, fast asleep
 They did seem.
 They felt not only fright
 But courtesy, I deem.
 Let him address the knight,
 Him whom they all esteem.

Sculpted stone pillar at
Sainte-Anne-en-Tregastel,
France. 4th century B.C.E.

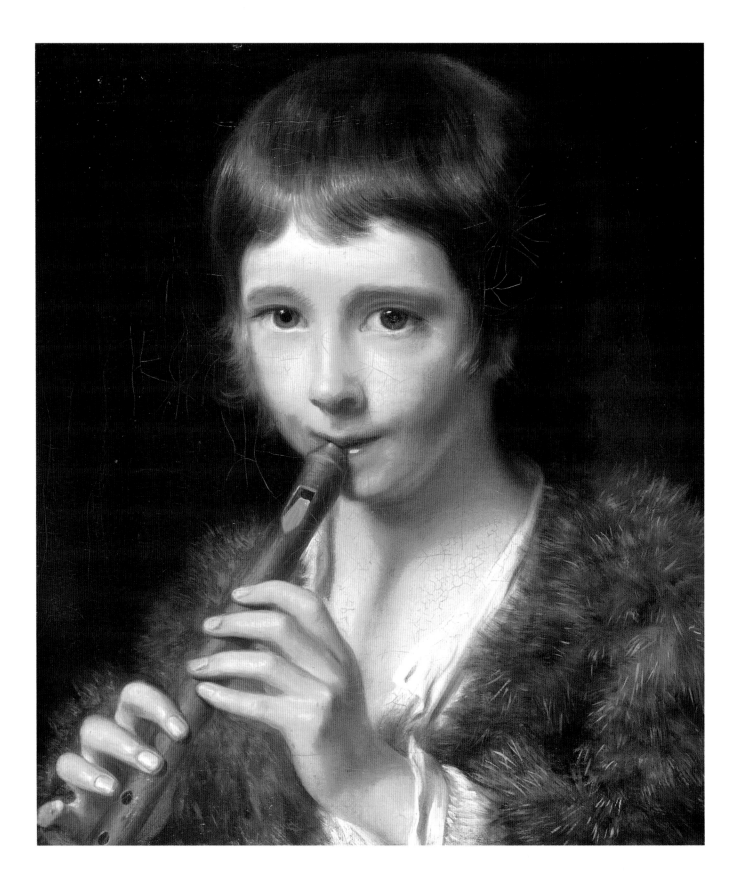

The Piping Boy (Camillus, Son of the Artist), Nathaniel Hone The Elder (1718–1784), Irish. Oil on canvas, 1769.

OISÍN'S MOTHER

James Stephens

Irish

CHAPTER I

Evening was drawing nigh, and the Fianna-Finn had decided to hunt no more that day. The hounds were whistled to heel, and a sober, homeward march began. For men will walk soberly in the evening, however they go in the day, and dogs will take the mood from their masters.

They were pacing so, through the golden-shafted, tender-coloured eve, when a fawn leaped suddenly from covert, and, with that leap, all quietness vanished: the men shouted, the dogs gave tongue, and a furious chase commenced.

Fionn loved a chase at any hour, and, with Bran and Sceólan, he outstripped the men and dogs of his troop, until nothing remained in the limpid world but Fionn, the two hounds, and the nimble, beautiful fawn. These, and the occasional boulders, round which they raced, or over which they scrambled; the solitary tree which dozed aloof and beautiful in the path, the occasional clump of trees that hived sweet shadow as a hive hoards honey, and the rustling grass that stretched to infinity, and that moved and crept and swung under the breeze in endless, rhythmic billowings.

In his wildest moment Fionn was thoughtful, and now, although running hard, he was thoughtful. There was no movement of his beloved hounds that he did not know; not a twitch or fling of the head, not a cock of the ears or tail that was not significant to him. But on this chase whatever signs the dogs gave were not understood by their master.

He had never seen them in such eager flight. They were almost utterly absorbed in it, but they did not whine with eagerness, nor did they cast any glance towards him for the encouraging word which he never failed to give when they sought it.

They did look at him, but it was a look which he could not comprehend. There was a question and a statement in those deep eyes, and he could not understand what that question might be, nor what it was they sought to convey. Now and again one of the dogs turned a head in full flight, and stared, not at Fionn, but distantly backwards, over the spreading and swelling plain where their companions of the hunt had disappeared.

"They are looking for the other hounds," said Fionn.

"And yet they do not give tongue! Tongue it, a Vran!" he shouted, "Bell it out, a Heólan!"

It was then they looked at him, the look which he could not understand and had never seen on a chase. They did not tongue it, nor bell it, but they added silence to silence and speed to speed, until the lean grey bodies were one pucker and lashing of movement.

Fionn marvelled.

"They do not want the other dogs to hear or to come on this chase," he murmured, and he wondered what might be passing within those slender heads.

"The fawn runs well," his thought continued. "What is it, a Vran, my heart? After her, a Heólan! Hist and away, my loves!"

"There is going and to spare in that beast yet," his mind went on. "She is not stretched to the full, nor half stretched. She may outrun even Bran," he thought ragingly.

They were racing through a smooth valley in a steady, beautiful, speedy flight when, suddenly, the fawn stopped and lay on the grass, and it lay with the calm of an animal that has no fear, and the leisure of one that is not pressed.

"Here is a change," said Fionn, staring in astonishment. "She is not winded," he said. "What is she lying down for?"

But Bran and Sceólan did not stop; they added another inch to their long-stretched easy bodies, and came up on the fawn.

"It is an easy kill," said Fionn regretfully. "They have her," he cried.

But he was again astonished, for the dogs did not kill. They leaped and played about the fawn, licking its face, and rubbing delighted noses against its neck.

Fionn came up then. His long spear was lowered in his fist at the thrust, and his sharp knife was in its sheath, but he did not use them, for the fawn and the two hounds began to play round him, and the fawn was as affectionate towards him as the hounds were; so that when a velvet nose was thrust in his palm, it was as often a fawn's muzzle as a hound's.

In that joyous company he came to wide Allen of Leinster, where the people were surprised to see the hounds and the fawn and the Chief and none other of the hunters that had set out with them.

When the others reached home, the Chief told of his chase, and it was agreed that such a fawn must not be killed, but that it should be kept and well treated, and that it should be the pet fawn of the Fianna. But some of those who remembered Bran's parentage thought that as Bran herself had come from the Shí so this fawn might have come out of the Shí also.

CHAPTER II

Late that night, when he was preparing for rest, the door of Fionn's chamber opened gently and a young woman came into the room. The captain stared at her, as he well might, for he had never seen or imagined to see a woman so beautiful as this was. Indeed, she was not a woman, but a young girl, and her bearing was so gently noble, her look so modestly high, that the champion dared scarcely look at her, although he could not by any means have looked away.

As she stood within the doorway, smiling, and shy as a flower, beautifully timid as a fawn, the Chief communed with his heart.

"She is the Sky-woman of the Dawn," he said. "She is the light on the foam. She is white and odorous as an apple-blossom. She smells of spice and honey. She is my beloved beyond the women of the world. She shall never be taken from me."

And that thought was delight and anguish to him: delight because of such sweet prospect, anguish because it was not yet realised, and might not be.

As the dogs had looked at him on the chase with a look that he did not understand, so she looked at him, and in her regard there was a question that baffled him and a statement which he could not follow.

He spoke to her then, mastering his heart to do it.

"I do not seem to know you," he said.

"You do not know me indeed," she replied.

"It is the more wonderful," he continued gently, "for I should know every person that is here. What do you require from me?"

"I beg your protection, royal captain."

"I give that to all," he answered. "Against whom do you desire protection?"

"I am in terror of the Fear Doirche."

"The Dark Man of the Shí?"

"He is my enemy," she said.

"He is mine now," said Fionn. "Tell me your story."

"My name is Saeve, and I am a woman of Faery," she commenced. "In the Shí many men gave me their love, but I gave my love to no man of my country."

"That was not reasonable," the other chided with a blithe heart.

"I was contented," she replied, "and what we do not want we do not lack. But if my love went anywhere it went to a mortal, a man of the men of Ireland."

"By my hand," said Fionn in mortal distress, "I marvel who that man can be!"

"He is known to you," she murmured. "I lived thus in the peace of Faery, hearing often of my mortal champion, for the rumour of his great deeds had gone through the Shí, until a day came when the Black Magician of the Men of God put his eye on me, and, after that day, in whatever direction I looked I saw his eye."

She stopped at that, and the terror that was in her heart was on her face.

"He is everywhere," she whispered. "He is in the bushes, and on the hill. He looked up at me from the water, and he stared down on me from the sky. His voice commands out of the spaces, and it demands secretly in the heart. He is not here or there, he is in all places at all times. I cannot escape from him," she said, "and I am afraid," and at that she wept noise-lessly and stared at Fionn.

"He is my enemy," Fionn growled. "I name him as my enemy."

"You will protect me," she implored.

"Where I am let him not come," said Fionn. "I also have knowledge. I am Fionn, the son of Uail, the son of Baiscne, a man among men and a god where the gods are."

"He asked me in marriage," she continued, "but my mind was full of my own dear hero, and I refused the Dark Man."

"That was your right, and I swear by my hand that if the man you desire is alive and unmarried he shall marry you or he will answer to me for the refusal."

"He is not married," said Saeve, "and you have small control over him."

The Chief frowned thoughtfully.

"Except the High King and the kings I have authority in this land."

"What man has authority over himself?" said Saeve.

"Do you mean that I am the man you seek?" said Fionn.

"It is to yourself I gave my love," she replied.

"This is good news," Fionn cried joyfully, "for the moment you came through the door I loved and desired you, and the thought that you wished for another man went into my heart like a sword."

Indeed, Fionn loved Saeve as he had not loved a woman before and would never love one again. He loved her as he had never loved anything before. He could not bear to be away from her. When he saw her he did not see the world, and when he saw the world without her it was as though he saw nothing, or as if he looked on a prospect that was bleak and depressing. The belling of a stag had been music to Fionn, but when Saeve spoke that was sound enough for him. He had loved to hear the cuckoo calling in the spring from the tree that is highest in the hedge, or the blackbird's jolly whistle in an autumn bush, or the thin, sweet enchantment that comes to the mind when a lark thrills out of sight in the air and the hushed fields listen to the song. But his wife's voice was sweeter to Fionn than the singing of a lark. She filled him with wonder and surmise. There was magic in the tips of her fingers. Her thin palm ravished him. Her slender foot set his heart beating; and whatever way her head moved there came a new shape of beauty to her face.

"She is always new," said Fionn. "She is always better than any other woman; she is always better than herself."

He attended no more to the Fianna. He ceased to hunt. He did not listen to the songs of poets or the curious sayings of magicians, for all these were in his wife, and something that was beyond these was in her also.

"She is this world and the next one; she is completion," said Fionn.

CHAPTER III

It happened that the men of Lochlann came on an expedition against Ireland. A monstrous fleet rounded the bluffs of Ben Edair, and the Danes landed there, to prepare an attack which would render them masters of the country. Fionn and the Fianna-Finn marched against them. He did not like the men of Lochlann at any time, but this time he moved against them in wrath, for not only were they attacking Ireland, but they had come between him and the deepest joy his life had known.

It was a hard fight, but a short one. The Lochlannachs were driven back to their ships, and within a week the only Danes remaining in Ireland were those that had been buried there.

That finished, he left the victorious Fianna and returned swiftly to the plain of Allen, for he could not bear to be one unnecessary day parted from Saeve.

"You are not leaving us!" exclaimed Goll mac Morna.

"I must go," Fionn replied.

"You will not desert the victory feast," Conán reproached him.

"Stay with us, Chief," Caelte begged.

"What is a feast without Fionn?" they complained.

But he would not stay.

"By my hand," he cried, "I must go. She will be looking for me from the window."

"That will happen indeed," Goll admitted.

"That will happen," cried Fionn. "And when she sees me far out on the plain, she will run through the great gate to meet me."

"It would be the queer wife would neglect that run," Conán growled.

"I shall hold her hand again," Fionn entrusted to Caelte's ear.

Highland Felicity, Ben Lebrig in the Background,
James William Giles (1801–1870), Scottish.

"You will do that, surely."

"I shall look into her face," his lord insisted.

But he saw that not even beloved Caelte understood the meaning of that, and he knew sadly and yet proudly that what he meant could not be explained by any one and could not be comprehended by any one.

"You are in love, dear heart," said Caelte.

"In love he is," Conán grumbled. "A cordial for women, a disease for men, a state of wretchedness."

"Wretched in truth," the Chief murmured. "Love makes us poor. We have not eyes enough to see all that is to be seen, nor hands enough to seize the tenth of all we want. When I look in her eyes I am tormented because I am not looking at her lips, and when I see her lips my soul cries out, 'Look at her eyes, look at her eyes.'"

"That is how it happens," said Goll rememberingly.

"That way and no other," Caelte agreed.

And the champions looked backwards in time on these lips and those, and knew their Chief would go.

When Fionn came in sight of the great keep his blood and his feet quickened, and now and again he waved a spear in the air.

"She does not see me yet," he thought mournfully.

"She cannot see me yet," he amended, reproaching himself.

But his mind was troubled, for he thought also, or he felt without thinking, that had the positions been changed he would have seen her at twice the distance.

"She thinks I have been unable to get away from the battle, or that I was forced to remain for the feast."

And, without thinking it, he thought that had the positions been changed he would have known that nothing could retain the one that was absent.

"Women," he said, "are shamefaced, they do not like to appear eager when others are observing them."

But he knew that he would not have known if others were observing him, and that he would not have cared about it if he had known. And he knew that his Saeve would not have seen, and would not have cared for any eyes than his.

He gripped his spear on that reflection, and ran as he had not run in his life, so that it was a panting, dishevelled man that raced heavily through the gates of the great Dun.

Within the Dun there was disorder. Servants were shouting to one another, and women were running to and fro aimlessly, wringing their hands and screaming; and, when they saw the Champion, those nearest to him ran away, and there was a general effort on the part of every person to get behind every other person. But Fionn caught the eye of his butler, Gariv Cronán, the Rough Buzzer, and held it.

"Come you here," he said.

And the Rough Buzzer came to him without a single buzz in his body.

"Where is the Flower of Allen?" his master demanded.

"I do not know, master," the terrified servant replied.

"You do not know!" said Fionn. "Tell what you do know."

And the man told him this story.

CHAPTER IV

"When you had been away for a day the guards were surprised. They were looking from the heights of the Dun, and the Flower of Allen was with them. She, for she had a quest's eye, called out that the master of the Fianna was coming over the ridges to the Dun, and she ran from the keep to meet you."

"It was not I," said Fionn.

"It bore your shape," replied Gariv Cronán. "It had your armour and your face, and the dogs, Bran and Sceólan, were with it."

"They were with me," said Fionn.

"They seemed to be with it," said the servant humbly.

"Tell us this tale," cried Fionn.

"We were distrustful," the servant continued. "We had never known Fionn to return from a combat before it had been fought, and we knew you could not have reached Ben Edar or encountered the Lochlannachs. So we urged our lady to let us go out to meet you, but to remain herself in the Dun."

"It was good urging," Fionn assented.

"She would not be advised," the servant wailed. "She cried to us, 'Let me go to meet my love'."

"Alas!" said Fionn.

"She cried on us, 'Let me go to meet my husband, the father of the child that is not born.'"

"Alas!" groaned deep-wounded Fionn.

"She ran towards your appearance that had your arms stretched out to her."

At that wise Fionn put his hand before his eyes, seeing all that happened.

"Tell on your tale," said he.

"She ran to those arms, and when she reached them the figure lifted its hand. It touched her with a hazel rod, and, while we looked, she disappeared, and where she had been there was a fawn standing and shivering. The fawn turned and bounded towards the gate of the Dun, but the hounds that were by flew after her."

Fionn stared on him like a lost man.

"They took her by the throat—" the shivering servant whispered.

"Ah!" cried Fionn in a terrible voice.

"And they dragged her back to the figure that seemed to be Fionn. Three times she broke away and came bounding to us, and three times the dogs took her by the throat and dragged her back."

"You stood to look!" the Chief snarled.

"No, master, we ran, but she vanished as we got to her; the great hounds vanished away, and that being that seemed to be Fionn disappeared with them. We were left in the rough grass, staring about us and at each other, and listening to the moan of the wind and the terror of our hearts."

"Forgive us, dear master," the servant cried.

But the great captain made him no answer. He stood as though he were dumb and blind, and now and again he beat terribly on his breast with his closed fist, as though he would kill that within him which should be dead and could not die. He went so, beating on his breast, to his inner room in the Dun, and he was not seen again for the rest of that day, nor until the sun rose over Moy Lífe in the morning.

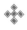

CHAPTER V

For many years after that time, when he was not fighting against the enemies of Ireland, Fionn was searching and hunting through the length and breadth of the country in the hope that he might again chance on his lovely lady from the Shí. Through all that time he slept in misery each night and he rose each day to grief. Whenever he hunted he brought only the hounds that he trusted, Bran and Sceólan, Lomaire, Brod, and Lomlu; for if a fawn was chased each of these five great dogs would know if that was a fawn to be killed or one to be protected, and so there was small danger to Saeve and a small hope of finding her.

Once, when seven years had passed in fruitless search, Fionn and the chief nobles of the Fianna were hunting Ben Gulbain. All the hounds of the Fianna were out, for Fionn had now given up hope of encountering the Flower of Allen. As the hunt swept along the sides of the hill there arose a great outcry of hounds from a narrow place high on the slope and, over all that uproar there came the savage baying of Fionn's own dogs.

"What is this for?" said Fionn, and with his companions he pressed to the spot whence the noise came.

"They are fighting all the hounds of the Fianna," cried a champion.

And they were. The five wise hounds were in a circle and were giving battle to an hundred dogs at once. They were bristling and terrible, and each bite from those great, keen jaws was woe to the beast that received it. Nor did they fight in silence as was their custom and training, but between each onslaught the great heads were uplifted, and they pealed loudly, mournfully, urgently, for their master.

"They are calling on me," he roared.

And with that he ran, as he had only once before run, and the men who were nigh to him went racing as they would not have run for their lives.

They came to the narrow place on the slope of the mountain, and they saw the five great hounds in a circle keeping off the other dogs, and in the middle of the ring a little boy was standing. He had long, beautiful hair, and he was naked. He was not daunted by the terrible combat and clamour of the hounds. He

did not look at the hounds, but he stared like a young prince at Fionn and the champions as they rushed towards him scattering the pack with the butts of their spears. When the fight was over, Bran and Sceólan ran whining to the little boy and licked his hands.

"They do that to no one," said a bystander. "What new master is this they have found?"

Fionn bent to the boy.

"Tell me, my little prince and pulse, what your name is, and how you have come into the middle of a hunting-pack, and why you are naked?"

But the boy did not understand the language of the men of Ireland. He put his hand into Fionn's, and the Chief felt as if that little hand had been put into his heart. He lifted the lad to his great shoulder.

"We have caught something on this hunt," said he to Caelte mac Ronán. "We must bring this treasure home. You shall be one of the Fianna-Finn, my darling," he called upwards.

The boy looked down on him, and in the noble trust and fearlessness of that regard Fionn's heart melted away.

"My little fawn!" he said.

And he remembered that other fawn. He set the boy between his knees and stared at him earnestly and long.

"There is surely the same look," he said to his wakening heart; "that is the very eye of Saeve."

The grief flooded out of his heart as at a stroke, and joy foamed into it in one great tide. He marched back singing to the encampment, and men saw once more the merry Chief they had almost forgotten.

CHAPTER VI

Just as at one time he could not be parted from Saeve, so now he could not be separated from this boy. He had a thousand names for him, each one more tender than the last: "My Fawn, My Pulse, My Secret Little Treasure," or he would call him "My Music, My Blossoming Branch, My Store in the Heart, My Soul." And the dogs were as wild for the boy as Fionn was. He could sit in safety among a pack that would have torn any

man to pieces, and the reason was that Bran and Sceólan, with their three whelps, followed him about like shadows. When he was with the pack these five were with him, and woeful indeed was the eye they turned on their comrades when these pushed too closely or were not properly humble. They thrashed the pack severally and collectively until every hound in Fionn's kennels knew that the little lad was their master, and that there was nothing in the world so sacred as he was.

In no long time the five wise hounds could have given over their guardianship, so complete was the recognition of their young lord. But they did not so give over, for it was not love they gave the lad but adoration.

Fionn even may have been embarrassed by their too close attendance. If he had been able to do so he might have spoken harshly to his dogs, but he could not; it was unthinkable that he should; and the boy might have spoken harshly to him if he had dared to do it. For this was the order of Fionn's affection: first there was the boy; next, Bran and Sceólan with their three whelps; then Caelte mac Ronán, and from him down through the champions. He loved them all, but it was along that precedence his affections ran. The thorn that went into Bran's foot ran into Fionn's also. The world knew it, and there was not a champion but admitted sorrowfully that there was reason for his love.

Little by little the boy came to understand their speech and to speak it himself, and at last he was able to tell his story to Fionn.

There were many blanks in the tale, for a young child does not remember very well. Deeds grow old in a day and are buried in a night. New memories come crowding on old ones, and one must learn to forget as well as to remember. A whole new life had come on this boy, a life that was instant and memorable, so that his present memories blended into and obscured the past, and he could not be quite sure if that which he told of had happened in this world or in the world he had left.

CHAPTER VII

"I used to live," he said, "in a wide, beautiful place. There were hills and valleys there, and woods and streams, but in whatever direction I went I came always to a cliff, so tall it seemed to lean against the sky, and so straight that even a goat would not have imagined to climb it."

"I do not know of any such place," Fionn mused.

"There is no such place in Ireland," said Caelte, "but in the Shí there is such a place."

"There is in truth," said Fionn.

"I used to eat fruits and roots in the summer," the boy continued, "but in the winter food was left for me in a cave."

"Was there no one with you?" Fionn asked.

"No one but a deer that loved me, and that I loved."

"Ah me!" cried Fionn in anguish, "tell me your tale, my son."

"A dark stern man came often after us, and he used to speak with the deer. Sometimes he talked gently and softly and coaxingly, but at times again he would shout loudly and in a harsh, angry voice. But whatever way he talked the deer would draw away from him in dread, and he always left her at last furiously."

"It is the Dark Magician of the Men of God," cried Fionn despairingly.

"It is indeed, my soul," said Caelte.

"The last time I saw the deer," the child continued, "the dark man was speaking to her. He spoke for a long time. He spoke gently and angrily, and gently and angrily, so that I thought he would never stop talking, but in the end he struck her with a hazel rod, so that she was forced to follow him when he went away. She was looking back at me all the time and she was crying so bitterly that any one would pity her. I tried to follow her also, but I could not move, and I cried after her too, with rage and grief, until I could see her no more and hear her no more. Then I fell on the grass, my senses went away from me, and when I awoke I was on the hill in the middle of the hounds where you found me."

That was the boy whom the Fianna called Oisín, or the Little Fawn. He grew to be a great fighter afterwards, and he was the chief maker of poems in the world. But he was not yet finished with the Shí. He was to go back into Faery when the time came, and to come thence again to tell these tales, for it was by him these tales were told.

DEIRDRE'S LAMENT FOR NAOISE

Anonymous, 12th century

Irish, translated by Lady Gregory

"My sight is gone from me with looking at the grave of Naoise; it is short till my life will leave me, and those who would have keened me do not live.

"I am Deirdre without gladness, and I at the end of my life; since it is grief to be without them, I myself will not be long after them."

After that complaint Deirdre loosed out her hair, and threw herself on the body of Naoise before it was put in the grave and gave three kisses to him, and when her mouth touched his blood, the colour of burning sods came into her cheeks, and she rose up like one that had lost her wits, and she went on through the night till she came where the waves were breaking on the strand.

"Naoise, my gentle, well-learned comrade, make no delay in crying him with me; cry for Ardan that killed the wild boars, cry for Ainnle whose strength was great.

"It was Naoise that would kiss my lips, my first man and my first sweetheart; it was Ainnle would pour out my drink, and it was Ardan would lay my pillow.

"It was Naoise had the deep sound of the waves in his voice; it was the song of Ardan that was good, and the voice of Ainnle towards their green dwelling-place.

"I do not sleep at any time, and the colour is gone from my face; there is no sound can give me delight since the sons of Usnach do not come.

"I do not sleep through the night; my senses are scattered away from me, I do not care for food or drink. I have no welcome to-day for the pleasant drink of nobles, or ease, or comfort, or delight, or a great house, or the palace of a king.

"What is country to me, or land, or lordship? What are swift horses? What are jewels and gold? Och! it is I will be lying to-night on the strand like the beautiful sons of Usnach."

Then Deirdre went close to the waves, and she said: "Since the other is not with me now, I will spend no more of my lifetime without him."

And with that she drove the black knife into her side, but she drew it out again and threw it in the sea to her right hand, the way no one would be blamed for her death.

Deirdre of the Sorrows,
John McKirdy Duncan
(1866–1945), Irish.
Black chalk on paper.

THE WHITE STALLION

PETE MORGAN

Scottish

There was that horse
 that I found then
 my white one
big tall and lean as
 and mean as hell.

And people who saw me
 would stare as I passed them
 and say
 'Look at him . . .
 how he rides his cock-horse.'

But my steed
 the white stallion
stormed into the moonlight
 and on it was me.

There were those girls
 that I found then
 my loved ones
small fat and lean ones
 and virgins as well.

And those girls who saw me
 would weep as I passed them
 and cry
 'Look at him . . .
 how he rides his cock-horse.'

But my steed
 the white stallion
went proud in the still night
 and on it was me.

There was one girl
 that I loved then—
 a woman—
as tall and as lithe as
 a woman should be.

And soon as I saw her
 I dismounted my stallion
 to stay
 by the woman
 whose love I required.

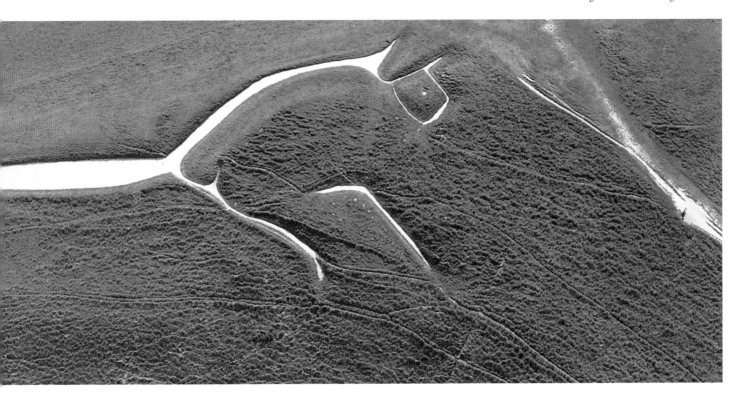

But my steed
 the white stallion
rode off in the moonlight
 and on it was she.

Goodbye to the horse
 to the woman
 and stallion.
Farewell to my cock-horse
 and loving as well.

To people who see me
 and stare as I pass them
 I wail
 'Look at me . . .
 I once rode a cock-horse.'

But my steed
 the white stallion
is lost in the moonlight
 and on it rides she.

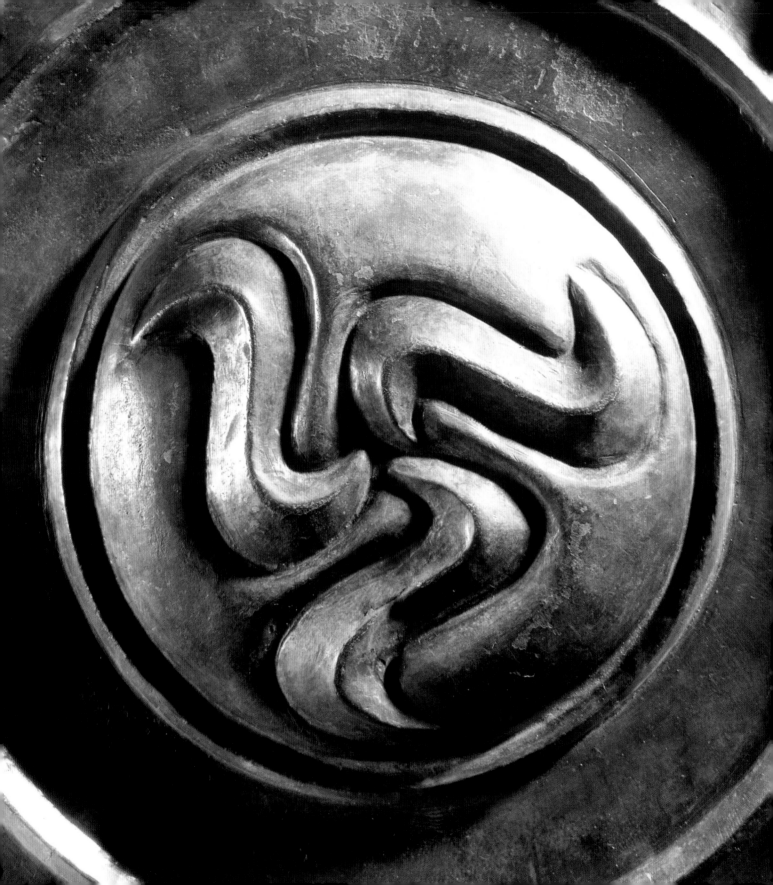

THE REIGN
OF CONAIRE

Anonymous, 8th century

Irish, edited by Tom Peete Cross & Clark Harris Slover

Good his reign. Since he assumed the kingship, no cloud has veiled the sun for the space of a day from the middle of spring to the middle of autumn. And not a dewdrop has fallen from grass till midday, and wind would not touch a cow's tail until noon . . . No wolf has attacked anything save one bullcalf of each byre. In Conaire's reign are the three crowns on Erin, namely, a crown of corn ears, and a crown of flowers and a crown of oak mast. In his reign, each man deems the other's voice as melodious as the strings of harps, because of the excellence of the law and the peace and the good-will prevailing throughout Erin.

LAMENT FOR CORC AND NIALL OF THE NINE HOSTAGES

Torna, The last great bard of Pagan Ireland

Irish

My foster-children were not slack;
Corc or Niall ne'er turned his back:
Niall, of Tara's palace hoar,
Worthy seed of Owen More;
Corc, of Cashel's pleasant rock,
Con-cead-caha's honored stock.
Joint exploits made Erin theirs—
Joint exploits of high compeers;
Fierce they were, and stormy strong;
Niall, amid the reeling throng,
Stood terrific; nor was Corc
Hindmost in the heavy work.
Niall Mac Eochy Vivahain
Ravaged Albin, hill and plain;
While he fought from Tara far,
Corc disdained unequal war.
Never saw I man like Niall,
Making foreign foemen reel;
Never saw I man like Corc,
Swinging at the savage work;
Never saw I better twain,
Search all Erin round again—
Twain so stout in warlike deeds—
Twain so mild in peaceful weeds.

These the foster-children twain
Of Torna, I who sing the strain;
These they are, the pious ones,
My sons, my darling foster-sons!
Who duly every day would come

To glad the old man's lonely home.
Ah, happy days I've spent between
Old Tara's hall and Cashel-green!
From Tara down to Cashel ford,
From Cashel back to Tara's lord.
When with Niall, his regent, I
Dealt with princes royally.
If with Corc perchance I were,
I was his prime counsellor.

Therefore Niall I ever set
On my right hand—thus to get
Judgements grave, and weighty words,
For the right hand loyal lords;
But, ever on my left-hand side,
Gentle Corc, who knew not pride,
That none other so might part
His dear body from my heart.
Gone is generous Corc O'Yeon—woe is me!
Gone is valiant Niall O'Con—woe is me!
Gone the root of Tara's stock—woe is me!
Gone the head of Cashel rock—woe is me!
Broken is my witless brain—
Niall, the mighty king, is slain!
Broken is my bruised heart's core—
Corc, the Righ-More, is no more!
Mourns Lea Con, in tribute's chain,
Lost Mac Eochy Vivahain,
And her lost Mac Lewy true—
Mourns Lea Mogha, ruined too!

Warrior, with hat.
Stone figure from
Hirschlanden,
6th century B.C.E.

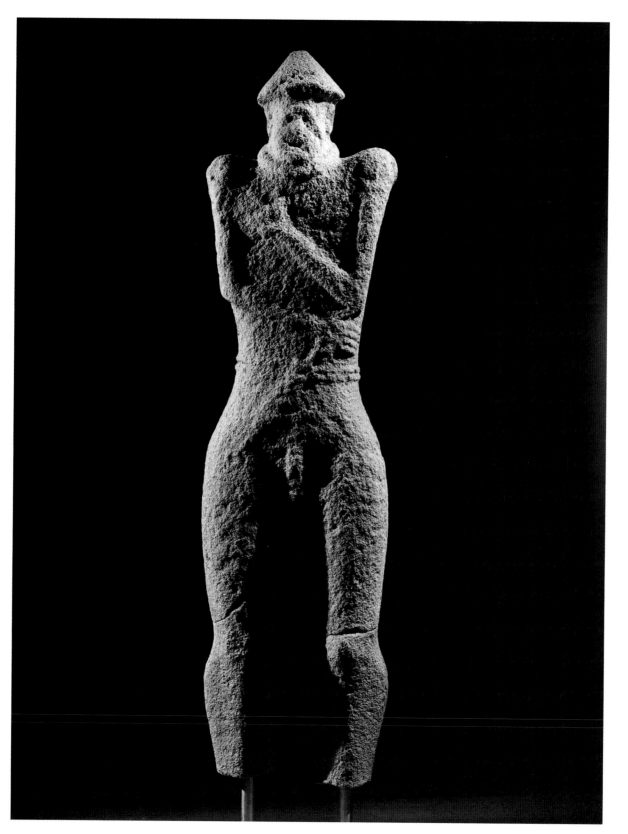

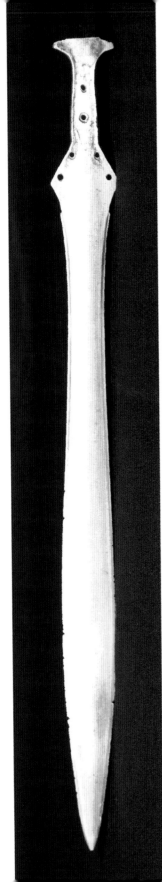

Late Bronze Age sword
from Ewart Park,
Northumberland.

THE SONG OF CARROLL'S SWORD

Dallan MacMore

Irish

Hail, sword of Carroll! Oft hast thou been in the great woof of war,
Oft giving battle, beheading high princes.

Oft has thou gone a-raiding in the hands of kings of great judgments
Oft has thou divided the spoil with a good king worthy of thee.

Oft where men of Leinster were hast thou been in a white hand,
Oft hast thou been among kings, oft among great bands.

Many were the kings that wielded thee in fight,
Many a shield hast thou cleft in battle, many a head and chest, many a fair skin.

Forty years without sorrow Enna of the noble hosts had thee,
Never wast thou in a strait, but in the hands of a very fierce king.

Enna gave thee—'twas no niggardly gift—to his own son, to Dunling,
For thirty years in his possession, at last thou broughtest ruin on him.

Many a king upon a noble steed possessed thee unto Dermot the kingly, the fierce:
Sixteen years was the time Dermot had thee.

At the feast of Alenn, Dermot the hardy-born bestowed thee, Dermot, the noble king,
gave thee to the man of Mairg, to Murigan.

Forty years stoutly thou wast in the hand of Alenn's high-king,
With Murigan of mighty deeds thou never wast a year without battle.

In Wexford Murigan, the King of Vikings, gave thee to Carroll:
While he was upon the yellow earth Carroll gave thee to none.

Thy bright point was a crimson point in the battle of Odva of the foreigners.
When thou leftest Aed Finnliath on his back in the battle of Odva of the noble routs.

Crimson was thy edge, it was seen; at Belach Moon thou wast proved,
In the valorous battle of Alvy's Plain throughout which the fighting raged.

Before thee the goodly host broke on a Thursday at Doon Och-tair,
When Aed the fierce and brilliant fell upon the hillside above Leafin.

Before thee the host broke on the day when Cealleadh was slain,
Flannagan's son, with numbers of troops, in high lofty great Tara.

Before thee they ebbed southwards in the battle of the Boyne of the rough feats,
When Cnogva fell, the lance of valour, at seeing thee, for dread of thee.

Thou wast furious, thou wast not weak, heroic was thy swift force,
When Ailill Frosach of Fál fell in the front of the onset.

Thou never hadst a day of defeat with Carroll of the beautiful garths,
He swore no lying oath, he went not against his word.

Thou never hadst a day for sorrow, many a night thou hadst abroad;
Thou hadst awaiting thee many a king with many a battle.

O sword of the kings of mighty fires, do not fear to be astray!
Thou shalt find thy man of craft, a lord worthy of thee.

Who shall henceforth possess thee, or to whom wilt thou deal ruin?
From the day that Carroll departed, with whom wilt thou be bedded?

Thou shalt not be neglected until thou come to the house of glorious Naas:
Where Finn of the feasts is, they will hail thee with 'welcome.'

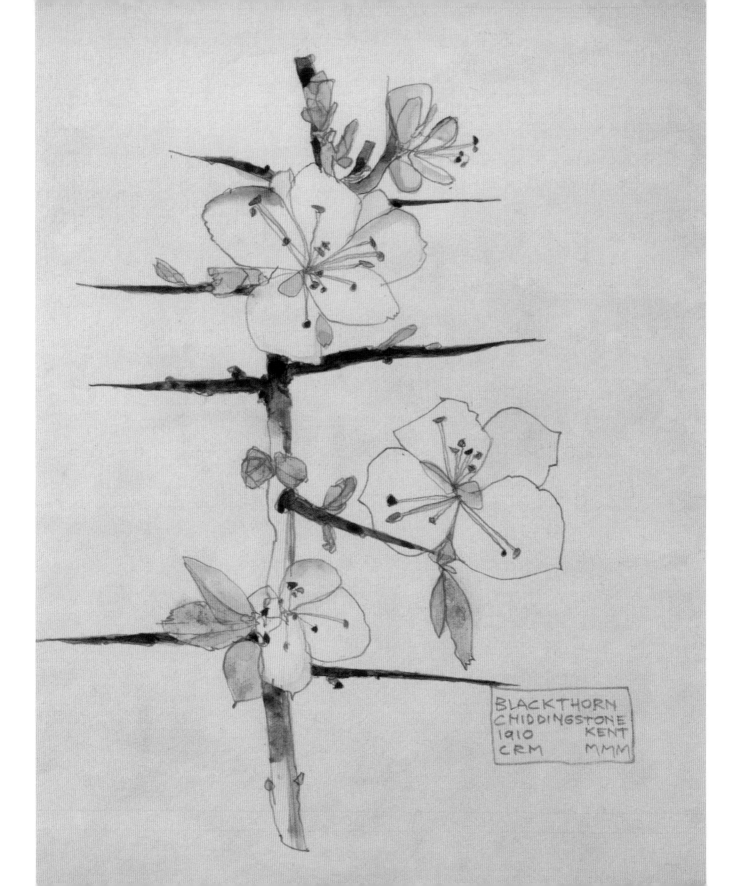

BLACKTHORN
CHIDDINGSTONE
1910 KENT
CRM MMM

Blackthorn, Chiddingstone, Kent,
Charles Rennie Mackintosh
(1868–1928), Scottish.
Pencil and watercolor on
paper, 1910.

FROM *THE MABINOGION*

THE WINNING OF OLWEN

Anonymous, c. 12th century

Welsh

There was once a king and queen who had a little boy, and they called his name Kilwch. The queen, his mother, fell ill soon after his birth, and as she could not take care of him herself she sent him to a woman she knew up in the mountains, so that he might learn to go out in all weathers, and bear heat and cold, and grow tall and strong. Kilwch was quite happy with his nurse, and ran races and climbed hills with the children who were his playfellows, and in the winter, when the snow lay on the ground, sometimes a man with a harp would stop and beg for shelter, and in return would sing them songs of strange things that had happened in the years gone by.

But long before this changes had taken place in the court of Kilwch's father. Soon after she had sent her baby away the queen became much worse, and at length, seeing that she was going to die, she called her husband to her and said:

'Never again shall I rise from this bed, and by and bye thou wilt take another wife. But lest she should make thee forget thy son, I charge thee that thou take not a wife until thou see a briar with two blossoms upon my grave.' And this he promised her. Then she further bade him to see to her grave that nothing might grow thereon. This likewise he promised her, and soon she died, and for seven years the king sent a man every morning to see that nothing was growing on the queen's grave, but at the end of seven years he forgot.

One day when the king was out hunting he rode past the place where the queen lay buried, and there he saw a briar growing with two blossoms on it.

'It is time that I took a wife,' said he, and after long looking he found one. But he did not tell her about his son; indeed he hardly remembered that he had one till she heard it at last from an old woman whom she had gone to visit. And the new queen was very pleased, and sent messengers to fetch the boy, and in his father's court he stayed, while the years went by till one day the queen told him that a prophecy had foretold that he was to win for his wife Olwen the daughter of Yspaddaden Penkawr.

When he heard this Kilwch felt proud and happy. Surely he must be a man now, he thought, or there would be no talk of a wife for him, and his mind dwelt all day upon his promised bride, and what she would be like when he beheld her.

'What aileth thee, my son?' asked his father at last, when Kilwch had forgotten something he had been bidden to do, and Kilwch blushed red as he answered:

'My stepmother says that none but Olwen, the daughter of Yspaddaden Penkawr, shall be my wife.'

'That will be easily fulfilled,' replied his father. 'Arthur the king is thy cousin. Go therefore unto him and beg him to cut thy hair, and to grant thee this boon.'

Then the youth pricked forth upon a dapple grey horse of four years old, with a bridle of linked gold, and gold upon his saddle. In his hand he bore two spears of silver with heads of steel; a war-horn of ivory was slung round his shoulder, and by his side hung a golden sword. Before him were two brindled white-breasted greyhounds with collars of rubies round their necks, and the one that was on the left side bounded across to the right side, and the one on the right to the left, and like two sea-swallows sported round him. And his horse cast up four sods with his four hoofs, like four swallows in the air about his head, now above, now below. About him was a robe of purple, and an apple of gold was at each corner, and every one of the apples was of the value of a hundred cows. And the blades of grass bent not beneath him, so light were his horse's feet as he journeyed toward the gate of Arthur's palace.

'Is there a porter?' cried Kilwch, looking round for someone to open the gate.

'There is; and I am Arthur's porter every first day of January,' answered a man coming out to him. 'The rest of the year there are other porters, and among them Pennpingyon, who goes upon his head to save his feet.'

'Well, open the portal, I say.'

'No, that I may not do, for none can enter save the son of a king or a pedlar who has goods to sell. But elsewhere there will be food for thy dogs and hay for thy horse, and for thee collops cooked and peppered, and sweet wine shall be served in the guest chamber.'

'That will do not for me,' answered Kilwch. 'If thou wilt not open the gate I will send up three shouts that shall be heard from Cornwall unto the north, and yet again to Ireland.'

'Whatsoever clamour thou mayest make,' spake Glewlwyd the porter, 'thou shalt not enter until I first go and speak with Arthur.'

Then Glewlwyd went into the hall, and Arthur said to him:

'Hast thou news from the gate?' and the porter answered:

'Far have I travelled, both in this island and elsewhere, and many kingly men have I seen; but never yet have I beheld one equal in majesty to him who now stands at the door.'

'If walking thou didst enter here, return thou running,' replied Arthur, 'and let everyone that opens and shuts the eye show him respect and serve him, for it is not meet to keep such a man in the wind and rain.' So Glewlwyd unbarred the gate and Kilwch rode in upon his charger.

'Greeting unto thee, O ruler of this land,' cried he, 'and greeting no less to the lowest than to the highest.'

'Greeting to thee also,' answered Arthur. 'Sit thou between two of my warriors, and thou shalt have minstrels before thee and all that belongs to one born to be a king, while thou remainest in my palace.'

'I am not come,' replied Kilwch, 'for meat and drink, but to obtain a boon, and if thou grant it me I will pay it back, and will carry thy praise to the four winds of heaven. But if thou wilt not grant it to me, then I will proclaim thy discourtesy wherever thy name is known.'

'What thou askest that shalt thou receive,' said Arthur, 'as far as the wind dries and the rain moistens, and the sun revolves and the sea encircles and the earth extends. Save only my ship and my mantle, my sword and my lance, my shield and my dagger, and Guinevere my wife.'

'I would that thou bless my hair,' spake Kilwch, and Arthur answered:

'That shall be granted thee.'

Forthwith he bade his men fetch him a comb of gold and a scissors with loops of silver, and he combed the hair of Kilwch his guest.

'Tell me who thou art,' he said, 'for my heart warms to thee, and I feel thou art come of my blood.'

'I am Kilwch, son of Kilydd,' replied the youth.

'Then my cousin thou art in truth,' replied Arthur, 'and whatsoever boon thou mayest ask thou shalt receive.'

'The boon I crave is that thou mayest win for me Olwen, the daughter of Yspaddaden Penkawr, and this boon I seek likewise at the hands of thy warriors. From Sol, who can stand all day upon one foot; from Ossol, who, if he were to find himself on the top of the highest mountain in the world, could make it into a level plain in the beat of a bird's wing; from Clust, who, though he were buried under the earth, could yet hear the ant leave her nest fifty miles away: from these and from Kai and from Bedwyr and from all thy mighty men I crave this boon.'

'O Kilwch,' said Arthur, 'never have I heard of the maiden of whom thou speakest, nor of her kindred, but I will send messengers to seek her if thou wilt give me time.'

'From this night to the end of the year right willingly will I grant thee,' replied Kilwch; but when the end of the year came and the messengers returned Kilwch was wroth, and spoke rough words to Arthur.

It was Kai, the boldest of the warriors and the swiftest of foot—he who could pass nine nights without sleep, and nine days beneath the water—that answered him:

'Rash youth that thou art, darest thou speak thus to Arthur? Come with us, and we will not part company till we have won that maiden, or till thou confess that there is none such in the world.'

Then Arthur summoned his five best men and bade them go with Kilwch. There was Bedwyr the one-handed, Kai's comrade and brother in arms, the swiftest man in Britain save Arthur; there was Kynddelig, who knew the paths in a land where he had never been as surely as he did those of his own country; there was Gwrhyr, that could speak all tongues; and Gwalchmai the son of Gwyar, who never returned till he had gained what he sought; and last of all there was Menw, who could weave a spell over them so that none might see them, while they could see everyone.

So these seven journeyed together till they reached a vast open plain in which was a fair castle. But though it seemed so close it was not until the evening of the third day that they really drew near to it, and in front of it a flock of sheep was spread, so many in number that there seemed no end to them. A shepherd stood on a mound watching over them, and by his side was a dog, as large as a horse nine winters old.

'Whose is this castle, O herdsman?' asked the knights.

'Stupid are ye truly,' answered the herdsman. 'All the world knows that this is the castle of Yspaddaden Penkawr.'

'And who art thou?'

'I am called Custennin, brother of Yspaddaden, and ill has he treated me. And who are you, and what do you here?'

'We come from Arthur the king, to seek Olwen the daughter of Yspaddaden,' but at this news the shepherd gave a cry:

'O men, be warned and turn back while there is yet time. Others have gone on that quest, but none have escaped to tell the tale,' and he rose to his feet as if to leave them. Then Kilwch held out to him a ring of gold, and he tried to put it on his finger, but it was too small, so he placed it in his glove, and went home and gave it to his wife.

'Whence came this ring?' asked she, 'for such good luck is not wont to befall thee.'

'The man to whom this ring belonged thou shalt see here in the evening,' answered the shepherd; 'he is Kilwch, son of Kilydd, cousin to king Arthur, and he has come to seek Olwen.' And when the wife heard that she knew that Kilwch was her nephew, and her heart yearned after him, half with joy at the thought of seeing him, and half with sorrow for the doom she feared.

Soon they heard steps approaching, and Kai and the rest entered into the house and ate and drank. After that the woman opened a chest, and out of it came a youth with curling yellow hair.

'It is a pity to hide him thus,' said Gwrhyr, 'for well I know that he has done no evil.'

'Three and twenty of my sons has Yspaddaden slain, and I have no more hope of saving this one,' replied she, and Kai was full of sorrow and answered:

'Let him come with me and be my comrade, and he shall never be slain unless I am slain also.' And so it was agreed.

'What is your errand here?' asked the woman.

'We seek Olwen the maiden for this youth,' answered Kai; 'does she ever come hither so that she may be seen?'

'She comes every Saturday to wash her hair, and in the vessel where she washes she leaves all her rings, and never does she so much as send a messenger to fetch them.'

'Will she come if she is bidden?' asked Kai, pondering.

'She will come; but unless you pledge me your faith that you will not harm her I will not fetch her.'

'We pledge it,' said they, and the maiden came.

A fair sight was she in a robe of flame-coloured silk, with a collar of ruddy gold about her neck, bright with emeralds and rubies. More yellow was her head than the flower of the broom, and her skin was whiter than the foam of wave, and fairer were her hands than the blossom of the wood anemone. Four white trefoils sprang up where she trod, and therefore was she called Olwen.

She entered, and sat down on a bench beside Kilwch, and he spake to her:

'Ah, maiden, since first I heard thy name I have loved thee—wilt thou not come away with me from this evil place?'

'That I cannot do,' answered she, 'for I have given my word to my father not to go without his knowledge, for his life will only last till I am betrothed. Whatever is, must be, but this counsel I will give you. Go, and ask me of my father, and whatsoever he shall require of thee grant it, and thou shalt win me; but if thou deny him anything thou wilt not obtain me, and it will be well for thee if thou escape with thy life.'

'All this I promise,' said he.

So she returned to the castle, and all Arthur's men went after her, and entered the hall.

'Greeting to thee, Yspaddaden Penkawr,' said they. 'We come to ask thy daughter Olwen for Kilwch, son of Kilydd.'

'Come hither to-morrow and I will answer you,' replied Yspaddaden Penkawr, and as they rose to leave the hall he caught up one of the three poisoned darts that lay beside him and flung it in their midst. But Bedwyr saw and caught it, and flung it back so hard that it pierced the knee of Yspaddaden.

'A gentle son-in-law, truly!' he cried, writhing with pain. 'I shall ever walk the worse for this rudeness. Cursed be the smith who forged it, and the anvil on which it was wrought!'

That night the men slept in the house of Custennin the herdsman, and the next day they proceeded to the castle, and entered the hall, and said:

'Yspaddaden Penkawr, give us thy daughter and thou shalt keep her dower. And unless thou wilt do this we will slay thee.'

'Her four great grandmothers and her four great grandfathers yet live,' answered Yspaddaden Penkawr; 'it is needful that I take counsel with them.'

'Be it so; we will go to meat,' but as they turned he took up the second dart that lay by his side and cast it after them. And Menw caught it, and flung it at him, and wounded him in the chest, so that it came out at his back.

'A gentle son-in-law, truly!' cried Yspaddaden; 'the iron pains me like the bite of a horse-leech. Cursed be the hearth whereon it was heated, and the smith who formed it!'

The third day Arthur's men returned to the palace into the presence of Yspaddaden.

'Shoot not at me again,' said he, 'unless you desire death. But lift up my eyebrows, which have fallen over my eyes, that I may see my son-in-law.' Then they arose, and as they did so Yspaddaden Penkawr took the third poisoned dart and cast it at them. And Kilwch caught it, and flung it back, and it passed through his eyeball, and came out on the other side of his head.

'A gentle son-in-law, truly! Cursed be the fire in which it was forged and the man who fashioned it!'

The next day Arthur's men came again to the palace and said:

'Shoot not at us any more unless thou desirest more pain than even now thou hast, but give us thy daughter without more words.'

'Where is he that seeks my daughter? Let him come hither so that I may see him.' And Kilwch sat himself in a chair and spoke face to face with him.

'Is it thou that seekest my daughter?'

'It is I,' answered Kilwch.

'First give me thy word that thou wilt do nothing towards me that is not just, and when thou hast won for me that which I shall ask, then thou shalt wed my daughter.'

'I promise right willingly,' said Kilwch. 'Name what thou wilt.'

'Seest thou yonder hill? Well, in one day it shall be rooted up and ploughed and sown, and the grain shall ripen, and of that wheat I will bake the cakes for my daughter's wedding.'

'It will be easy for me to compass this, although thou mayest deem it will not be easy,' answered Kilwch, thinking of Ossol, under whose feet the highest mountain became straightway a plain, but Yspaddaden paid no heed, and continued:

'Seest thou that field yonder? When my daughter was born nine bushels of flax were sown therein, and not one blade has sprung up. I require thee to sow fresh flax in the ground that my daughter may wear a veil spun from it on the day of her wedding.'

'It will be easy for me to compass this.'

'Though thou compass this there is that which thou wilt not compass. For thou must bring me the basket of Gwyddneu Garanhir which will give meat to the whole world. It is for thy wedding feast. Thou must also fetch me the drinking-horn that is never empty, and the harp that never ceases to play until it is bidden. Also the comb and scissors and razor that lie between the two ears of Trwyth the boar, so that I may arrange my hair for the wedding. And though thou get this yet there is that which thou wilt not get, for Trwyth the boar will not let any man take from him the comb and the scissors, unless Drudwyn the whelp hunt him. But no leash in the world can hold

Drudwyn save the leash of Cant Ewin, and no collar will hold the leash except the collar of Canhastyr.'

'It will be easy for me to compass this, though thou mayest think it will not be easy,' Kilwch answered him.

'Though thou get all these things yet there is that which thou wilt not get. Throughout the world there is none that can hunt with this dog save Mabon the son of Modron. He was taken from his mother when three nights old, and it is not known where he now is, nor whether he is living or dead, and though thou find him yet the boar will never be slain save only with the sword of Gwrnach the giant, and if thou obtain it not neither shalt thou obtain my daughter.'

'Horses shall I have, and knights from my lord Arthur. And I shall gain thy daughter, and thou shalt lose thy life.'

The speech of Kilwch the son of Kilydd with Yspaddaden Penkawr was ended.

Then Arthur's men set forth, and Kilwch with them, and journeyed till they reached the largest castle in the world, and a black man came out to meet them.

'Whence comest thou, O man?' asked they, 'and whose is that castle?'

'That is the castle of Gwrnach the giant, as all the world knows,' answered the man, 'but no guest ever returned thence alive, and none may enter the gate except a craftsman, who brings his trade.' But little did Arthur's men heed his warning, and they went straight to the gate.

'Open!' cried Gwrhyr.

'I will not open,' replied the porter.

'And wherefore?' asked Kai.

'The knife is in the meat, and the drink is in the horn, and there is revelry in the hall of Gwrnach the giant, and save for a craftsman who brings his trade the gate will not be opened to-night.'

'Verily, then, I may enter,' said Kai, 'for there is no better burnisher of swords than I.'

'This will I tell Gwrnach the giant, and I will bring thee his answer.'

'Bid the man come before me,' cried Gwrnach, when the porter had told his tale, 'for my sword stands much in need of polishing,' so Kai passed in and saluted Gwrnach the giant.

'Is it true what I hear of thee, that thou canst burnish swords?'

'It is true,' answered Kai. Then was the sword of Gwrnach brought to him.

'Shall it be burnished white or blue?' said Kai, taking a whetstone from under his arm.

'As thou wilt,' answered the giant, and speedily did Kai polish half the sword. The giant marvelled at his skill, and said:

'It is a wonder that such a man as thou shouldst be without a companion.'

'I have a companion, noble sir, but he has no skill in this art.'

'What is his name?' asked the giant.

'Let the porter go forth, and I will tell him how he may know him. The head of his lance will leave its shaft, and draw blood from the wind, and descend upon its shaft again.' So the porter opened the gate and Bedwyr entered.

Now there was much talk amongst those who remained without when the gate closed upon Bedwyr, and Goreu, son of Custennin, prevailed with the porter, and he and his companions got in also and hid themselves.

By this time the whole of the sword was polished, and Kai gave it into the hand of Gwrnach the giant, who felt it and said:

'Thy work is good; I am content.'

Then said Kai:

'It is thy scabbard that hath rusted thy sword; give it to me that I may take out the wooden sides of it and put in new ones.' And he took the scabbard in one hand and the sword in the other, and came and stood behind the giant, as if he would have sheathed the sword in the scabbard. But with it he struck a blow at the head of the giant, and it rolled from his body. After that they despoiled the castle of its gold and jewels, and returned, bearing the sword of the giant, to Arthur's court.

They told Arthur how they had sped, and they all took counsel together, and agreed that they must set out on the quest for Mabon the son of Modron, and Gwrhyr, who knew the languages of beasts and of birds, went with them. So they journeyed until they came to the nest of an ousel, and Gwrhyr spoke to her.

'Tell me if thou knowest aught of Mabon the son of Modron, who was taken when three nights old from between his mother and the wall.'

And the ousel answered:

'When I first came here I was a young bird, and there was a smith's anvil in this place. But from that time no work has been done upon it, save that every evening I have pecked at it, till now there is not so much as the size of a nut remaining thereof. Yet all that time I have never once heard of the man you name. Still, there is a race of beasts older than I, and I will guide you to them.'

So the ousel flew before them, till she reached the stag of Redynvre; but when they inquired of the stag whether he knew aught of Mabon he shook his head.

'When first I came hither,' said he, 'the plain was bare save for one oak sapling, which grew up to be an oak with a hundred branches. All that is left of that oak is a withered stump, but never once have I heard of the man you name. Nevertheless, as you are Arthur's men, I will guide you to the place where there is an animal older than I'; and the stag ran before them till he reached the owl of Cwm Cawlwyd. But when they inquired of the owl if he knew aught of Mabon he shook his head.

'When first I came hither,' said he, 'the valley was a wooded glen; then a race of men came and rooted it up. After that there grew a second wood, and then a third, which you see. Look at my wings also—are they not withered stumps? Yet until to-day I have never heard of the man you name. Still, I will guide you to the oldest animal in the world, and the one that has travelled most, the eagle of Gwern Abbey.' And he flew before them, as fast as his old wings would carry him, till he reached the eagle of Gwern Abbey, but when they inquired of the eagle whether he knew aught of Mabon he shook his head.

'When I first came hither,' said the eagle, 'there was a rock here, and every evening I pecked at the stars from the top of it. Now, behold, it is not even a span high! But only once have I heard of the man you name, and that was when I went in search of food as far as Llyn Llyw. I swooped down upon a salmon, and struck my claws into him, but he drew me down under water till scarcely could I escape from him. Then I summoned all my kindred to destroy him, but he made peace with me, and I took fifty fish spears from his back. Unless he may know something of the man whom you seek I cannot tell who may. But I will guide you to the place where he is.'

So they followed the eagle, who flew before them, though so high was he in the sky, it was often hard to mark his flight. At length he stopped above a deep pool in a river.

'Salmon of Llyn Llyw,' he called, 'I have come to thee with an embassy from Arthur to inquire if thou knowest aught concerning Mabon the son of Modron?' And the salmon answered:

'As much as I know I will tell thee. With every tide I go up the river, till I reach the walls of Gloucester, and there have I found such wrong as I never found elsewhere. And that you may see that what I say is true let two of you go thither on my shoulders.' So Kai and Gwrhyr went upon the shoulders of the salmon, and were carried under the walls of the prison, from which proceeded the sound of great weeping.

'Who is it that thus laments in this house of stone?'

'It is I, Mabon the son of Modron.'

'Will silver or gold bring thy freedom, or only battle and fighting?' asked Gwrhyr again.

'By fighting alone shall I be set free,' said Mabon.

Then they sent a messenger to Arthur to tell him that Mabon was found, and he brought all his warriors to the castle of Gloucester and fell fiercely upon it; while Kai and Bedwyr went on the shoulders of the salmon to the gate of the dungeon, and broke it down and carried away Mabon. And he now being free returned home with Arthur.

After this, on a certain day, as Gwythyr was walking across a mountain he heard a grievous cry, and he hastened towards it. In a little valley he saw the heather burning and the fire spreading fast towards an anthill, and all the ants were hurrying to and fro, not knowing whither to go. Gwythyr had pity on them, and put out the fire, and in gratitude the ants brought him the nine bushels of flax seed which Yspaddaden Penkawr required of Kilwch. And many of the other marvels were done likewise by Arthur and his knights, and at last it came to the fight with Trwyth the boar, to obtain the comb and the scissors and the razor that lay between his ears. But hard was the boar to catch, and fiercely did he fight when Arthur's men gave him battle, so that many of them were slain.

Up and down the country went Trwyth the boar, and Arthur followed after him, till they came to the Severn sea. There three knights caught his feet unawares and plunged him into the water, while one snatched the razor from him, and another seized the scissors. But before they laid hold of the comb he had shaken them all off, and neither man nor horse nor dog could reach him till he came to Cornwall, whither Arthur had sworn he should not go. Thither Arthur followed after him with his knights, and if it had been hard to win the razor and the scissors, the struggle for the comb was fiercer still. Often it seemed as if the boar would be the victor, but at length Arthur prevailed, and the boar was driven into the sea. And whether he was drowned or where he went no man knows to this day.

In the end all the marvels were done, and Kilwch set forward, and with him Goreu, the son of Custennin, to Yspaddaden Penkawr, bearing in their hands the razor, the scissors and the comb, and Yspaddaden Penkawr was shaved by Kaw.

'Is thy daughter mine now?' asked Kilwch.

'She is thine,' answered Yspaddaden, 'but it is Arthur and none other who has won her for thee. Of my own free will thou shouldst never have had her, for now I must lose my life.' And as he spake Goreu the son of Custennin cut off his head, as it had been ordained, and Arthur's hosts returned each man to his own country.

FROM *THE MABINOGION*

THE ADVENTURE OF LLUDD AND LLEUELYS

Anonymous, c. 12th century

Welsh, translated by Patrick K. Ford

Beli Mawr son of Mynogan had three sons: Lludd, Caswallawn, and Ninniaw; according to the lore about him, Lleuelys was a fourth son. After Beli died, the kingdom of the Isle of Britain fell into the hands of Lludd, his eldest son, and Lludd ruled it successfully. He refurbished the walls of London, and surmounted them with countless towers. After that he ordered the citizens to build houses of such quality that no kingdom would have houses as splendid as were in London.

And besides that, he was a good warrior and generous, and he gave food and drink freely to all who sought it, and although he had many forts and cities, he loved this one more than any other, and dwelt there most of the year. For that reason it was called Caer Lludd, and finally Caer Llundein. After the foreign people came it was called Llundein or Londres.

Lludd loved Lleuelys best of all his brothers, for he was a wise and prudent man. When Lleuelys heard that the king of France had died leaving no heir save a daughter, and that he had left his realm in her hands, he came to his brother Lludd seeking counsel and encouragement from him. And not only for personal advantage, but to try to add honor, dignity, and merit to their race, if he could go to the kingdom of France to seek that woman for his wife. His brother agreed with him immediately, and he was pleased with that counsel. Without delay ships were made ready and filled with armed horsemen, and they set out for France. As soon as they disembarked, they sent messengers to announce to the nobles of France the nature of the business they had come to attempt. And by joint counsel of the nobles of France and her princes, the maiden was given to Lleuelys, and the realm's crown along with her. After that, he ruled the land wisely, prudently, and in good fortune, as long as he lived.

After some time had passed, three oppressions came upon the isle of Britain, such that none of the islands had ever seen before. The first of these was the advent of a people called the Coraniaid; so great was their knowledge that there was no utterance over the face of the land—however low it was spoken—that, if the wind met it, they didn't know. For that reason, one could do them no harm.

The second oppression was a cry that resounded every May-day eve above every hearth in Britain; it went through the hearts of men and terrified them so much that men lost their color and their strength, women miscarried, sons and daughters lost their senses and all animals, forests, earth and waters were left barren.

The third oppression was that despite how extensive the preparations and provisions were that were readied in the king's courts, even though it be a year's provision of food and drink, nothing was ever had of it except what could be consumed on the very first night.

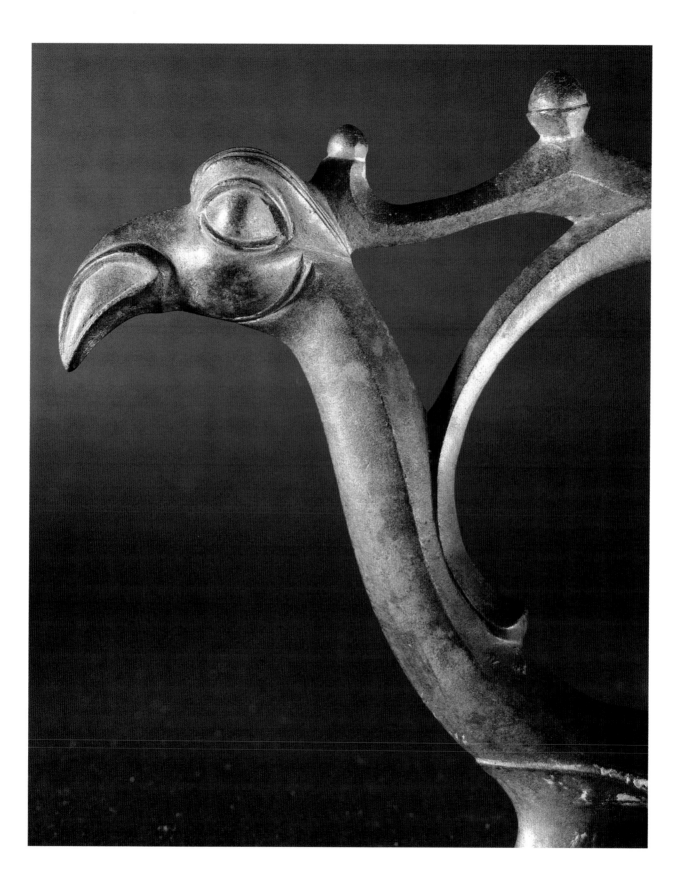

The first oppression was evident and clear enough, but no one knew the meaning of the other two oppressions. There was greater hope, therefore, of deliverance from the first than from the second or third.

Lludd, the king, grew anxious and worried then, for he didn't know how he could get relief from those oppressions. He summoned all the nobles of his realm, and sought advice from them concerning what they could do against those oppressions. With the unanimous counsel of the nobles, Lludd son of Beli determined to go to his brother Lleuelys, king of France, for he was a man of great and wise counsel, from whom to seek advice. And they prepared a fleet—secretly and quietly, lest that people or anyone else know the meaning of their business except the king and his counselors. When they had been prepared, Lludd and those whom he had selected went to their ships and began to plough the seas toward France.

When news of that came to Lleuelys—since he did not know the reason for his brother's fleet—he came from the other side to meet him, with an enormous fleet. When Lludd saw that, he left all his ships out at sea except one, and in that he went to meet his brother. The other did the same. After they came together, each put his arms around the other's neck, and they greeted each other with brotherly affection. When Lludd had told his brother the purpose of his mission, Lleuelys said that he knew the meaning of his arrival in those lands. Then they conspired to conduct their business differently, in order that the wind might not carry their speech, lest the Coraniaid know what they said. So Lleuelys had a long brass horn made, and they talked through that. But whatever speech one of them uttered through the horn, only adverse, contrary speech was heard by the other. When Lleuelys saw that, and that a demon was obstructing them and creating turmoil in the horn, he had wine poured into the horn to cleanse it. By virtue of the wine, the demon was driven out.

When their speech was unobstructed, Lleuelys told his brother that he would give him some vermin, and that he should let some of them live to breed, in case by chance that sort of oppression came again. The others he should take and break up in water. That, he affirmed, would be good to destroy the race of Coraniaid, as follows: after he came home to his realm, he should summon all the people together—his people and the Coraniaid people in the same assembly, with the pretext of making peace between them. When they were all together, he should take that charged water and sprinkle it on everyone universally. And he affirmed that that water would poison the Coraniaid people, but that it would neither kill nor injure any of his own people.

"The second oppression in your realm," he said, "is a dragon. A dragon of foreign blood is fighting with him and seeking to overthrow him. Because of that, your dragon utters a horrible scream. This is how you shall be instructed regarding that: after you return home, have the length and width of the island measured. Where you discover the exact center, have that place dug up. Then, have a vatful of the best mead that can be made put into that hole, with a cover of silk brocade over the top of the vat. And then you yourself stand watch, and you will see the dragons fighting in the shape of horrible animals. Finally, they will assume the form of dragons in the air. Last of all, after they cease their violent and fierce battle, being tired, they will fall in the shape of two young pigs onto the coverlet. They will sink the sheet with them and draw it down to the bottom of the vat; they will drink all the mead, and after that they will sleep. Then immediately wrap the cover around them. In the strongest place you can find in your kingdom, deposit them in a stone chest, and hide it in the ground. And as long as they remain in that secure place, no oppression shall visit the isle of Britain from another place."

"The cause of the third oppression," he said, "is a powerful magician who carries off your food, your drink, and your provisions, and by his sorcery and his magic he puts everyone to sleep. And so you yourself must stand guard over your banquets and your feasts. And lest he induce sleep in you, have a vat of cold water at hand, and when sleep weighs you down, get into the vat."

Lludd returned to his country then, and without delay summoned every single one of his own people and the Coraniaid. He broke the vermin up in water, as Lleuelys had taught him, and sprinkled it generally over everyone. All the Coraniaid folk were destroyed instantly without injury to any of the Britons.

Some time after that, Lludd had the island measured in length and breadth; the middle point was found to be in Oxford. There he had the earth dug up, and in that hole he put a vat full of the best mead that could be made, with a silk veil over the surface. He himself stood watch that night. As he was thus, he could see the dragons fighting. When they grew weary and exhausted, they fell onto the screen and dragged it down with them to the bottom of the vat. After they drank the mead they slept; as they slept, Lludd wrapped the veil about them. In the safest place he could find in Eryri, he secluded them in a stone chest. After that the place was called Dinas Emrys; before that it was known as Dinas Ffaraon Dandde. He was one of three stewards whose hearts broke from sorrow.

Thus was stopped the tempestuous scream that was in the realm.

When that was done, Lludd the king had a feast of great magnitude prepared. When it was ready, he put a vat full of cold water beside him and he personally stood guard. And as he stood there fully armed, about the third watch of the night, he heard much magnificent music and songs of different kinds, and drowsiness driving him to sleep. What he did then—lest his plan be thwarted and he be overcome by sleep—was to leap into the water frequently. At last a man of enormous stature, armed with powerful, heavy weapons, came in carrying a basket. As was his custom, he put all the preparations and the provisions of food and drink into the basket and started out with it. Nothing astounded Lludd more than such a quantity as that fitting into that basket. Thereupon, Lludd the King set out after him, and shouted; "Stop! Stop!" he said, "though you have committed many outrages and have been responsible for many losses before this, you'll do it no more—unless your prowess proves you stronger than I or more valiant."

Immediately, he set the basket on the floor and waited for him. They fought ferociously, until sparks flew from their weapons. Finally, Lludd took hold of him, and fate took care that the victory fell to Lludd, casting the tyrant to the ground beneath him. When he had conquered him through force and violence, the fellow sought protection from him.

"How could I give you protection," said the King, "after

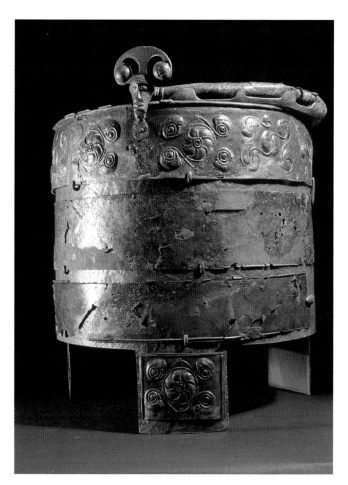

The Aylesford Bucket.
Bronze and wood,
1st century B.C.E.

how much loss and injury you have perpetrated against me?"

"All the losses I have ever caused you," said the other, "I will restore to you, as well as I have carried them off, and I will not do the like from this moment on, but will be your faithful man henceforth."

And the King accepted that from him. Thus did Lludd ward off the three oppressions from the Isle of Britain. From then until the end of his life, Lludd ruled the Isle of Britain successfully and peacefully.

This tale is called the Adventure of Lludd and Lleuelys, and so it ends.

EXCALIBUR

Malory

English

'Knight, hold your hand, for if you slay that knight you will put this realm into great danger.'

'Why, who is he?' said the knight.

'It is King Arthur,' replied Merlin.

Then the knight would have slain King Arthur for dread of his wrath, and heaved up his sword; but at that Merlin cast an enchantment on the knight, so that he fell to the earth in a great sleep. Then Merlin took up King Arthur, and rode on the knight's horse.

'Alas!' said Arthur, 'what have you done, Merlin? Have you slain this knight by your crafts? There lived not a more worshipful knight than he was; I would gladly lose a year's income to have him alive.'

'Don't worry,' said Merlin, 'he is better off than you; he is only asleep and will awake in three hours . . .' Right so he and the king departed, and went to a hermit who was a good man and a great healer. The hermit cleaned all Arthur's wounds and gave him good salves. The king was there three days and, when his wounds were healing so well that he could ride, they departed.

The Taking of Excalibur, John McKirdy Duncan (1866–1945), Irish. Tempera.

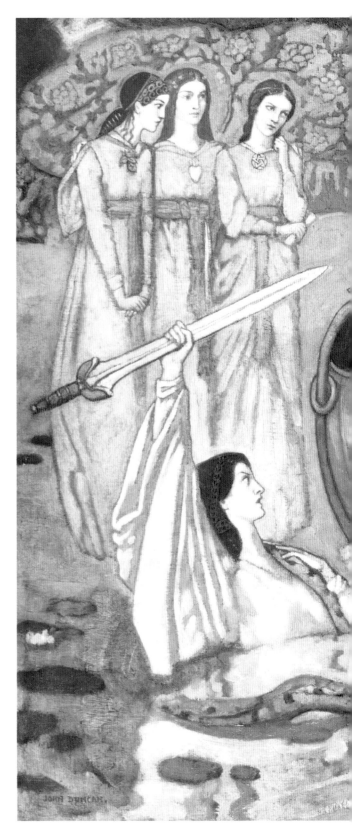

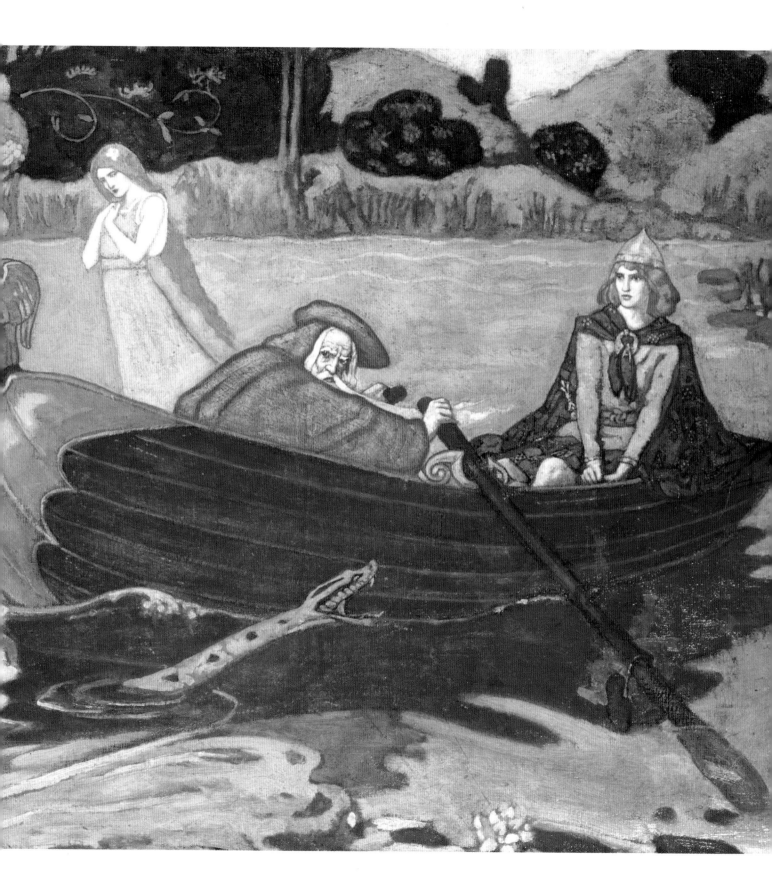

And as they rode, Arthur said, 'I have no sword.'

'Cease to trouble,' said Merlin. 'I know of only one good sword in this whole land; it is in a lake inhabited by faeries. If you are able to gain this sword, it will last you through to the end.'

'Ah, fair Merlin,' said the king, 'can you obtain this sword for me?'

'I can only tell you where it is,' replied Merlin . . . They rode close by the sea, then Merlin turned left towards a mountain, and thus they came to a lake. 'How does the water look to you?' asked Merlin.

'It looks extremely deep,' replied Arthur, 'and as if no man could enter it without perishing.'

'You speak correctly,' said Merlin. 'No man has entered it without the permission of the faeries and not died as a consequence. Yet know that in this lake is the good sword of which I told you.'

'In this lake?' said the king, 'and how may it be achieved?'

'That you will see soon enough,' answered Merlin, 'if God wills it.' While they were speaking in this manner, they looked into the centre of the lake and saw a sword appear from beneath the waters, held aloft by a hand and arm clad in white samite. 'There you can see,' said Merlin, 'the sword of which I told you, the same sword that you will carry.'

As he spoke they saw a damsel coming towards them over the surface of the water. 'What damsel is that?' said Arthur.

'That is the Lady of the Lake,' said Merlin. 'Within the lake is a rock, and inside it is the fairest palace on earth, and richly furnished; and this damsel will come to you soon. You should speak fair to her, so that she will give you the sword.'

And straight away the damsel came to King Arthur, and greeted him, and he her. 'Damsel,' said Arthur, 'what sword is that, that yonder arm holds above the water? I wish it were mine, for I have no sword.'

'Sir Arthur, King,' said the damsel, 'that sword is mine, and it is called Excalibur, which is to say, Cut-steel. And if you will give me a gift when I ask it of you, you shall have it.'

'By my faith,' said Arthur, 'I will give you whatever gift you may ask.'

'Well,' said the damsel, 'go into that barge, and row yourself to the sword, and take it and the scabbard with you; I will ask for my gift when I see my time.'

So Arthur and Merlin dismounted and tied their horses to two trees, and they went into the barge, and when they came to the sword that the hand held up, Sir Arthur took it up by the hilt, and the hand and arm went under the water.

And they came back to land, but the damsel was nowhere to be seen, and they rode on. And Sir Arthur looked at the sword and he liked it passing well.

'Which do you like better,' said Merlin, 'the sword, or the scabbard?'

'I like the sword better,' answered Arthur.

'You are the more unwise,' said Merlin, 'for the scabbard is worth ten of the sword; for while you have the scabbard upon you, you shall never lose a drop of blood, however sorely wounded you may be, and therefore keep the scabbard always with you.'. . .

So they came to Caerleon, of which his knights were passing glad. And when they heard of his adventures, they marvelled that he would hazard his person in this way, alone. But all men of worship said that is was merry to be under such a chieftain, that would put his person in adventure as other poor knights did.

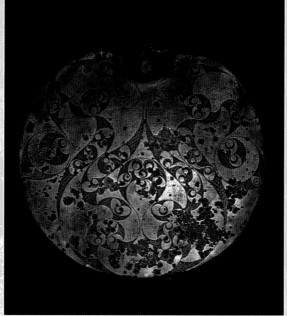

EPIGRAM

Cynddelw

Welsh

Proud its call when its cry is raised,

when horns are blown in concord,

horn of Llywelyn, lord of great hosts,

broad-based, thin-mouthed and loud of blast.

A horn after killing, a happy horn,

horn of Llywelyn's advance guard,

a horn of wood, a brave man sounds it,

a tapering horn in the track of hounds.

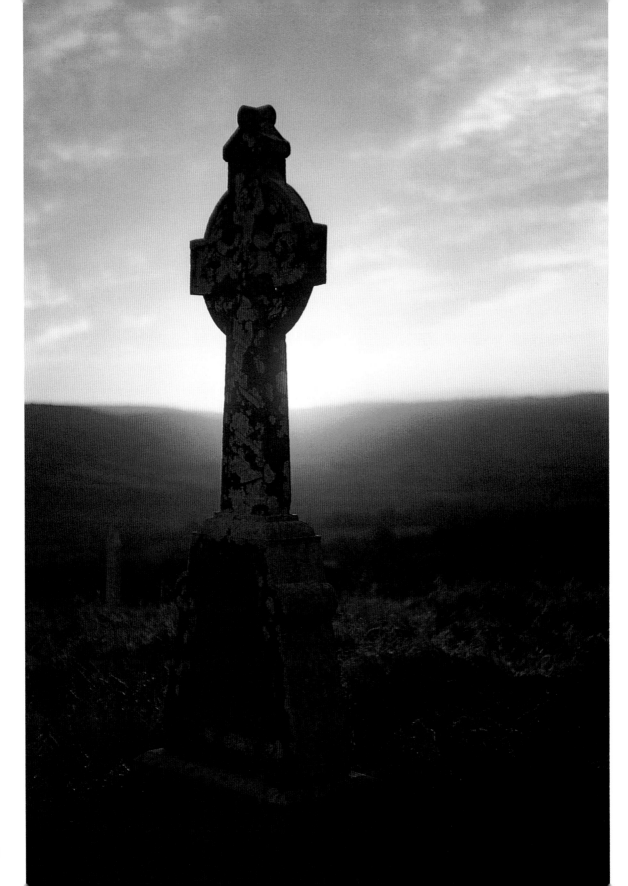

KINCORA

Anonymous, 12th century

Irish, translated by James Clarence Mangan

Ah, where, Kincora! is Brian the Great?
And where is the beauty that once was thine?
Oh, where are the princes and nobles that sate
At the feasts in thy halls, and drank the red wine,
 Where, O Kincora?

Oh, where Kincora! are thy valorous lords?
Oh, whither, thou Hospitable! are they gone?
Oh, where are the Dalcassians of the Golden Swords?
And where are the warriors Brian led on?
 Where, O Kincora?

And where is Murrough, the descendant of kings—
The defeater of a hundred—the daringly brave—
Who set but slight store by jewels and rings—
Who swam down the torrent and laughed at its wave?
 Where, O Kincora?

And where is Donogh, King Brian's worthy son?
And where is Conaing, the Beautiful Chief?
And Kian, and Corc? Alas! they are gone—
They have left me this night alone with my grief!
 Left me, Kincora!

And where are the chiefs with whom Brian went forth
The ne'er-vanquished son of Evin the Brave,
The great King of Onaght, renowned for his worth,
And the hosts of Baskinn, from the western wave?
 Where, O Kincora?

Oh, where is Duvlann of the Swift-footed Steeds?
And where is Kian, who was son of Molloy?

And where is King Lonergan, the fame of whose deeds
In the red battlefield no time can destroy?
 Where, O Kincora?

And where is that youth of majestic height,
The faith-keeping Prince of the Scots?—Even he,
As wide as his fame was, as great as was his might,
Was tributary, O Kincora, to thee!
 Thee, O Kincora!

They are gone, those heroes of royal birth,
Who plundered no churches, and broke no trust,
'Tis weary for me to be living on earth
When they, O Kincora, lie low in the dust!
 Low, O Kincora!

Oh, never again will Princes appear,
To rival the Dalcassians of the Cleaving Swords!
I can never dream of meeting afar or anear,
In the east or the west, such heroes and lords!
 Never, O Kincora!

Oh, dear are the images my memory calls up
Of Brian Boru!—how he never would miss
To give me at the banquet the first bright cup!
Ah! why did he heap on me honor like this?
 Why, O Kincora?

I am MacLiag, and my home is on the Lake;
Thither often, to that palace whose beauty is fled,
Came Brian to ask me, and I went for his sake.
Oh, my grief! that I should live, and Brian be dead
 Dead, O Kincora!

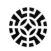

SUMMER IS GONE

Anonymous, 9th century

Irish, translated by Kuno Meyer

My tidings for you: the stag bells,
Winter snows, summer is gone.

Wind high and cold, low the sun.
Short his course, sea running high.

Deep-red the bracken, its shape all gone—
The wild-goose has raised his wonted cry.

Cold has caught the wings of birds:
Season of ice—these are my tidings.

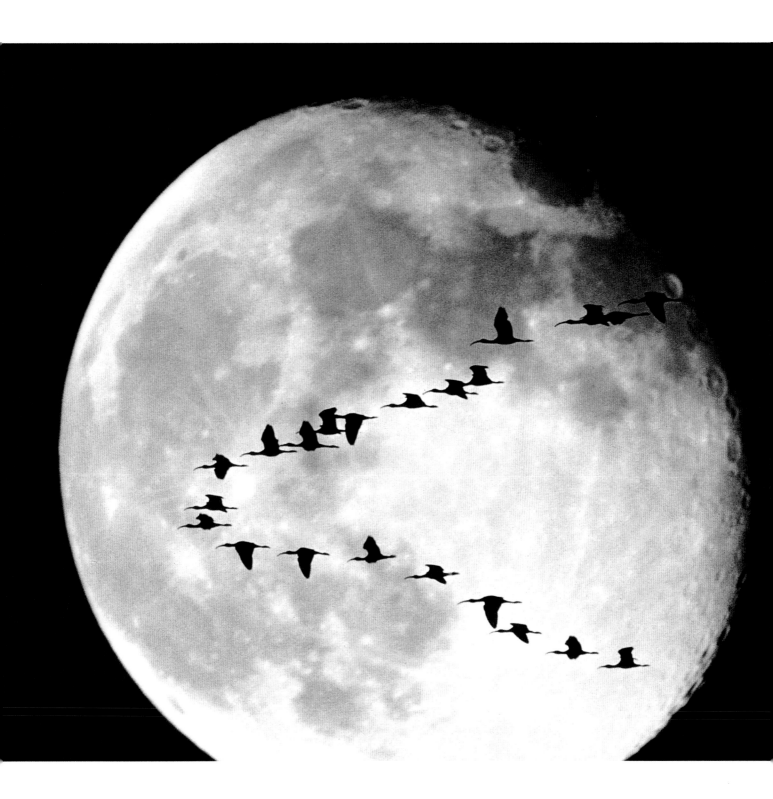

A STUDY.
THE LADY OF SHALOTT.
SIR NOEL PATON, R.S.A., LL.D.

THE DANCE HALF DONE

Mary Ann Larkin

Irish

Our fate was settled centuries ago

when the huge floes cracked

loosening mist upon the island

sealing in

the flow of light over distances

herons in green-grey waters

a girl's red hair

falling from the turret

The island itself suspended

in a primal sac of light

fed by a dark cord from within the bog

Poets send their words into the mist

in this land where symbols live—

like a dance behind a grey scrim

a promise unfulfilled

a yes or a no never said

just as the mouth begins to form the words

as the heron lifts its leg

the girl her comb

We are stamped by this

land of murmurs and half-heard chants

a dreaminess in our gaze

hands caught in mid-air

eyes following a passage of light

The young women wrap themselves in grey wool

and go walking

The young men watch

We remember

the dance half-done

the kiss almost given

the red hair falling from the turret

hear, above grey waters,

the half-promise of the lute

The Lady of Shalott, Sir Joseph
Noel Paton (1821–1901),
Scottish. 1832.

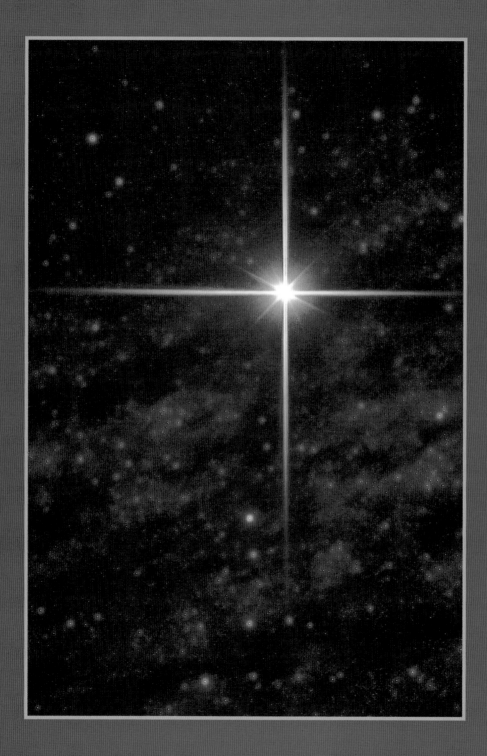

"[The druids] hold that the soul of a dead man does not descend to the silent, sunless world of Hades, but becomes reincarnate elsewhere, if they are right, death is merely a point of change in perpetual existence."

—LUCAN, PHARSALIA

THE DRUIDS WERE THE SEERS, PHILOSOPHERS, ambassadors, advisers to royalty, teachers, judges, natural scientists and masters of the supernatural arts. The Indo-European root of the word *druid* means oak knowledge. Another theory is that the word comes from *dru-vid* meaning thorough knowledge. The druids worshipped in sacred groves and had an extensive knowledge of the healing properties of herbs and plants.

Star addresses the concepts that we attribute to this priestly class as they pervade Celtic lore, poetry and myth. We have seen in *Song* examples of how the land was held sacred. The sacred sights of the druids were considered the meeting places between heaven and earth, the spiritual and the material. Stone circles, sacred groves and the ceremonies held within them reflected a concept of existence that is spiral—a wheel of existence. They recognized a single life force which permeates all creation—mineral, floral, animal or human. Every part of the whole was revered as the microcosm within a vibrant macrocosm.

Both women and men practiced druidry. Fionn was raised by foster mothers who were both druids. The children of King Lir were changed into swans by their druid stepmother, Aoife. These priests honored the goddess as well as the god. This was not a dualistic system that pitted dark against light, but a pantheistic one that celebrated the triad—the triple goddess. The concept of the trinity owes its origins to the Celts.

There is an ever-present belief in reincarnation and the immortality of the soul. Valerius Maximus, describing the druids of Southern France, records "that they lend to each other sums that are repayable in the next world, so firmly are they convinced that the souls of men are immortal." Death, though part of life, is never regarded as the victor as seen in *And Death Shall Have No Dominion* by Dylan Thomas (page 158). The historian Peter Berresford Ellis in his *Introduction to Celtic Mythology* tells us "The druids taught that death is only a changing of place. When a soul dies in this world, it is reborn in the Otherworld and when a soul dies in the Otherworld, it is reborn in this. Thus birth was greeted with mourning and death with exaltation by the ancient Celts."

Also celebrated in this section are the magical skills of the druids. They perceived time as an ever-expansive *now*, not as a linear construct. In this system all incarnations are concurrent, which makes comprehensible what is referred to in Celtic myth as shape-shifting. It was understood that an initiated druid had the power to assume shapes of animals or any living people in this world or any other. The stories in *Star* are full of tales of these polymorphous events, a marvelous example is Watho the witch in George MacDonald's superb tale *The Day Boy and the Night Girl*. Implicit within this system is an understanding that all things are imbued with sacred spirit—birds, deer, trees, stars, streams.

This final section marks the end of the pastoral year. This is a time of great spiritual intensity for the Celts—a time they believed the Otherworld became visible to man. We end our journey with tales of the fairy hosts as they manifest in the season of Samhain (SAV-awn). *Star* represents the final part of the year and the life cycle. Its selections communicate the wisdom born of reflection found in this last season of the year.

INSTRUCTIONS OF A KING

CORMAC MACART

Irish

James I of Scotland (1394-1437), Anonymous. Oil on panel, 14th century.

I was a listener in woods,
I was a gazer at stars,
I was blind where secrets were concerned,
I was silent in a wilderness,
I was talkative among many,
I was mild in the mead-hall,
I was stern in the battle,
I was gentle towards allies,
I was a physician of the sick,
I was weak towards the feeble,
I was strong towards the powerful,
I was not close lest I should be burdensome,
I was not arrogant though I was wise,
I was not given to promising though I was strong,
I was not venturesome though I was swift,
I did not deride the old though I was young,
I was not boastful though I was a good fighter,
I would not speak of anyone in his absence,
I would not reproach, but I would praise,
I would not ask, but I would give,
For it is through these habits that the young become
 old and kingly warriors.

Do not deride the old, though you are young;
Nor the poor, though you are wealthy;
Nor the lame, though you are swift;
Nor the blind, though you are given sight;
Nor the sick, though you are strong;
Nor the dull, though you are clever;
Nor the foolish, though you are wise.

Be not too wise, be not too foolish;
Be not too conceited, be not too diffident;
Be not too haughty, be not too humble;
Be not too talkative, be not too silent;
Be not too harsh, be not too feeble.

If you be too wise, they will expect (too much) of you;
If you be too foolish, you will be deceived;
If you be too conceited, you will be thought vexatious;
If you be too humble, you will be without honor;
If you be too talkative, you will not be heeded;
If you be too silent, you will not be regarded;
If you be too harsh, you will be broken;
If you be too feeble, you will be crushed.

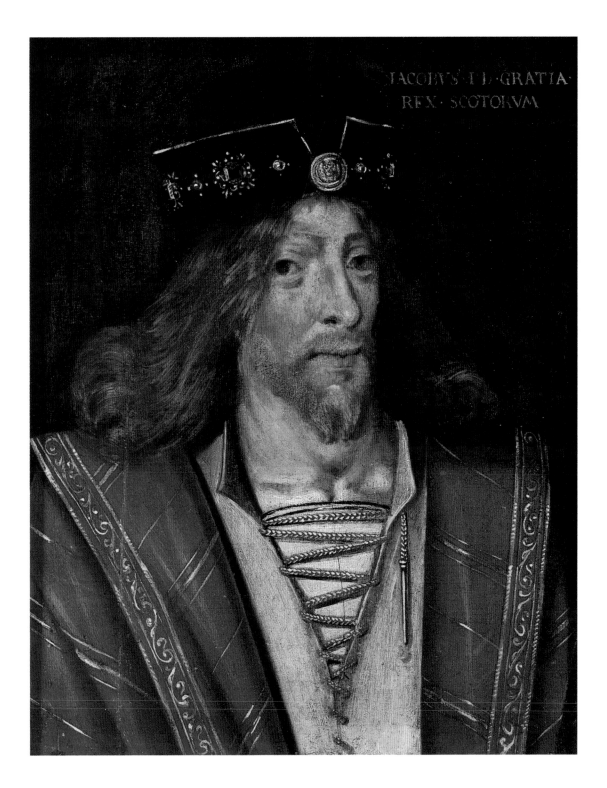

Within the image: JACOBVS·I·D·GRATIA REX·SCOTORVM

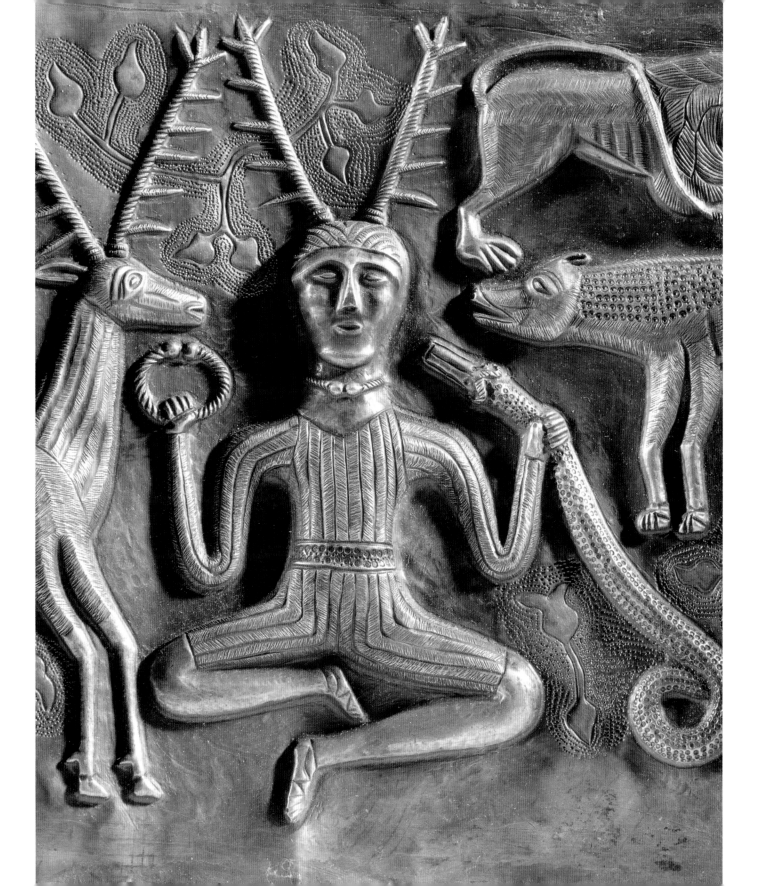

"Wisdom of serpent be thine,
Wisdom of raven be thine,
Wisdom of valiant eagle be thine"
—Gaelic Scottish Prayer

SERPENT'S TAIL

Robert Graves

English

When you are old as I now am

I shall be young as you, my lamb;

For lest love's timely force should fail

The Serpent swallows his own tail.

Detail of Gundestrup
cauldron, inner plate.
Celtic shaman holding a
snake and torque amidst
animals, Irish. Embossed
silver, gilded, 1st–2nd
century B.C.E.

AND DEATH SHALL HAVE NO DOMINION

Dylan Thomas

Welsh

And death shall have no dominion.
Dead men naked they shall be one
With the man in the wind and the west moon;
When their bones are picked clean and the clean bones gone,
They shall have stars at elbow and foot;
Though they go mad they shall be sane,
Though they sink through the sea they shall rise again;
Though lovers be lost love shall not;
And death shall have no dominion.

And death shall have no dominion.
Under the windings of the sea
They lying long shall not die windily;
Twisting on racks when sinews give way,
Strapped to a wheel, yet they shall not break;
Faith in their hands shall snap in two,
And the unicorn evils run them through;
Split all ends up they shan't crack;
And death shall have no dominion.

And death shall have no dominion.
No more may gulls cry at their ears
Or waves break loud on the seashores;
Where blew a flower may a flower no more
Lift its head to the blows of the rain;
Though they be mad and dead as nails,
Heads of the characters hammer through daisies;
Break in the sun till the sun breaks down,
And death shall have no dominion.

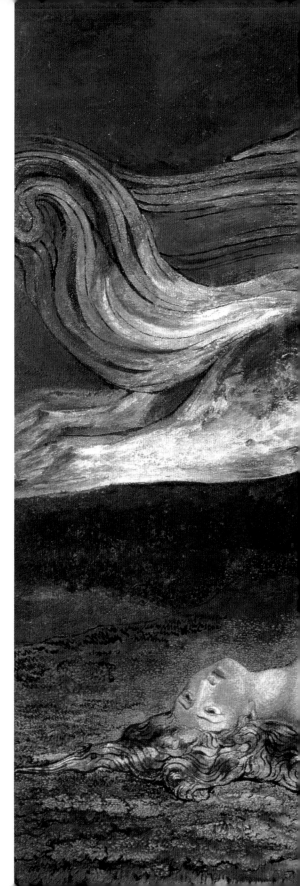

Pity, William Blake (1757–1827), English. Watercolor on paper, c. 1795.

158

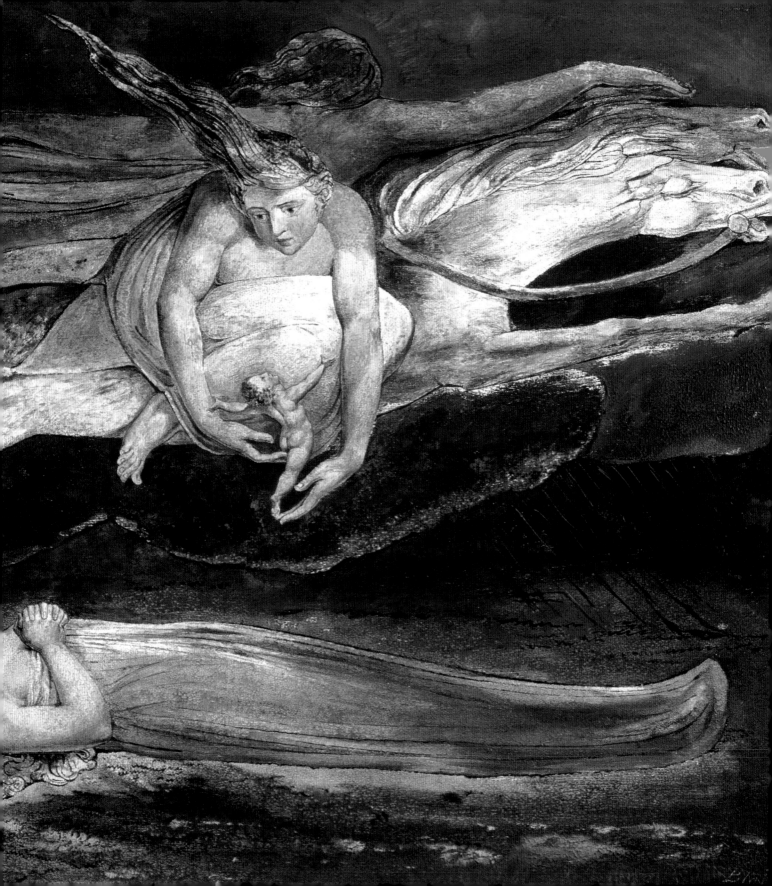

THE COMING OF WISDOM WITH TIME

WILLIAM BUTLER YEATS

Irish

Though leaves are many, the root is one;

Through all the lying days of my youth

I swayed my leaves and flowers in the sun;

Now I may wither into the truth.

The Green Man at Seedtime, Glyn Morgan (living artist), Welsh. Oil on canvas, 1996.

Harvest, Ceri Richards
(1903-1971), Welsh.
Oil on canvas, 1969.

EXCERPT FROM *ANCIENT LEGENDS OF IRELAND*

THE PROPERTIES OF HERBS AND THEIR USE IN MEDICINE

Lady Francesca Speranza Wilde

Irish

The Irish, according to the saying of a wise man of the race, are the last of the 305 great Celtic nations of antiquity spoken of by Josephus, the Jewish historian; and they alone preserve inviolate the ancient venerable language, minstrelsy, and Bardic traditions, with the strange and mystic secrets of herbs, through whose potent powers they can cure disease, cause love or hatred, discover the hidden mysteries of life and death, and dominate over the fairy wiles of the malific demons.

The ancient people used to divine future events, victory in wars, safety in a dangerous voyage, triumph of a projected undertaking, success in love, recovery from sickness, or the approach of death; all through the skillful use of herbs, the knowledge of which had come down to them through the earliest traditions of the human race. One of these herbs, called the *Fairy-plant*, was celebrated for its potent power of divination; but only the adepts knew the mystic manner of its preparation for use.

There are seven herbs that nothing natural, or supernatural can injure; they are vervain, John's-wort, speedwell, eyebright, mallow, yarrow, and self-help. But they must be pulled at noon on a bright day, near the full of the moon, to have full power.

It is firmly believed that the herb-women who perform curses receive their knowledge from the fairies, who impart to them the mystical secrets of herbs and where to find them; but these secrets must not be revealed except on the death-bed, and then only to the eldest of the family. Many mysterious rites are practised in the making and the giving of potions; and the messenger who carries the draught to the sufferer must never look behind him nor utter a word till he hands the medicine to the patient, who instantly swallows a cup of the mixture before other hands have touched it.

A celebrated doctor in the south was an old woman, who had lived seven years with the fairies. She performed wonderful cures, and only required a silver tenpence to be laid on her table for the advice given and for the miraculous herb potion.

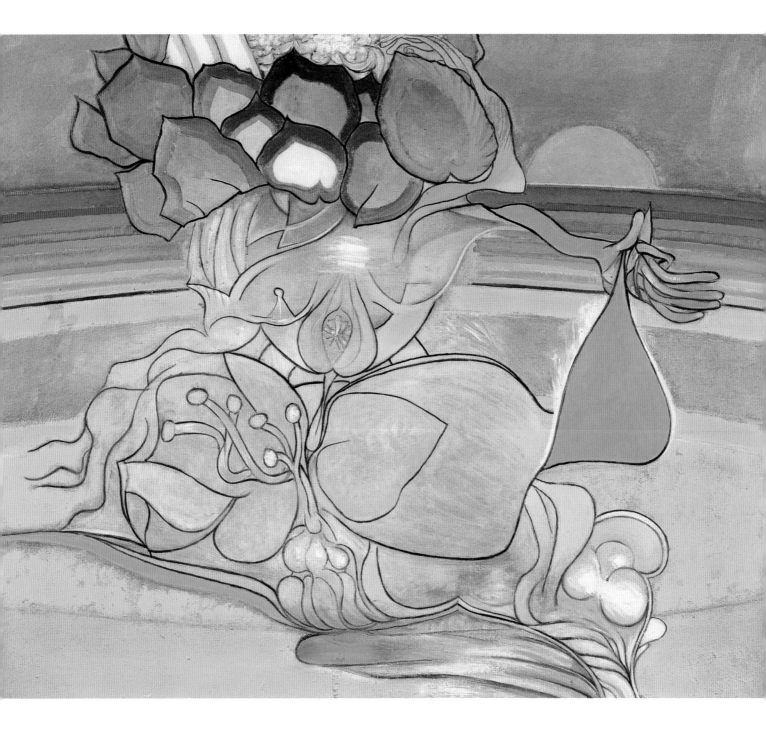

Bronze helmet from
northern Great Britain.
6th century B.C.E.

THE CRANE BAG

Anonymous, 12th century

Irish, translated by Eoin Macneill

I have a question for thee, Caoilte, man of the interchanged weapons: to whom did the good Crane-bag belong that Cumhall son of Tréanmhór had?

A crane that belonged to gentle Manannán—it was a treasure of power with many virtues—from its skin, strange thing to prize—from it was made the Crane-bag.

Tell us what was the crane, my Caoilte of many exploits, or, tell us, man, why its skin was put about the treasures.

Aoife, daughter of dear Dealbhaoth, sweetheart of Ilbhreac of many beauties—both she and Iuchra of comely hue fell in love with the man.

Iuchra, enraged, beguiled Aoife to come swimming, it was no happy visit: when she drove her fiercely forth in the form of a crane over the moorlands.

Aoife then demanded of the beautiful daughter of Abhartach: 'How long am I to be in this form, woman, beautiful breast-white Iuchra?'

'The term I will fix will not be short for thee, Aoife of the slow-glancing eyes: thou shalt be two hundred white years in the noble house Manannán.

'Thou shalt be always in that house with everyone mocking thee, a crane that does not visit every land: thou shalt not reach any land.

'A good vessel of treasures will be made of thy skin—no small event: its name shall be—I do not lie—in distant times the Crane-bag.'

Manannán made this of the skin when she died: afterwards in truth it held every precious thing he had.

The shirt of Manannán and his knife, and Goibhne's girdle, altogether: a smith's hook from the fierce man: were treasures that the Crane-bag held.

The King of Scotland's shears full sure, and the King of Lochlainn's helmet, these were in it to be told of, and the bones of Asal's swine.

A girdle of the great whale's back was in the shapely Crane-bag: I will tell thee without harm, it used to be carried in it.

When the sea was full, its treasures were visible in its middle: when the fierce sea was in ebb, the Crane-bag in turn was empty.

There thou hast it, noble Oisin, how this thing itself was made: and now I shall tell its faring, its happenings.

Long time the Crane-bag belonged to heroic Lugh Long-arm: till at last the king was slain by the sons of Cearmaid Honey-mouth.

To them next the Crane-bag belonged after him, till the three, though active, fell by the great sons of Mile.

Manannán came without weariness, carried off the Crane-bag again: he showed it to no man till the time of Conaire came.

Comely Conaire slept on the side of Tara of the plains: when the cunning well-made man awoke, the Crane-bag was found about his neck.

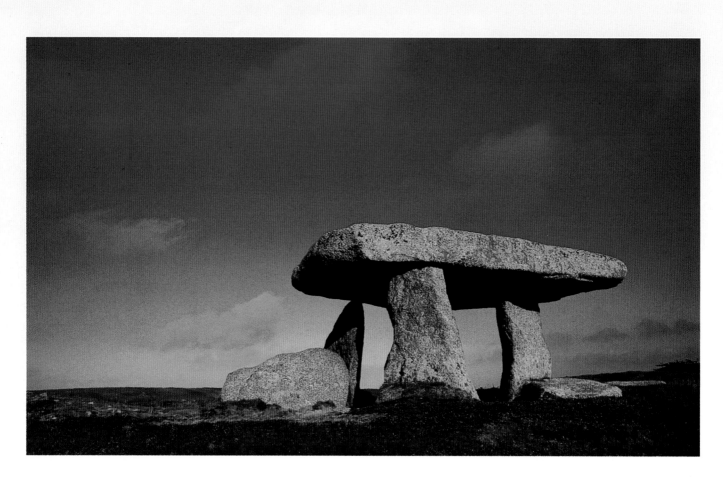

Megaliths-Lanyon Quoit,
Cornwall.

FERGUS AND THE DRUID

William Butler Yeats

Irish

Fergus. This whole day have I followed in the rocks,
And you have changed and flowed from shape to shape,
First as a raven on whose ancient wings
Scarcely a feather lingered, then you seemed
A weasel moving on from stone to stone,
And now at last you wear a human shape,
A thin grey man half lost in gathering night.

Druid. What would you, king of the proud Red Branch kings?

Fergus. This would I say, most wise of living souls:
Young subtle Conchubar sat close by me
When I gave judgment, and his words were wise,
And what to me was burden without end,
To him seemed easy, so I laid the crown
Upon his head to cast away my sorrow.

Druid. What would you, king of the proud Red Branch kings?

Fergus. A king and proud! and that is my despair.
I feast amid my people on the hill,
And pace the woods, and drive my chariot-wheels
In the white border of the murmuring sea;
And still I feel the crown upon my head.

Druid. What would you, Fergus?

Fergus. Be no more a king,
But learn the dreaming wisdom that is yours.

Druid. Look on my thin grey hair and hollow cheeks
And on these hands that may not lift the sword,
This body trembling like a wind-blown reed.
No woman's loved me, no man sought my help.

Fergus. A king is but a foolish labourer
Who wastes his blood to be another's dream.

Druid. Take, if you must, this little bag of dreams:
Unloose the cord, and they will wrap you round.

Fergus. I see my life go drifting like a river
From change to change; I have been many things—
A green drop in the surge, a gleam of light
Upon a sword, a fir-tree on a hill,
An old slave grinding at a heavy quern,
A king sitting upon a chair of gold—
And all these things were wonderful and great;
But now I have grown nothing, knowing all
Ah! Druid, Druid, how great webs of sorrow
Lay hidden in the small slate-coloured thing!

THE LITTLE GIRL'S RIDDLE

Eva Gore-Booth

Irish

Jungle Tales, Sir James Jebusa Shannon (1862–1923), Irish. Oil on canvas, 1895.

A jelly-fish afloat on the bright wave—
A white seagull—a great blue butterfly—
A hunted hare—a wolf in a dark cave;
All these I was; which one of these was I?

A gold-maned lion, mad with rage and fear,
A white bear ranging over trackless snow,
A savage living by my bow and spear,
A mighty fighter giving blow for blow,

A student gazing at the starry skies,
A Rebel planning the downfall of Kings,
A searcher of the wisdom of the wise,
A questioner of all mysterious things,

A priestess singing hymns to Proserpine,
And old king weary on a golden throne,
A marble-carver freeing limbs divine
From their cold bondage of enfolding stone,

A hot-head poet by the world reviled,
A heretic of desolate dreams and dire,
And now a little silent long-legged child
Weeping alone beside the nursery fire.

Ye who have guessed the hidden lights that burn
Behind the blue wings of the butterfly,
In a child's grief the riddle's answer learn—
"I was all these—yet none of these was I."

THE CHILDREN OF LIR

Katharine Tynan

Irish

Out upon the sand-dunes thrive the coarse long grasses,
 Herons standing knee-deep in the brackish pool,
Overhead the sunset fire and flame amasses,
 And the moon to eastward rises pale and cool:
Rose and green around her, silver-grey and pearly,
 Chequered with the black rooks flying home to bed;
For, to wake at daybreak, birds must couch them early,
 And the day's a long one since the dawn was red.

On the chilly lakelet, in that pleasant gloaming,
 See the sad swans sailing: they shall have no rest:
Never a voice to greet them save the bittern's booming
 Where the ghostly sallows sway against the West.
"Sister," saith the grey swan, "Sister, I am weary,"
 Turning to the white swan wet, despairing eyes;
"O," she saith, "my young one. O," she saith, "my dearie,"
 Casts her wings about him with a storm of cries.

Woe for Lir's sweet children whom their vile stepmother
 Glamoured with her witch-spell for a thousand years;
Died their father raving, on this throne another,
 Blind before the end came from the burning tears.
Long the swans have wandered over lake and river.
 Gone is all the glory of the race of Lir,
Gone and long forgotten like a dream of fever;
 But the swans remember the sweet days that were.

Hugh, the black and white swan with the beauteous feathers,
 Fiachra, the black swan with the emerald breast,
Conn, the youngest, dearest, sheltered in all weathers,
 Him his snow-white sister loves the tenderest.
These her mother gave her as she lay a-dying
 To her faithful keeping; faithful hath she been,
With her wings spread o'er them when the tempest's crying,
 And her songs so hopeful when the sky's serene.

Other swans have nests made 'mid the reeds and rushes,
 Lined with downy feathers where the cygnets sleep
Dreaming, if a bird dreams, till the daylight blushes,
 Then they sail out swiftly on the current deep.
With the proud swan-father, tall, and strong, and stately,
 And the mild swan-mother, grave with household cares,
All well-born and comely, all rejoicing greatly:
 Full of honest pleasure is a life like theirs.

But alas! for my swans, with the human nature,
 Sick with human longings, starved for human ties,
With their hearts all human cramped to a bird's stature,
 And the human weeping in the bird's soft eyes,
Never shall my swans build nests in some green river,
 Never fly to Southward in the autumn grey,
Bear no tender children, love no mates for ever,
 Robbed alike of bird's joys and of man's are they.

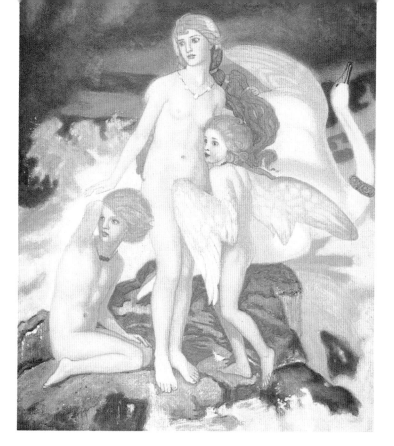

The Children of Lir,
John McKirdy Duncan,
(1866–1945), Irish.
Tempera on canvas.

Babbles Conn the youngest, "Sister, I remember
 At my father's palace how I went in silk,
Ate the juicy deer-flesh roasted from the ember,
 Drank from golden goblets my child's draught of milk.
Once I rode a-hunting, laughed to see the hurly,
 Shouted at the ball-play, on the lake did row;
You had for your beauty gauds that shone so rarely."
 "Peace," saith Fionnuala, "that was long ago."

"Sister," saith Fiachra, "well do I remember
 How the flaming torches lit the banquet-hall
And the fire leapt skyward in the mid-December,
 And among the rushes slept our stag-hounds tall.
By our father's right hand you sat shyly gazing,
 Smiling half and sighing, with your eyes aglow,
As the bards sang loudly, all your beauty praising."
 "Peace," saith Fionnuala, "that was long ago."

"Sister," then saith Hugh, "most do I remember
 One I called my brother, one, earth's goodliest man,
Strong as forest oaks are where the wild vines clamber,
 First at feast or hunting, in the battle's van.
Angus, you were handsome, wise and true, and tender,
 Loved by every comrade, feared by every foe:
Low, low, lies your beauty, all forgot your splendour."
 "Peace," saith Fionnuala, "that was long ago."

Dews are in the clear air, and the roselight paling,
 Over sands and sedges shines the evening star,
And the moon's disc lonely high in heaven is sailing,
 Silvered all the spear-heads of the rushes are,—
Housèd warm are all things as the night grows colder,
 Water-fowl and sky-fowl dreamless in the nest;
But the swans go drifting, drooping wing and shoulder
 Cleaving the still water where the fishes rest.

KING CORMAC'S VISION

Anonymous, 8th century

Irish

. . . a shining fountain, with five streams flowing out of it, and the hosts in turn drinking its water. Nine hazels of Buan grew over the well. The purple hazels dropped their nuts into the fountain, and five salmon which were in the fountain severed them and sent their husks floating down the streams.

THE VISION EXPLAINED

The fountain which thou sawest, with the five streams are the five senses through which knowledge is obtained. And no one will have knowledge who drinks not a draught out of the fountain itself and out of the streams. The folk of many arts are those who drink of them both.

Ice-Fields, Gwen O'Dowd (living artist), Irish. Oil on paper, 1990.

THE BOYHOOD OF FIONN

James Stephens

Irish

CHAPTER IX

All desires save one are fleeting, but that one lasts for ever. Fionn, with all desires, had the lasting one, for he would go anywhere and forsake anything for wisdom; and it was in search of this that he went to the place where Finegas lived on a bank of the Boyne Water. But for dread of the clann-Morna he did not go as Fionn. He called himself Deimne on that journey.

We get wise by asking questions, and even if these are not answered we get wise, for a well-packed question carries its answer on its back as a snail carries its shell. Fionn asked every question he could think of, and his master, who was a poet, and so an honourable man, answered them all, not to the limit of his patience, for it was limitless, but to the limit of his ability.

"Why do you live on the bank of a river?" was one of these questions.

"Because a poem is a revelation, and it is by the brink of running water that poetry is revealed to the mind."

"How long have you been here?" was the next query.

"Seven years," the poet answered.

"It is a long time," said wondering Fionn.

"I would wait twice as long for a poem," said the inveterate bard.

"Have you caught good poems?" Fionn asked him.

"The poems I am fit for," said the mild master. "No person can get more than that, for a man's readiness is his limit."

"Would you have got as good poems by the Shannon or the Suir or by sweet Ana Lifé?"

"They are good rivers," was the answer. "They all belong to good gods."

"But why did you choose this river out of all the rivers?"

Finegas beamed on his pupil.

"I would tell you anything," said he, "and I will tell you that."

Fionn sat at the kindly man's feet, his hands absent among tall grasses, and listening with all his ears.

"A prophecy was made to me," Finegas began. "A man of knowledge foretold that I should catch the Salmon of Knowledge in the Boyne Water."

"And then?" said Fionn eagerly.

"Then I would have All Knowledge."

"And after that?" the boy insisted.

"What should there be after that?" the poet retorted.

"I mean, what would you do with All Knowledge?"

"A weighty question," said Finegas smilingly. "I could answer it if I had All Knowledge, but not until then. What would you do, my dear?"

"I would make a poem," Fionn cried.

"I think too," said the poet, "that that is what would be done."

In return for instruction Fionn had taken over the service of his master's hut, and as he went about the household duties, drawing the water, lighting the fire, and carrying rushes for the floor and the beds, he thought over all the poet had taught him, and his mind dwelt on the rules of metre, the cunningness of words, and the need for a clean, brave mind. But in his thousand thoughts he yet remembered the Salmon of Knowledge as eagerly as his master did. He already venerated Finegas for his great learning, his poetic skill, for a hundred reasons; but, looking on him as the ordained eater of the Salmon of Knowledge, he venerated him to the edge of measure. Indeed, he loved as well as venerated this master because of his unfailing kindness, his patience, his readiness to teach, and his skill in teaching.

"I have learned much from you, dear master," said Fionn gratefully.

"All that I have is yours if you can take it," the poet answered, "for you are entitled to all that you can take, but to no more than that. Take, so, with both hands."

"You may catch the salmon while I am with you," the hopeful boy mused. "Would not that be a great happening!" and he stared in ecstasy across the grass at those visions which a boy's mind knows.

"Let us pray for that," said Finegas fervently.

"Here is a question," Fionn continued. "How does this salmon get wisdom into his flesh?"

"There is a hazel bush overhanging a secret pool in a secret place. The Nuts of Knowledge drop from the Sacred Bush into the pool, and as they float, a salmon takes them in his mouth and eats them."

"It would be almost as easy," the boy submitted, "if one were to set on the track of the Sacred Hazel and eat the nuts straight from the bush."

"That would not be very easy," said the poet, "and yet it is not as easy as that, for the bush can only be found by its own knowledge, and that knowledge can only be got by eating the nuts, and the nuts can only be got by eating the salmon."

"We must wait for the salmon," said Fionn in a rage of resignation.

CHAPTER X

Life continued for him in a round of timeless time, wherein days and nights were uneventful and were yet filled with interest. As the day packed its load of strength into his frame, so it added its store of knowledge to his mind, and each night sealed the twain, for it is in the night that we make secure what we have gathered in the day.

If he had told of these days he would have told of a succession of meals and sleeps, and of an endless conversation, from which his mind would now and again slip away to a solitude of its own, where, in large hazy atmospheres, it swung and drifted and reposed. Then he would be back again, and it was a pleasure for him to catch up on the thought that was forward and re-create for it all the matter he had missed. But he could not often make these sleepy sallies; his master was too experienced a teacher to allow any such bright-faced, eager-eyed abstractions, and as the druid women had switched his legs around a tree, so Finegas chased his mind, demanding sense in his questions and understanding in his replies.

To ask questions can become the laziest and wobbliest occupation of a mind, but when you must yourself answer the problem that you have posed, you will meditate your question with care and frame it with precision. Fionn's mind learned to jump in a bumpier field than that in which he had chased rabbits. And when he had asked his question, and given his own answer to it, Finegas would take the matter up and make clear to him where the query was badly formed or at what point the answer had begun to go astray, so that Fionn came to understand by what successions a good question grows at last to a good answer.

One day, not long after the conversation told of, Finegas came to the place where Fionn was. The poet had a shallow osier basket on his arm, and on his face there was a look that was at once triumphant and gloomy. He was excited certainly, but he was sad also, and as he stood gazing on Fionn his eyes were so kind that the boy was touched, and they were yet so melancholy that it almost made Fionn weep.

"What is it, my master?" said the alarmed boy.

The poet placed his osier basket on the grass.

"Look in the basket, dear son," he said.

Fionn looked.

"There is a salmon in the basket."

"It is The Salmon," said Finegas with a great sigh.

Fionn leaped for delight.

"I am glad for you, master," he cried. "Indeed I am glad for you."

"And I am glad, my dear soul," the master rejoined.

But, having said it, he bent his brow to his hand and for a long time he was silent and gathered into himself.

"What should be done now?" Fionn demanded, as he stared on the beautiful fish.

Finegas rose from where he sat by the osier basket.

"I will be back in a short time," he said heavily. "While I am away you may roast the salmon, so that it will be ready against my return."

"I will roast it indeed," said Fionn.

The poet gazed long and earnestly on him.

"You will not eat any of my salmon while I am away?" he asked.

"I will not eat the littlest piece," said Fionn.

"I am sure you will not," the other murmured, as he turned and walked slowly across the grass and behind the sheltering bushes on the ridge.

Fionn cooked the salmon. It was beautiful and tempting and savoury as it smoked on a wooden platter among cool green leaves; and it looked all these to Finegas when he came from behind the fringing bushes and sat in the grass outside his door. He gazed on the fish with more than his eyes. He looked on it with his heart, with his soul in his eyes, and when he turned to look on Fionn the boy did not know whether the love that was in his eyes was for the fish or for himself. Yet he did know that a great moment had arrived for the poet.

"So," said Finegas, "you did not eat it on me after all?"

"Did I not promise?" Fionn replied.

"And yet," his master continued, "I went away so that you might eat the fish if you felt you had to."

"Why should I want another man's fish?" said proud Fionn.

"Because young people have strong desires. I thought you might have tasted it, and then you would have eaten it on me."

"I did taste it by chance," Fionn laughed, "for while the fish was roasting a great blister rose on its skin. I did not like the look of that blister, and I pressed it down with my thumb. That burned my thumb, so I popped it in my mouth to heal the smart. If your salmon tastes as nice as my thumb did," he laughed, "it will taste very nice."

"What did you say your name was, dear heart?" the poet asked.

"I said my name was Deimne."

"Your name is not Deimne," said the mild man, "your name is Fionn."

"That is true," the boy answered, "but I do not know how you know it."

"Even if I have not eaten the Salmon of Knowledge I have some small science of my own."

"It is very clever to know things as you know them," Fionn replied wonderingly. "What more do you know of me, dear master?"

"I know that I did not tell you the truth," said the heavy-hearted man.

"What did you tell me instead of it?"

"I told you a lie."

"It is not a good thing to do," Fionn admitted. "What sort of a lie was the lie, master?"

"I told you that the Salmon of Knowledge was to be caught by me, according to the prophecy."

"Yes."

"That was true indeed, and I have caught the fish. But I did not tell you that the salmon was not to be eaten by me, although that also was in the prophecy, and that omission was the lie."

"It is not a great lie," said Fionn soothingly.

"It must not become a greater one," the poet replied sternly.

"Who was the fish given to?" his companion wondered.

"It was given to you," Finegas answered. "It was given to Fionn, the son of Uail, the son of Baiscne, and it will be given to him."

"You shall have a half of the fish," cried Fionn.

"I will not eat a piece of its skin that is as small as the point of its smallest bone," said the resolute and trembling bard. "Let you now eat up the fish, and I shall watch you and give praise to the gods of the Underworld and of the Elements."

Fionn then ate the Salmon of Knowledge, and when it had disappeared a great jollity and tranquility and exuberance returned to the poet.

"Ah," said he, "I had a great combat with that fish."

"Did it fight for its life?" Fionn inquired.

"It did, but that was not the fight I meant."

"You shall eat a Salmon of Knowledge too," Fionn assured him.

"You have eaten one," cried the blithe poet, "and if you make such a promise it will be because you know."

"I promise it and know it," said Fionn, "you shall eat a Salmon of Knowledge yet."

THE SELFISH GIANT

Oscar Fingall O'Flahertie Willis Wilde

Irish

Tree in Blossom, Peter Davidson (living artist), Welsh. Pastel on paper, 1997.

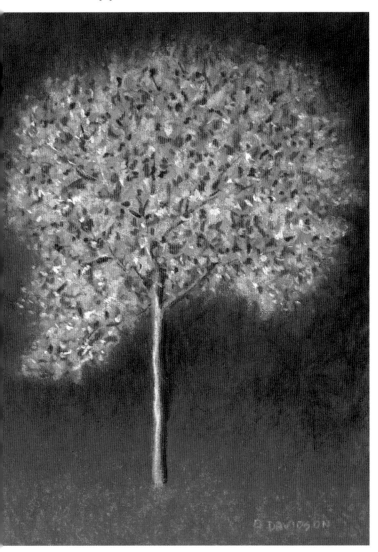

Every afternoon, as they were coming from school, the children used to go and play in the Giant's garden.

It was a large lovely garden, with soft green grass. Here and there over the grass stood beautiful flowers like stars, and there were twelve peach-trees that in the spring-time broke out into delicate blossoms of pink and pearl, and in the autumn bore rich fruit. The birds sat on the trees and sang so sweetly that the children used to stop their games in order to listen to them. "How happy we are here!" they cried to each other.

One day the Giant came back. He had been to visit his friend the Cornish ogre, and had stayed with him for seven years. After the seven years were over he had said all that he had to say, for his conversation was limited, and he determined to return to his own castle. When he arrived he saw the children playing in the garden.

"What are you doing here?" he cried in a very gruff voice, and the children ran away.

"My own garden is my own garden," said the Giant; "any one can understand that, and I will allow nobody to play in it but myself." So he built a high wall all round it, and put up a notice-board.

TRESPASSERS
WILL BE
PROSECUTED

He was a very selfish Giant.

The poor children had now nowhere to play. They tried to play on the road, but the road was very dusty and full of hard

stones, and they did not like it. They used to wander round the high wall when their lessons were over, and talk about the beautiful garden inside. "How happy we were there," they said to each other.

Then the Spring came, and all over the country there were little blossoms and little birds. Only in the garden of the Selfish Giant it was still winter. The birds did not care to sing in it as there were no children, and the trees forgot to blossom. Once a beautiful flower put its head out from the grass, but when it saw the notice-board it was so sorry for the children that it slipped back into the ground again, and went off to sleep. The only people who were pleased were the Snow and the Frost. "Spring has forgotten this garden," they cried, "so we will live here all the year round." The Snow covered up the grass with her great white cloak, and the Frost painted all the trees silver. Then they invited the North Wind to stay with them, and he came. He was wrapped in furs, and he roared all day about the garden, and blew the chimney-pots down. "This is a delightful spot," he said, "we must ask the Hail on a visit." So the Hail came. Every day for three hours he rattled on the roof of the castle till he broke most of the slates, and then he ran round and round the garden as fast as he could go. He was dressed in grey, and his breath was like ice.

"I cannot understand why the Spring is so late in coming," said the Selfish Giant, as he sat at the window and looked out at his cold white garden; "I hope there will be a change in the weather."

But the Spring never came, nor the Summer. The Autumn gave golden fruit to every garden, but to the Giant's garden she gave none. "He is too selfish," she said. So it was always Winter there, and the North Wind, and the Hail, and the Frost, and the Snow danced about through the trees.

One morning the Giant was lying awake in bed when he heard some lovely music. It sounded so sweet to his ears that he thought it must be the King's musicians passing by. It was really only a little linnet singing outside his window, but it was so long since he had heard a bird sing in his garden that it seemed to him to be the most beautiful music in the world. Then the Hail stopped dancing over his head, and the North Wind ceased roaring, and a delicious perfume came to him through the open casement. "I believe the Spring has come at last," said the Giant; and he jumped out of bed and looked out.

What did he see?

He saw a most wonderful sight. Through a little hole in the wall the children had crept in, and they were sitting in the branches of the trees. In every tree that he could see there was a little child. And the trees were so glad to have the children back again that they had covered themselves with blossoms, and were waving their arms gently above the children's heads. The birds were flying about and twittering with delight, and the flowers were looking up through the green grass and laughing. It was a lovely scene, only in one corner it was still winter. It was the farthest corner of the garden, and in it was standing a little boy. He was so small that he could not reach up to the branches of the tree, and he was wandering all round it crying bitterly. The poor tree was still quite covered with frost and snow, and the North Wind was blowing and roaring above it. "Climb up! little boy," said the Tree, and it bent its branches down as low as it could; but the boy was too tiny.

And the Giant's heart melted as he looked out. "How selfish I have been!" he said; "now I know why the Spring would not come here. I will put that poor little boy on the top of the tree, and then I will knock down the wall, and my garden shall be the children's playground for ever and ever." He was really very sorry for what he had done.

So he crept downstairs and opened the front door quite softly, and went out into the garden. But when the children saw him they were so frightened that they all ran away, and the garden became winter again. Only the little boy did not run, for his eyes were so full of tears that he did not see the Giant coming. And the Giant stole up behind him and took him gently in his hand, and put him up into the tree. And the tree broke at once into blossom, and the birds came and sang on it, and the little boy stretched out his two arms and flung them round the Giant's neck, and kissed him. And the other children, when they saw that the Giant was not wicked any longer, came running back, and with them came the Spring. "It is your garden now, little children," said the Giant, and he took a great axe and knocked down the wall. And when the people were going to market at twelve o'clock they found the Giant playing with the children in the most beautiful garden they had ever seen.

All day long they played, and in the evening they came to the Giant to bid him good-bye.

"But where is your little companion?" he said: "the boy I put into the tree." The Giant loved him the best because he had kissed him.

"We don't know," answered the children; "he has gone away."

"You must tell him to be sure and come here tomorrow," said the Giant. But the children said that they did not know where he lived, and had never seen him before; and the Giant felt very sad.

Every afternoon, when school was over, the children came and played with the Giant. But the little boy whom the Giant loved was never seen again. The Giant was very kind to all the children, yet he longed for his first little friend, and often spoke of him. "How I would like to see him!" he used to say.

Years went over, and the Giant grew very old and feeble. He could not play about any more, so he sat in a huge armchair, and watched the children at their games, and admired his garden. "I have many beautiful flowers," he said; "but the children are the most beautiful flowers of all."

One winter morning he looked out of his window as he was dressing. He did not hate the Winter now, for he knew that it was merely the Spring asleep, and that the flowers were resting.

Suddenly he rubbed his eyes in wonder, and looked and looked. It certainly was a marvellous sight. In the farthest corner of the garden was a tree quite covered with lovely white blossoms. Its branches were all golden, and silver fruit hung down from them, and underneath it stood the little boy he had loved.

Downstairs ran the Giant in great joy, and out into the garden. He hastened across the grass, and came near to the child. And when he came quite close his face grew red with anger, and he said, "Who hath dared to wound thee?" For on the palms of the child's hands were the prints of two nails, and the prints of two nails were on the little feet.

"Who hath dared to wound thee?" cried the Giant; "tell me, that I may take my big sword and slay him."

"Nay!" answered the child; "but these are the wounds of Love."

"Who art thou?" said the Giant, and a strange awe fell on him, and he knelt before the little child.

And the child smiled on the Giant, and said to him, "You let me play once in your garden, to-day you shall come with me to my garden, which is Paradise."

And when the children ran in that afternoon, they found the Giant lying dead under the tree, all covered with white blossoms.

Summertime, Walter Frederick Osborne (1859–1903), Irish. Oil on canvas, 1901.

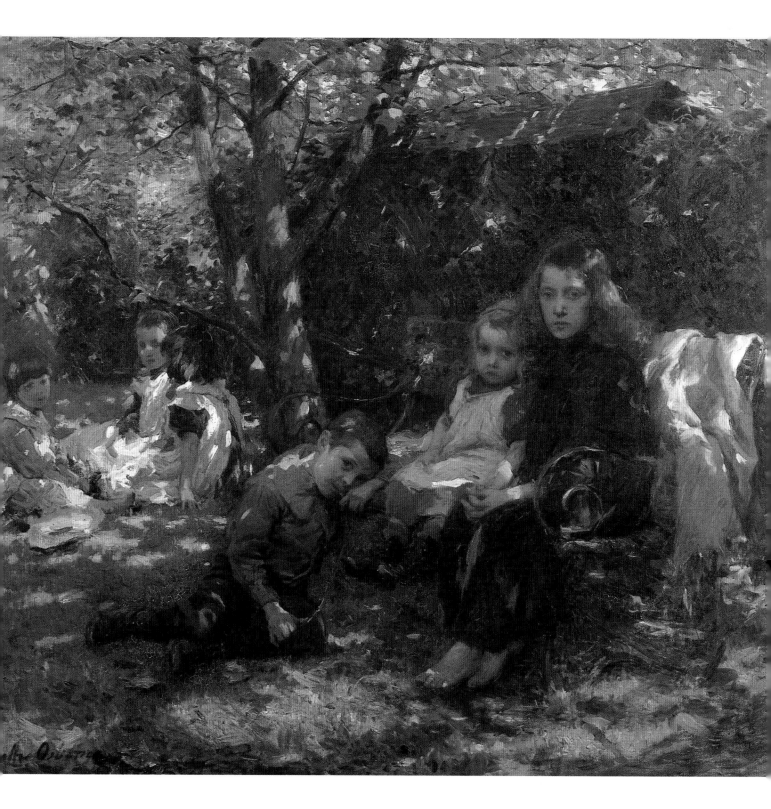

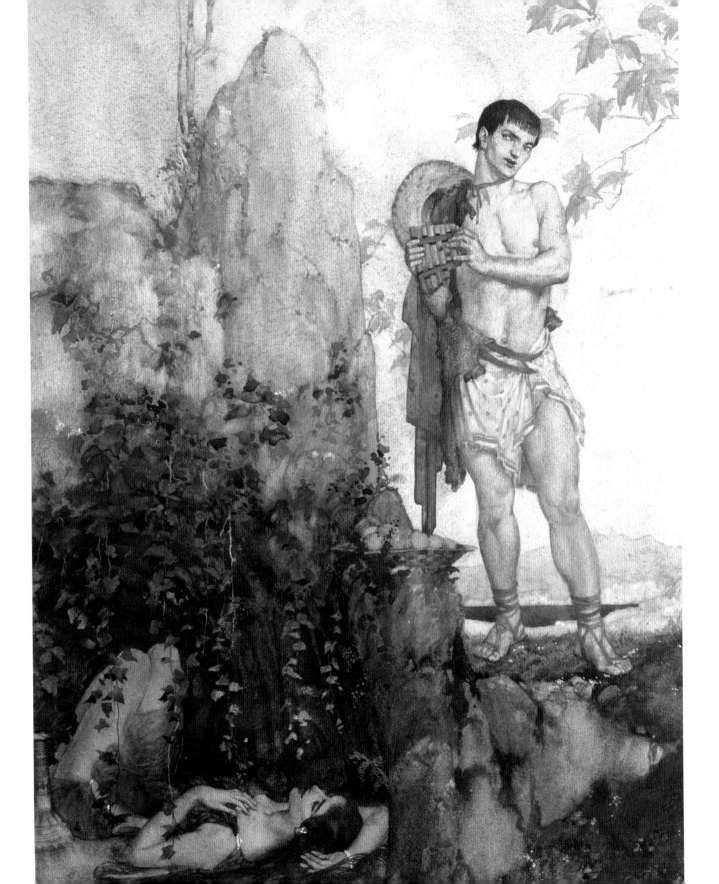

THE DAY BOY AND THE NIGHT GIRL

George MacDonald

Scottish

WATHO

There was once a witch who desired to know everything. But the wiser a witch is, the harder she knocks her head against the wall when she comes to it. Her name was Watho, and she had a wolf in her mind. She cared for nothing in itself—only for knowing it. She was not naturally cruel, but the wolf had made her cruel.

She was tall and graceful, with a white skin, red hair, and black eyes, which had a red fire in them. She was straight and strong, but now and then would fall bent together, shudder, and sit for a moment with her head turned over her shoulder, as if the wolf had got out of her mind onto her back.

AURORA

This witch got two ladies to visit her. One of them belonged to the court, and her husband had been sent on a far and difficult embassy. The other was a young widow, whose husband had lately died and who had since lost her sight. Watho lodged them in different parts of her castle, and they did not know of each other's existence.

The castle stood on the side of a hill sloping gently down into a narrow valley, in which was a river, with a pebbly channel and a continual song. The garden went down to the bank of the river, enclosed by high walls, which crossed the river and there stopped. Each wall had a double row of battlements, and between the rows was a narrow walk.

In the topmost story of the castle the Lady Aurora occupied a spacious apartment of several large rooms looking southward. The windows projected oriel-wise over the garden below, and there was a splendid view from them both up and down and across the river. The opposite side of the valley was steep, but not very high. Far away, snow peaks were visible. These rooms Aurora seldom left, but their airy spaces, the brilliant landscape and sky, the plentiful sunlight, the musical instruments, books, pictures, curiosities, with the company of Watho, who made herself charming, precluded all dullness. She had venison and feathered game to eat, milk and pale sunny sparkling wine to drink.

She had hair of the yellow gold, waved and rippled; her skin was fair, not white like Watho's, and her eyes were of the blue of the heavens when bluest; her features were delicate but strong, her mouth large and finely curved, and haunted with smiles.

VESPER

Behind the castle the hill rose abruptly; the northeastern tower, indeed, was in contact with the rock and communicated with the interior of it. For in the rock was a series of chambers, known only to Watho and the one servant whom she trusted, called Falca. Some former owner had constructed these chambers after the tomb of an Egyptian king and probably with the same design, for in the center of one of them stood what could only be a sarcophagus, but that and others were walled off. The sides and roofs of them were carved in low relief and curiously painted. Here the witch lodged the blind lady, whose name was Vesper. Her eyes were black, with long black lashes; her skin had a look of darkened silver, but was of purest tint and grain; her hair was black and fine and straight-flowing; her features were exquisitely formed, and if less beautiful yet more lovely from sadness; she always looked as if she wanted to lie down and not rise again. She did not know she was lodged in a tomb, though now and then she wondered she never touched a

window. There were many couches, covered with richest silk, and soft as her own cheek, for her to lie upon; and the carpets were so thick she might have cast herself down anywhere—as befitted a tomb. The place was dry and warm, and cunningly pierced for air, so that it was always fresh, and lacked only sunlight. There the witch fed her upon milk, and wine dark as a carbuncle, and pomegranates, and purple grapes, and birds that dwell in marshy places; and she played to her mournful tunes, and caused wailful violins to attend her, and told her sad tales, thus holding her ever in an atmosphere of sweet sorrow.

PHOTOGEN

Watho at length had her desire, for witches often get what they want; a splendid boy was born to the fair Aurora. Just as the sun rose, he opened his eyes. Watho carried him immediately to a distant part of the castle and persuaded the mother that he never cried but once, dying the moment he was born. Overcome with grief, Aurora left the castle as soon as she was able, and Watho never invited her again.

And now the witch's care was that the child should not know darkness. Persistently she trained him until at last he never slept during the day and never woke during the night. She never let him see anything black, and even kept all dull colors out of his way. Never, if she could help it, would she let a shadow fall upon him, watching against shadows as if they had been live things that would hurt him. All day he basked in the full splendor of the sun, in the same large rooms his mother had occupied. Watho used him to the sun, until he could bear more of it than any dark-blooded African. In the hottest of every day, she stripped him and laid him in it, that he might ripen like a peach; and the boy rejoiced in it, and would resist being dressed again. She brought all her knowledge to bear on making his muscles strong and elastic and swiftly responsive— that his soul, she said laughingly, might sit in every fiber, be all in every part, and awake the moment of call. His hair was of the red gold, but his eyes grew darker as he grew, until they were as black as Vesper's. He was the merriest of creatures, always laughing, always loving, for a moment raging, then laughing afresh. Watho called him Photogen.

NYCTERIS

Five or six months after the birth of Photogen, the dark lady also gave birth to a baby; in the windowless tomb of a blind mother, in the dead of night, under the feeble rays of a lamp in an alabaster globe, a girl came into the darkness with a wail. And just as she was born for the first time, Vesper was born for the second, and passed into a world as unknown to her as this was to her child—who would have to be born yet again before she could see her mother.

Watho called her Nycteris, and she grew as like Vesper as possible—in all but one particular. She had the same dark skin, dark eyelashes and brows, dark hair, and gently sad look; but she had just the eyes of Aurora, the mother of Photogen, and if they grew darker as she grew older, it was only a darker blue. Watho, with the help of Falca, took the greatest possible care of her— in every way consistent with her plans, that is, the main point in which was that she should never see any light but what came from the lamp. Hence her optic nerves, and indeed her whole apparatus for seeing, grew both larger and more sensitive; her eyes, indeed, stopped short only of being too large. Under her dark hair and forehead and eyebrows, they looked like two breaks in a cloudy night sky, through which peeped the heaven where the stars and no clouds live. She was a sadly dainty little creature. No one in the world except those two was aware of the being of the little bat. Watho trained her to sleep during the day and wake during the night. She taught her music, in which she was herself a proficient, and taught her scarcely anything else.

HOW PHOTOGEN GREW

The hollow in which the castle of Watho lay was a cleft in a plain rather than a valley among hills, for at the top of its steep sides, both north and south, was a tableland, large and wide. It was covered with rich grass and flowers, with here and there a wood, the outlying colony of a great forest. These grassy plains were the finest hunting grounds in the world. Great herds of small but fierce cattle, with humps and shaggy manes, roved about them, also antelopes and gnus, and the tiny roe deer, while the woods were swarming with wild creatures. The tables of the castle were mainly supplied from them. The chief of Watho's

The Sleeping Princess, Frances Macdonald (1874–1921), English. Pastel, c. 1895-1897.

huntsmen was a fine fellow, and when Photogen began to outgrow the training she could give him, she handed him over to Fargu. He with a will set about teaching him all he knew. He got him pony after pony, larger and larger as he grew, every one less manageable than that which had preceded it, and advanced him from pony to horse, and from horse to horse, until he was equal to anything in that kind which the country produced. In similar fashion he trained him to the use of bow and arrow, substituting every three months a stronger bow and longer arrows; and soon he became, even on horseback, a wonderful archer. He was but fourteen when he killed his first bull, causing jubilation among the huntsmen and, indeed, through all the castle, for there too he was the favorite. Every day, almost as soon as the sun was up, he went out hunting, and would in general be out nearly the whole of the day. But Watho had laid upon Fargu just one commandment, namely, that Photogen should on no account, whatever the plea, be out until sundown, or so near it as to wake in him the desire of

seeing what was going to happen; and this commandment Fargu was anxiously careful not to break; for although he would not have trembled had a whole herd of bulls come down upon him, charging at full speed across the level, and not an arrow left in his quiver, he was more than afraid of his mistress. When she looked at him in a certain way, he felt, he said, as if his heart turned to ashes in his breast, and what ran in his veins was no longer blood, but milk and water. So that, ere long, as Photogen grew older, Fargu began to tremble, for he found it steadily growing harder to restrain him. So full of life was he, as Fargu said to his mistress, much to her content, that he was more like a live thunderbolt than a human being. He did not know what fear was, and that not because he did not know danger; for he had had a severe laceration from the razor-like tusk of a boar—whose spine, however, he had severed with one blow of his hunting knife before Fargu could reach him with defense. When he would spur his horse into the midst of a herd of bulls, carrying only his bow and his short

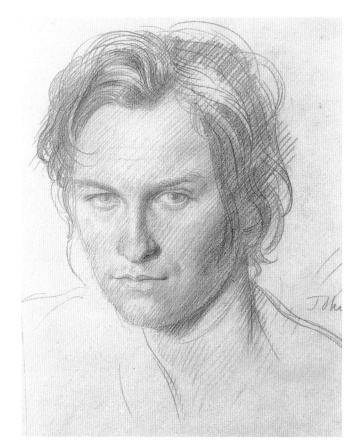

Portrait of Henry Lamb (1885–1960), Augustus John (1878–1961),
Welsh. Pencil on paper, 20th century.

sword, or shoot an arrow into a herd and go after it as if to
reclaim it for a runaway shaft, arriving in time to follow it with
a spear thrust before the wounded animal knew which way to
charge, Fargu thought with terror how it would be when he came
to know the temptation of the huddle-spot leopards, and the
knife-clawed lynxes, with which the forest was haunted. For the
boy had been so steeped in the sun, from childhood so saturated
with his influence, that he looked upon every danger from a sov-
ereign height of courage. When, therefore, he was approaching
his sixteenth year, Fargu ventured to beg Watho that she would lay
her commands upon the youth himself and release him from
responsibility for him. One might as soon hold a tawny-maned
lion as Photogen, he said. Watho called the youth, and in the pres-
ence of Fargu laid her commands upon him never to be out when

the rim of the sun should touch the horizon, accompanying the
prohibition with hints of consequences nonetheless awful than
they were obscure. Photogen listened respectfully, but as he knew
neither the taste of fear nor the temptation of the night, her
words were but sounds to him.

The little education she intended Nycteris to have, Watho gave
her by word of mouth. Not meaning she should have light
enough to read by, to leave other reasons unmentioned, she
never put a book in her hands. Nycteris, however, saw so much
better than Watho imagined, that the light she gave her was
quite sufficient, and she managed to coax Falca into teaching
her the letters, after which she taught herself to read, and
Falca now and then brought her a child's book. But her chief
pleasure was in her instrument. Her very fingers loved it and
would wander about its keys like feeding sheep. She was not
unhappy. She knew nothing of the world except the tomb in
which she dwelt, and had some pleasure in everything she did.
But she desired, nevertheless, something more or different. She
did not know what it was, and the nearest she could come to
expressing it to herself was that she wanted more room. Watho
and Falca would go from her beyond the shine of the lamp, and
come again; therefore, surely there must be more room
somewhere. As often as she was left alone, she would fall to
poring over the colored bas-reliefs on the walls. These were
intended to represent various of the powers of Nature under
allegorical similitudes, and as nothing can be made that does
not belong to the general scheme, she could not fail at least to
imagine a flicker of relationship between some of them, and
thus a shadow of the reality of things found its way to her.

There was one thing, however, which moved and taught her
more than all the rest—the lamp, namely, that hung from the
ceiling, which she always saw alight, though she never saw the
flame, only the slight condensation towards the center of the
alabaster globe. And besides the operation of the light itself
after its kind, the indefiniteness of the globe and the softness
of the light, giving her the feeling as if her eyes could go in and
into its whiteness, were somehow also associated with the idea

of space and room. She would sit for an hour together gazing up at the lamp, and her heart would swell as she gazed. She would wonder what had hurt her, when she found her face wet with tears, and then would wonder how she could have been hurt without knowing it. She never looked thus at the lamp except when she was alone.

THE LAMP

Watho, having given orders, took it for granted they were obeyed and that Falca was all night long with Nycteris, whose day it was. But Falca could not get into the habit of sleeping through the day and would often leave her alone half the night. Then it seemed to Nycteris that the white lamp was watching over her. As it was never permitted to go out—while she was awake at least—Nycteris, except by shutting her eyes, knew less about darkness than she did about light. Also, the lamp being fixed high overhead and in the center of everything, she did not know much about shadows either. The few there were fell almost entirely on the floor, or kept like mice about the foot of the walls.

Once, when she was thus alone, there came the noise of a far-off rumbling: she had never before heard a sound of which she did not know the origin, and here therefore was a new sign of something beyond these chambers. Then came a trembling, then a shaking; the lamp dropped from the ceiling to the floor with a great crash, and she felt as if both her eyes were hard shut and both her hands over them. She concluded that it was the darkness that had made the rumbling and the shaking and, rushing into the room, had thrown down the lamp. She sat trembling. The noise and the shaking ceased, but the light did not return. The darkness had eaten it up!

Her lamp gone, the desire at once awoke to get out of her prison. She scarcely knew what *out* meant; out of one room into another, where there was not even a dividing door, only an open arch, was all she knew of the world. But suddenly she remembered that she had heard Falca speak of the lamp going out: this must be what she had meant. And if the lamp had gone out, where had it gone? Surely where Falca went, and like her it would come again. But she could not wait. The desire to go out

grew irresistible. She must follow her beautiful lamp! She must find it! She must see what it was about!

Now there was a curtain covering a recess in the wall, where some of her toys and gymnastic things were kept; and from behind that curtain Watho and Falca always appeared, and behind it they vanished. How they came out of solid wall she had not an idea: all up to the wall was open space, and all beyond it seemed wall; but clearly the first and only thing she could do was to feel her way behind the curtain. It was so dark that a cat could not have caught the largest of mice. Nycteris could see better than any cat, but now her great eyes were not of the smallest use to her. As she went she trod upon a piece of the broken lamp. She had never worn shoes or stockings, and the fragment, though being of soft alabaster, it did not cut, yet hurt her foot. She did not know what it was, but as it had not been there before the darkness came, she suspected that it had to do with the lamp. She kneeled, therefore, and searched with her hands, and bringing two large pieces together, recognized the shape of the lamp. Therefore it flashed upon her that the lamp was dead, that this brokenness was the death of which she had read without understanding, that the darkness had killed the lamp. What then could Falca have meant when she spoke of the lamp *going out*? There was the lamp—dead indeed, and so changed that she would never have taken it for a lamp but for the shape! No, it was not the lamp any more now it was dead, for all that made it a lamp was gone, namely, the bright shining of it. Then it must be the shine, the light, that had gone out! That must be what Falca meant—and it must be somewhere in the other place in the wall. She started afresh after it, and groped her way to the curtain.

Now she had never in her life tried to get out, and did not know how; but instinctively she began to move her hands about over one of the walls behind the curtain, half expecting them to go into it, as she supposed Watho and Falca did. But the wall repelled her with inexorable hardness, and she turned to the one opposite. In so doing, she set her foot upon an ivory die, and as it met sharply the same spot the broken alabaster had already hurt, she fell forward with her outstretched hands against the wall. Something gave way, and she tumbled out of the cavern.

OUT

But alas! *out* was very much like *in*, for the same enemy, the darkness, was here also. The next moment, however, came a great gladness—a firefly, which had wandered in from the garden. She saw the tiny spark in the distance. With slow pulsing ebb and throb of light, it came pushing itself through the air, drawing nearer and nearer, with that motion which more resembles swimming than flying, and the light seemed the source of its own motion.

"My lamp! my lamp!" cried Nycteris. "It is the shiningness of my lamp, which the cruel darkness drove out. My good lamp has been waiting for me here all the time! It knew I would come after it, and waited to take me with it."

She followed the firefly, which, like herself, was seeking the way out. If it did not know the way, it was yet light; and because all light is one, any light may serve to guide to more light. If she was mistaken in thinking it the spirit of her lamp, it was of the same spirit as her lamp—and had wings. The gold-green jet boat, driven by light, went throbbing before her through a long, narrow passage. Suddenly it rose higher, and the same moment Nycteris fell upon an ascending stair. She had never seen a stair before, and found going up a curious sensation. Just as she reached what seemed the top, the firefly ceased to shine, and so disappeared. She was in utter darkness once more. But when we are following the light, even its extinction is a guide. If the firefly had gone on shining, Nycteris would have seen the stair turn and would have gone up to Watho's bedroom; whereas now, feeling straight before her, she came to a latched door, which after a good deal of trying she managed to open—and stood in a maze of wondering perplexity, awe, and delight. What was it? Was it outside of her, or something taking place in her head? Before her was a very long and very narrow passage, broken up she could not tell how, and spreading out above and on all sides to an infinite height and breadth and distance—as if space itself were growing out of a trough. It was brighter than her rooms had ever been—brighter than if six alabaster lamps had been burning in them. There was a quantity of strange streaking and mottling about it, very different from the shapes on her walls. She was in a dream of pleasant perplexity, of delightful bewilderment. She could not tell whether she was upon her feet or drifting about like the firefly, driven by the pulses of an inward bliss. But she knew little as yet of her inheritance. Unconsciously, she took one step forward from the threshold, and the girl who had been from her very birth a troglodyte stood in the ravishing glory of a southern night, lit by a perfect moon—not the moon of our northern clime but the moon like silver glowing in a furnace: a moon one could see to be a globe—not far off, a mere flat disk on the face of the blue but hanging down halfway and looking as if one could see all round it by a mere bending of the neck.

"It is my lamp," she said, and stood dumb with parted lips. She looked and felt as if she had been standing there in silent ecstasy from the beginning.

"No, it is not my lamp," she said after a while. "It is the mother of all the lamps."

And with that she fell on her knees and spread out her hands to the moon. She could not in the least have told what was in her mind, but the action was in reality just a begging of the moon to be what she was—that precise incredible splendor hung in the far-off roof, that very glory essential to the being of poor girls born and bred in caverns. It was a resurrection—nay, a birth itself—to Nycteris. What the vast blue sky, studded with tiny sparks like the heads of diamond nails, could be; what the moon, looking so absolutely content with light—why, she knew less about them than you and I! but the greatest of astronomers might envy the rapture of such a first impression at the age of sixteen. Immeasurably imperfect it was, but false the impression could not be, for she saw with the eyes made for seeing, and saw indeed what many men are too wise to see.

As she knelt, something softly flapped her, embraced her, stroked her, fondled her. She rose to her feet but saw nothing, did not know what it was. It was likest a woman's breath. For she knew nothing of the air even, had never breathed the still newborn freshness of the world. Her breath had come to her only through long passages and spirals in the rock. Still less did

Moonscape, Peter Davidson (living artist), Welsh. Watercolor on paper, 1988.

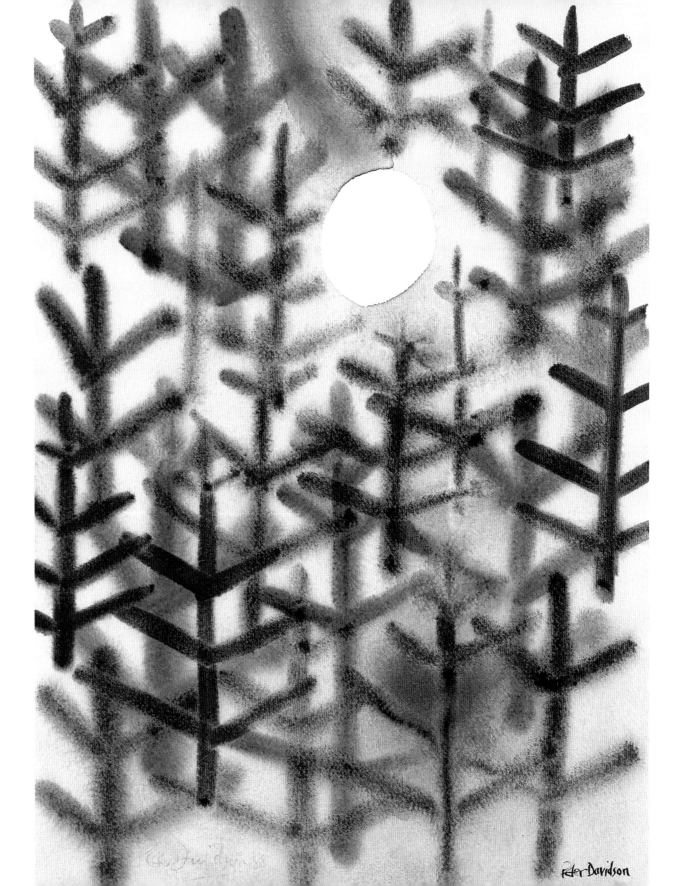

Peter Davidson

she know of the air alive with motion—of that thrice blessed thing, the wind of a summer night. It was like a spiritual wine, filling her whole being with an intoxication of purest joy. To breathe was a perfect existence. It seemed to her the light itself she drew into her lungs. Possessed by the power of the gorgeous night, she seemed at one and the same moment annihilated and glorified.

She was in the open passage or gallery that ran round the top of the garden walls, between the cleft battlements, but she did not once look down to see what lay beneath. Her soul was drawn to the vault above her, with its lamp and its endless room. At last she burst into tears, and her heart was relieved, as the night itself is relieved by its lightning and rain.

And now she grew thoughtful. She must hoard this splendor! What a little ignorance her jailers had made of her! Life was a mighty bliss, and they had scraped hers to the bare bone! They must not know that she knew. She must hide her knowledge—hide it even from her own eyes, keeping it close in her bosom, content to know that she had it, even when she could not brood on its presence, feasting her eyes with its glory. She turned from the vision, therefore, with a sigh of utter bliss, and with soft quiet steps and groping hands stole back into the darkness of the rock. What was darkness or the laziness of Time's feet to one who had seen what she had that night seen? She was lifted above all weariness—above all wrong.

When Falca entered, she uttered a cry of terror. But Nycteris called to her not to be afraid and told her how there had come a rumbling and a shaking, and the lamp had fallen. Then Falca went and told her mistress, and within an hour a new globe hung in the place of the old one. Nycteris thought it did not look so bright and clear as the former, but she made no lamentation over the change; she was far too rich to heed it. For now, prisoner as she knew herself, her heart was full of glory and gladness; at times she had to hold herself from jumping up, and going dancing and singing about the room. When she slept, instead of dull dreams, she had splendid visions. There were times, it is true, when she became restless, and impatient to look upon her riches, but then she would reason with herself, saying "What does it matter if I sit here for ages with my poor pale lamp, when out there a lamp is burning at which ten thousand little lamps are glowing with wonder?"

She never doubted she had looked upon the day and the sun, of which she had read; and always when she read of the day and the sun, she had the night and the moon in her mind; and when she read of the night and the moon, she thought only of the cave and the lamp that hung there.

THE GREAT LAMP

It was some time before she had a second opportunity of going out, for Falca since the fall of the lamp had been a little more careful and seldom left her for long. But one night, having a little headache, Nycteris lay down upon her bed and was lying with her eyes closed when she heard Falca come to her and felt she was bending over her. Disinclined to talk, she did not open her eyes and lay quite still. Satisfied that she was asleep, Falca left her, moving so softly that her very caution made Nycteris open her eyes and look after her—just in time to see her vanish—through a picture, as it seemed, that hung on the wall a long way from the usual place of issue. She jumped up, her headache forgotten, and ran in the opposite direction; got out, groped her way to the stair, climbed, and reached the top of the wall. Alas! The great room was not so light as the little one she had left! Why? Sorrow of sorrows, the great lamp was gone! Had its globe fallen and its lovely light gone out upon great wings, a resplendent firefly oaring itself through a yet grander and lovelier room? She looked down to see if it lay anywhere broken to pieces on the carpet below; but she could not even see the carpet. But surely nothing very dreadful could have happened—no rumbling or shaking; for there were all the little lamps shining brighter than before; not one of them looking as if any unusual matter had befallen. What if each of those little lamps was growing into a big lamp and, after being a big lamp for a while, had to go out and grow a bigger lamp still—out there, beyond this *out*? Ah! Here was the living thing that could not be seen, come to her again—bigger tonight with such loving kisses and such liquid strokings of her cheeks and forehead, gently tossing her hair, and delicately toying with it! But it ceased, and all was still. Had it gone out? What would happen next? Perhaps the little lamps had not to grow

great lamps but to fall one by one and go out first? With that came from below a sweet scent, then another, and another. Ah, how delicious! Perhaps they were all coming to her only on their way out after the great lamp! Then came the music of the river, which she had been too absorbed in the sky to note the first time. What was it? Alas! alas! another sweet living thing on its way out. They were all marching slowly out in long lovely file, one after the other, each taking its leave of her as it passed! It must be so; here were more and more sweet sounds, following and fading! The whole of the *out* was going out again; it was all going after the great lovely lamp! She would be left the only creature in the solitary day! Was there nobody to hang up a new lamp for the old one and keep the creatures from going! She crept back to her rock very sad. She tried to comfort herself by saying that anyhow there would be room out there; but as she said it she shuddered at the thought of *empty* room.

When next she succeeded in getting out, a half-moon hung in the east: a new lamp had come, she thought, and all would be well.

It would be endless to describe the phases of feeling through which Nycteris passed, more numerous and delicate than those of a thousand changing moons. A fresh bliss bloomed in her soul with every varying aspect of infinite nature. Ere long she began to suspect that the new moon was the old moon, gone out and come in again like herself; also that, unlike herself, it wasted and grew again; that it was indeed a live thing, subject like herself to caverns and keepers and solitudes, escaping and shining when it could. Was it a prison like hers it was shut in, and did it grow dark when the lamp left it? Where could be the way into it?— With that first she began to look below, as well as above and around her; and then first noted the tops of the trees between her and the floor. There were palms with their red-fingered hands full of fruit; eucalyptus trees crowded with little boxes of powder puffs; oleanders with their half-caste roses; and orange trees with their clouds of young silver stars and their aged balls of gold. Her eyes could see colors invisible to ours in the moonlight, and all these she could distinguish well, though at first she took them for the shapes and colors of the carpet of the great room. She longed to get down among them, now she saw they

were real creatures, but she did not know how. She went along the whole length of the wall to the end that crossed the river, but found no way of going down. Above the river she stopped to gaze with awe upon the rushing water. She knew nothing of water but from what she drank and what she bathed in; and as the moon shone on the dark, swift stream, singing lustily as it flowed, she did not doubt the river was alive, a swift rushing serpent of life, going—out? whither? And then she wondered if what was brought into her rooms had been killed that she might drink it and have her bath in it.

Once when she stepped out upon the wall, it was into the midst of a fierce wind. The trees were all roaring. Great clouds were rushing along the skies and tumbling over the little lamps: the great lamp had not come yet. All was in tumult. The wind seized her garments and hair and shook them as if it would tear them from her. What could she have done to make the gentle creature so angry? Or was this another creature altogether—of the same kind but hugely bigger and of a very different temper and behavior? But the whole place was angry. Or was it that the creatures dwelling in it, the wind, and the trees, and the clouds, and the river, had all quarreled, each with all the rest? Would the whole come to confusion and disorder? But as she gazed wondering and disquieted, the moon, larger than ever she had seen her, came lifting herself above the horizon to look, broad and red, as if she, too, were swollen with anger that she had been roused from her rest by their noise and compelled to hurry up to see what her children were about, thus rioting in her absence, lest they should rack the whole frame of things. And as she rose, the loud wind grew quieter and scolded less fiercely, the trees grew stiller and moaned with a lower complaint, and the clouds hunted and hurled themselves less wildly across the sky. And as if she were pleased that her children obeyed her very presence, the moon grew smaller as she ascended the heavenly stair; her puffed cheeks sank, her complexion grew clearer, and a sweet smile spread over her countenance, as peacefully she rose and rose. But there was treason and rebellion in her court; for ere she reached the top of her great stairs, the clouds had assembled, forgetting their late wars, and very still they were as they laid their heads together and conspired. Then combining, and lying silently in wait until she came near, they threw themselves upon her

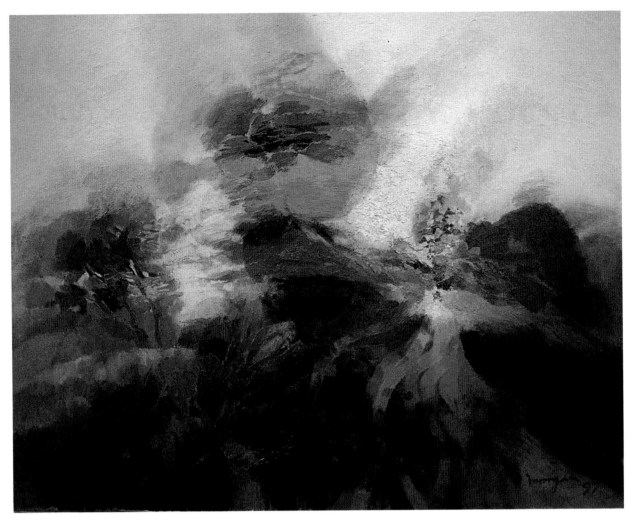

Orpheus in the West, Glyn Morgan (living artist), Welsh. Oil on canvas, 1997.

and swallowed her up. Down from the roof came spots of wet, faster and faster, and they wetted the cheeks of Nycteris; and what could they be but the tears of the moon, crying because her children were smothering her? Nycteris wept too, and, not knowing what to think, stole back in dismay to her room.

The next time, she came out in fear and trembling. There was the moon still, away in the west—poor, indeed, and old, and looking dreadfully worn, as if all the wild beasts in the sky had been gnawing at her—but there she was, alive still, and able to shine!

THE SUNSET

Knowing nothing of darkness, or stars, or moon, Photogen spent his days in hunting. On a great white horse he swept over the grassy plains, glorying in the sun, fighting the wind, and killing the buffaloes.

One morning, when he happened to be on the ground a little earlier than usual and before his attendants, he caught sight of an animal unknown to him, stealing from a hollow into which the sun rays had not yet reached. Like a swift shadow it sped over the grass, slinking southward to the forest. He gave chase, noted the

body of a buffalo it had half eaten, and pursued it the harder. But with great leaps and bounds the creature shot farther and farther ahead of him, and vanished. Turning therefore defeated, he met Fargu, who had been following him as fast as his horse could carry him.

"What animal was that, Fargu?" he asked. "How he did run!"

Fargu answered he might be a leopard, but he rather thought from his pace and look that he was a young lion.

"What a coward he must be!" said Photogen.

"Don't be too sure of that," rejoined Fargu. "He is one of the creatures the sun makes uncomfortable. As soon as the sun is down, he will be brave enough."

He had scarcely said it, when he repented; nor did he regret it the less when he found that Photogen made no reply. But alas! said was said.

"Then," said Photogen to himself, "that contemptible beast is one of the terrors of sundown, of which Madame Watho spoke!"

He hunted all day, but not with his usual spirit. He did not ride so hard and did not kill one buffalo. Fargu to his dismay observed also that he took every pretext for moving farther south, nearer to the forest. But all at once, the sun now sinking in the west, he seemed to change his mind, for he turned his horse's head and rode home so fast that the rest could not keep him in sight. When they arrived, they found his horse in the stable and concluded that he had gone into the castle. But he had in truth set out again by the back of it. Crossing the river a good way up the valley, he reascended to the ground they had left, and just before sunset reached the skirts of the forest.

The level orb shone straight in between the bare stems, and saying to himself he could not fail to find the beast, he rushed into the wood. But even as he entered, he turned, and looked to the west. The rim of the red was touching the horizon, all jagged with broken hills. "Now," said Photogen, "we shall see"; but he said it in the face of a darkness he had not proved. The moment the sun began to sink among the spikes and saw edges, with a kind of sudden flap at his heart a fear inexplicable laid hold of the youth; and as he had never felt anything of the kind before, the very fear itself terrified him. As the sun sank, it rose like the shadow of the world, and grew deeper and darker. He could not even think what it might be, so utterly did it enfeeble him. When the last flaming scimitar edge of the sun went out like a lamp, his horror seemed to blossom into very madness. Like the closing lids of an eye—for there was no twilight, and this night no moon—the terror and the darkness rushed together, and he knew them for one. He was no longer the man he had known, or rather thought himself. The courage he had had was in no sense his own—he had only had courage, not been courageous; it had left him, and he could scarcely stand—certainly not stand straight, for not one of his joints could he make stiff or keep from trembling. He was but a spark of the sun, in himself nothing.

The beast was behind him—stealing upon him! He turned. All was dark in the wood, but to his fancy the darkness here and there broke into pairs of green eyes, and he had not the power even to raise his bow hand from his side. In the strength of despair he strove to rouse courage enough: not to fight—that he did not even desire—but to run. Courage to flee home was all he could ever imagine, and it would not come. But what he had not was ignominiously given him. A cry in the wood, half a screech, half a growl, sent him running like a boar-wounded cur. It was not even himself that ran, it was fear that had come alive in his legs; he did not know that they moved. But as he ran he grew able to run—gained courage at least to be a coward. The stars gave a little light. Over the grass he sped, and nothing followed him. "How fallen, how changed," from the youth who had climbed the hill as the sun went down! A mere contempt to himself, the self that contemned was a coward with the self it contemned! There lay the shapeless black of a buffalo, humped upon the grass: He made a wide circuit, and swept on like a shadow driven in the wind. For the wind had arisen, and added to his terror: it blew from behind him. He reached the brow of the valley and shot down the steep descent like a falling star. Instantly the whole upper country behind him arose and pursued him! The wind came howling after him, filled with screams, shrieks, yells, roars, laughter, and chattering, as if all the animals of the forest were careering with it. In his ears was a trampling rush, the thunder of the hooves of the cattle, in career from every quarter of the wide plains to the brow of the hill above him. He fled straight for the castle, scarcely with breath enough to pant.

As he reached the bottom of the valley, the moon peered up over its edge. He had never seen the moon before—except in the daytime, when he had taken her for a thin bright cloud. She was a fresh terror to him—so ghostly! so ghastly! so gruesome!—so knowing as she looked over the top of her garden wall upon the world outside! That was the night itself! the darkness alive—and after him! the horror of horrors coming down the sky to curdle his blood and turn his brain to a cinder! He gave a sob and made straight for the river, where it ran between the two walls, at the bottom of the garden. He plunged in, struggled through, clambered up the bank, and fell senseless on the grass.

THE GARDEN

Although Nycteris took care not to stay out long at a time and used every precaution, she could hardly have escaped discovery so long, had it not been that the strange attacks to which Watho was subject had been more frequent of late and had at last settled into an illness which kept her to her bed. But whether from an access of caution or from suspicion, Falca, having now to be much with her mistress both day and night, took it at length into her head to fasten the door as often as she went by her usual place of exit, so that one night, when Nycteris pushed, she found, to her surprise and dismay, that the wall pushed her again and would not let her through; nor with all her searching could she discover wherein lay the cause of the change. Then first she felt the pressure of her prison walls and, turning, half in despair, groped her way to the picture where she had once seen Falca disappear. There she soon found the spot by pressing upon which the wall yielded. It let her through into a sort of cellar, where was a glimmer of light from a sky whose blue was paled by the moon. From the cellar she got into a long passage, into which the moon was shining, and came to a door. She managed to open it and, to her great joy, found herself in *the other place*, not on the top of the wall, however, but in the garden she had longed to enter. Noiseless as a fluffy moth, she flitted away into the covert of the trees and shrubs, her bare feet welcomed by the softest of carpets, which, by the very touch, her feet knew to be alive, whence it came that it was so sweet and friendly to them. A soft little wind was out among the trees, running now here, now there,

like a child that had got its will. She went dancing over the grass, looking behind her at her shadow as she went. At first she had taken it for a little black creature that made game of her, but when she perceived that it was only where she kept the moon away, and that every tree, however great and grand a creature, had also one of these strange attendants, she soon learned not to mind it, and by and by it became the source of as much amusement to her as to any kitten its tail. It was long before she was quite at home with the trees, however. At one time they seemed to disapprove of her; at another not even to know she was there and to be altogether taken up with their own business. Suddenly, as she went from one to another of them, looking up with awe at the murmuring mystery of their branches and leaves, she spied one a little way off which was very different from all the rest. It was white, and dark and sparkling, and spread like a palm—a small slender palm, without much head; and it grew very fast, and sang as it grew. But it never grew any bigger, for just as fast as she could see it growing, it kept falling to pieces. When she got close to it, she discovered that it was a water tree—made of just such water as she washed with—only it was alive, of course, like the river: a different sort of water from that, doubtless, seeing the one crept swiftly along the floor and the other shot straight up, and fell, and swallowed itself, and rose again. She put her feet into the marble basin, which was the flowerpot in which it grew. It was full of real water, living and cool—so nice, for the night was hot!

But the flowers! Ah, the flowers! She was friends with them from the very first. What wonderful creatures they were! And so kind and beautiful, always sending out such colors and such scents—red scent, and white scent, and yellow scent—for the other creatures! The one that was invisible and everywhere took such a quantity of their scents and carried it away! Yet they did not seem to mind. It was their talk, to show they were alive and not painted, like those on the walls of her rooms and on the carpets.

She wandered along down the garden, until she reached the river. Unable then to get any farther—for she was a little afraid, and justly, of the swift watery serpent—she dropped on the grassy bank, dipped her feet in the water, and felt it running and pushing against them. For a long time she sat thus, and her

bliss seemed complete as she gazed at the river and watched the broken picture of the great lamp overhead, moving up one side of the roof, to go down the other.

SOMETHING QUITE NEW

A beautiful moth brushed across the great blue eyes of Nycteris. She sprang to her feet to follow it—not in the spirit of the hunter, but of the lover. Her heart—like every heart, if only its fallen sides were cleared away—was an inexhaustible fountain of love: she loved everything she saw. But as she followed the moth, she caught sight of something lying on the bank of the river, and not yet having learned to be afraid of anything, ran straight to see what it was. Reaching it, she stood amazed. Another girl, like herself! But what a strange-looking girl! so curiously dressed too! and not able to move! Was she dead! Filled suddenly with pity, she sat down, lifted Photogen's head, laid it on her lap, and began stroking his face. Her warm hands brought him to himself. He opened his black eyes, out of which had gone all the fire, and looked up with a strange sound of fear, half moan, half gasp. But when he saw her face, he drew a deep breath and lay motionless—gazing at her: those blue marvels above him, like a better sky, seemed to side with courage and assuage his terror. At length, in a trembling, awed voice, and a half whisper, he said, "Who are you?"

"I am Nycteris," she answered.

"You are a creature of the darkness and love the night," he said, his fear beginning to move again.

"I may be a creature of the darkness," she replied. "I hardly know what you mean. But I do not love the night. I love the day—with all my heart; and I sleep all the night long."

"How can that be?" said Photogen, rising on his elbow, but dropping his head on her lap again the moment he saw the moon. "How can it be," he repeated, "when I see your eyes there—wide awake?"

She only smiled and stroked him, for she did not understand him and thought he did not know what he was saying.

"Was it a dream, then?" resumed Photogen, rubbing his eyes. But with that his memory came clear, and he shuddered, and cried, "Oh, horrible, horrible! To be turned all at once into

a coward—a shameful, contemptible, disgraceful coward! I am ashamed—ashamed—and so frightened! It is all so frightful!"

"What is so frightful?" asked Nycteris, with a smile like that of a mother to her child waked from a bad dream.

"All, all," he answered. "All this darkness and the roaring."

"My dear," said Nycteris, "there is no roaring. How sensitive you must be! What you hear is only the walking of the water and the running about of the sweetest of all the creatures. She is invisible, and I call her Everywhere, for she goes through all the other creatures and comforts them. Now she is amusing herself, and them too, with shaking them and kissing them and blowing in their faces. Listen: do you call that roaring? You should hear her when she is rather angry, though! I don't know why, but she is sometimes, and then she does roar a little."

"It is so horribly dark!" said Photogen, who, listening while she spoke, had satisfied himself that there was no roaring.

"Dark!" she echoed. "You should be in my room when an earthquake has killed my lamp. I do not understand. How can you call this dark? Let me see; yes, you have eyes, and big ones, bigger than Madame Watho's or Falca's: not so big as mine, I fancy—only I never saw mine. But then—oh, yes!—I know now what is the matter! You can't see with them because they are so black. Darkness can't see, of course. Never mind: I will be your eyes and teach you to see. Look here—at these lovely white things in the grass, with red sharp points all folded together into one. Oh, I love them so! I could sit looking at them all day, the darlings!"

Photogen looked close at the flowers and thought he had seen something like them before, but could not make them out. As Nycteris had never seen an open daisy, so had he never seen a closed one.

Thus instinctively Nycteris tried to turn him away from this fear; and the beautiful creature's strange lovely talk helped not a little to make him forget it.

"You call it dark!" she said again, as if she could not get rid of the absurdity of the idea. "Why, I could count every blade of the green hair—I suppose it is what the books call grass—within two yards of me! And just look at the great lamp! It is brighter than usual today, and I can't think why you should be frightened or call it dark!"

Roses and Teardrops, Charles Rennie Mackintosh (1868–1928), Scottish. Pencil and watercolor, 1915–1923.

As she spoke, she went on stroking his cheeks and hair and trying to comfort him. But oh, how miserable he was, and how plainly he looked it! He was on the point of saying that her great lamp was dreadful to him, looking like a witch, walking in the sleep of death; but he was not so ignorant as Nycteris and knew even in the moonlight that she was a woman, though he had never seen one so young or so lovely before; and while she comforted his fear, her presence made him the more ashamed of it. Besides, not knowing her nature, he might annoy her and make her leave him to his misery. He lay still, therefore, hardly daring to move: all the little life he had seemed to come from her, and if he were to move, she might move; and if she were to leave him, he must weep like a child.

"How did you come here?" asked Nycteris, taking his face between her hands.

"Down the hill," he answered.

"Where do you sleep?" she asked.

He signed in the direction of the house. She gave a little laugh of delight.

"When you have learned not to be frightened, you will always be wanting to come out with me," she said.

She thought to herself she would ask her presently, when she had come to herself a little, how she had made her escape, for she must, of course, like herself, have got out of a cave, in which Watho and Falca had been keeping her.

"Look at the lovely colors," she went on, pointing to a rose-bush, on which Photogen could not see a single flower. "They are far more beautiful—are they not?—than any of the colors upon your walls. And then they are alive, and smell so sweet!"

He wished she would not make him keep opening his eyes to look at things he could not see; and every other moment he would start and grasp tight hold of her, as some fresh pang of terror shot into him.

"Come, come, dear!" said Nycteris. "You must not go on this way. You must be a brave girl, and—"

"A girl!" shouted Photogen, and started to his feet in wrath. "If you were a man, I should kill you."

"A man?" repeated Nycteris. "What is that? How could I be that? We are both girls—are we not?"

"No, I am not a girl," he answered, "although," he added, changing his tone and casting himself on the ground at her feet, "I have given you too good reason to call me one."

"Oh, I see!" returned Nycteris. "No, of course! You can't be a girl: girls are not afraid—without reason. I understand now: it is because you are not a girl that you are so frightened."

Photogen twisted and writhed upon the grass.

"No, it is not," he said sulkily. "it is this horrible darkness that creeps into me, goes all through me, into the very marrow of my bones—that is what makes me behave like a girl. If only the sun would rise!"

"The sun! What is it?" cried Nycteris, now in her turn conceiving a vague fear.

Then Photogen broke into a rhapsody, in which he vainly sought to forget his.

"It is the soul, the life, the heart, the glory of the universe," he said. "The worlds dance like motes in his beams. The heart

of man is strong and brave in his light, and when it departs his courage grows from him—goes with the sun—and he becomes such as you see me now."

"Then that is not the sun?" said Nycteris thoughtfully, pointing up to the moon.

"That!" cried Photogen, with utter scorn. "I know nothing about that, except that it is ugly and horrible. At best it can be only the ghost of a dead sun. Yes, that is it! That is what makes it look so frightful."

"No," said Nycteris, after a long, thoughtful pause. "You must be wrong there. I think the sun is the ghost of a dead moon, and that is how he is so much more splendid, as you say. Is there, then, another big room, where the sun lives in the roof?"

"I do not know what you mean," replied Photogen. "But you mean to be kind, I know, though you should not call a poor fellow in the dark a girl. If you will let me lie here, with my head in your lap, I should like to sleep. Will you watch me and take care of me?"

"Yes, that I will," answered Nycteris, forgetting all her own danger.

So Photogen fell asleep.

THE SUN

There Nycteris sat, and there the youth lay all night long, in the heart of the great cone shadow of the earth, like two pharaohs in one pyramid. Photogen slept and slept; and Nycteris sat motionless lest she should wake him and so betray him to his fear.

The moon rode high in the blue eternity. It was a very triumph of glorious night: the river ran babble-murmuring in deep soft syllables; the fountain kept rushing moonward and blossoming momently to a great silvery flower, whose petals were forever falling like snow, but with a continuous musical clash, into the bed of its exhaustion beneath; the wind woke, took a run among the trees, went to sleep, and woke again; the daisies slept on their feet at hers, but she did not know they slept; the roses might well seem awake, for their scent filled the air, but in truth they slept also, and the odor was that of their dreams; the oranges hung like gold lamps in the trees, and their

silvery flowers were the souls of their yet unembodied children; the scent of the acacia blooms filled the air like the very odor of the moon herself.

At last, unused to the living air, and weary with sitting so still and so long, Nycteris grew drowsy. The air began to grow cool. It was getting near the time when she, too, was accustomed to sleep. She closed her eyes just a moment, and nodded—opened them suddenly wide, for she had promised to watch.

In that moment a change had come. The moon had got round and was fronting her from the west, and she saw that her face was altered, that she had grown pale, as if she, too, were wan with fear and from her lofty place espied a coming terror. The light seemed to be dissolving out of her; she was dying—she was going out! And yet everything around looked strangely clear—clearer than ever she had seen anything before; how could the lamp be shedding more light when she herself had less? Ah, that was just it! See how faint she looked! It was because the light was forsaking her, and spreading itself over the room, that she grew so thin and pale! She was giving up everything! She was melting away from the roof like a bit of sugar in water.

Nycteris was fast growing afraid, and sought refuge with the face upon her lap. How beautiful the creature was! What to call it she could not think, for it had been angry when she called it what Watho called her. And wonder upon wonders! Now, even in the cold change that was passing upon the great room, the color as of a red rose was rising in the wan cheek. What beautiful yellow hair it was that spread over her lap! What great huge breaths the creature took! And what were those curious things it carried? She had seen them on her walls, she was sure.

Thus she talked to herself while the lamp grew paler and paler, and everything kept growing yet clearer. What could it mean? The lamp was dying—going out into the other place of which the creature in her lap had spoken, to be a sun! But why were the things growing clearer before it was yet a sun? That was the point. Was it her growing into a sun that did it? Yes! yes! It was coming death! She knew it, for it was coming upon her also! She felt it coming! What was she about to grow into? Something beautiful, like the creature in her lap? It might be! Anyhow, it must be death; for all her strength was going out of her, while all

around her was growing so light she could not bear it. She must be blind soon! Would she be blind or dead first?

For the sun was rushing up behind her. Photogen woke, lifted his head from her lap, and sprang to his feet. His face was one radiant smile. His heart was full of daring—that of the hunter who will creep into the tiger's den. Nycteris gave a cry, covered her face with her hands, and pressed her eyelids closed. Then blindly she stretched out her arms to Photogen, crying, "Oh, I am *so* frightened! What is this? It must be death! I don't wish to die yet. I love this room and the old lamp. I do not want the other place. This is terrible. I want to hide. I want to get into the sweet, soft, dark hands of all the other creatures. Ah me! Ah me!"

"What is the matter with you, girl?" said Photogen, with the arrogance of all male creatures until they have been taught by the other kind. He stood looking down upon her over his bow, of which he was examining the string. "There is no fear of anything now, child! It is day. The sun is all but up. Look! He will be above the brow of yon hill in one moment more! Goodbye. Thank you for my night's lodging. I'm off. Don't be a goose. If ever I can do anything for you—and all that, you know!"

"Don't leave me; oh, don't leave me!" cried Nycteris. "I am dying! I am dying! I can't move. The light sucks all the strength out of me. And oh, I am *so* frightened."

But already Photogen had splashed through the river, holding high his bow that it might not get wet. He rushed across the level and strained up the opposing hill. Hearing no answer, Nycteris removed her hands. Photogen had reached the top, and the same moment, the sun rays alighted upon him; the glory of the king of day crowded blazing upon the golden-haired youth. Radiant as Apollo, he stood in mighty strength, a flashing shape in the midst of flame. He fitted a glowing arrow to a gleaming bow. The arrow parted with a keen musical twang of the bowstring, and Photogen, darting after it, vanished with a shout. Up shot Apollo himself, and from his quiver scattered astonishment and exultation. But the brain of poor Nycteris was pierced through and through. She fell down in utter darkness. All around her was a flaming furnace. In despair and feebleness and agony, she crept back, feeling her way with doubt and difficulty and enforced persistence to her cell.

When at last the friendly darkness of her chamber folded her about with its cooling and consoling arms, she threw herself on her bed and fell fast asleep. And there she slept on, one alive in a tomb, while Photogen, above in the sun glory, pursued the buffaloes on the lofty plain, thinking not once of her, where she lay dark and forsaken, whose presence had been his refuge, her eyes and her hands his guardians through the night. He was in his glory and his pride; and the darkness and its disgrace had vanished for a time.

THE COWARD HERO

But no sooner had the sun reached the noonstead than Photogen began to remember the past night in the shadow of that which was at hand, and to remember it with shame. He had proved himself—and not to himself only, but to a girl as well—a coward! one bold in the daylight, while there was nothing to fear, but trembling like any slave when the night arrived. There was, there must be, something unfair in it! A spell had been cast upon him! He had eaten, he had drunk, something that did not agree with courage! In any case, he had been taken unprepared! How was he to know what the going down of the sun would be like? It was no wonder he should have been surprised into terror, seeing it was what it was—in its very nature so terrible! Also, one could not see where danger might be coming from! You might be torn in pieces, carried off, or swallowed up, without even seeing where to strike a blow! Every possible excuse he caught at, eager as a self-lover to lighten his self-contempt. That day he astonished the huntsmen—terrified them with his reckless daring—all to prove to himself he was no coward. But nothing eased his shame. One thing only had hope in it—the resolve to encounter the dark in solemn earnest, now that he knew something of what it was. It was nobler to meet a recognized danger than to rush contemptuously into what seemed nothing—nobler still to encounter a nameless horror. He could conquer fear and wipe out disgrace together. For a marksman and swordsman like him, he said, one with his strength and courage, there was but danger. Defeat there was not. He knew the darkness now, and when it came he would meet it as fearless and cool as now he felt himself. And again he said, "We shall see!"

He stood under the boughs of a great beech as the sun was going down, far away over the jagged hills: before it was half down, he was trembling like one of the leaves behind him in the first sigh of the night wind. The moment the last of the glowing disk vanished, he bounded away in terror to gain the valley, and his fear grew as he ran. Down the side of the hill, an abject creature, he went bounding and rolling and running; fell rather than plunged into the river, and came to himself, as before, lying on the grassy bank in the garden.

But when he opened his eyes, there were no girl eyes looking down into his; there were only the stars in the waste of the sunless Night—the awful all-enemy he had again dared but could not encounter. Perhaps the girl was not yet come out of the water! He would try to sleep, for he dared not move, and perhaps when he woke he would find his head on her lap and the beautiful dark face, with its deep-blue eyes, bending over him. But when he woke he found his head on the grass, and although he sprang up with all his courage, such as it was, restored, he did not set out for the chase with such an *élan* as the day before; and despite the sun glory in his heart and veins, his hunting was this day less eager; he ate little, and from the first was thoughtful even to sadness. A second time he was defeated and disgraced! Was his courage nothing more than the play of the sunlight on his brain? Was he a mere ball tossed between the light and the dark? Then what a poor contemptible creature he was! But a third chance lay before him. If he failed the third time, he dared not foreshadow what he must then think of himself! It was bad enough now—but then!

Alas! It went no better. The moment the sun was down, he fled as if from a legion of devils.

Seven times in all he tried to face the coming night in the strength of the past day, and seven times he failed—failed with such increase of failure, with such a growing sense of ignominy, overwhelming at length all the sunny hours and joining night to night, that what with misery, self-accusation, and loss of confidence, his daylight courage too began to fade, and at length, from exhaustion, from getting wet, and then lying out of doors all night, and night after night—worst of all, from the consuming of the deathly fear and the shame of shame, his sleep forsook him, and on the seventh morning, instead of going to the hunt,

he crawled into the castle and went to bed. The grand health over which the witch had taken such pains had yielded, and in an hour or two he was moaning and crying out in delirium.

AN EVIL NURSE

Watho was herself ill, as I have said, and was the worse tempered; and besides, it is a peculiarity of witches that what works in others to sympathy works in them to repulsion. Also, Watho had a poor, helpless, rudimentary spleen of a conscience left, just enough to make her uncomfortable, and therefore more wicked. So when she heard that Photogen was ill, she was angry. Ill, indeed! after all she had done to saturate him with the life of the system, with the solar might itself! He was a wretched failure, the boy! And because he was her failure, she was annoyed with him, began to dislike him, grew to hate him. She looked on him as a painter might upon a picture, or a poet upon a poem, which he had only succeeded in getting into an irrecoverable mess. In the hearts of witches, love and hate lie close together, and often tumble over each other. And whether it was that her failure with Photogen foiled also her plans in regard to Nycteris, or that her illness made her yet more of a devil's wife, certainly Watho now got sick of the girl, too, and hated to know her about the castle.

She was not too ill, however, to go to poor Photogen's room and torment him. She told him she hated him like a serpent and hissed like one as she said it, looking very sharp in the nose and chin, and flat in the forehead. Photogen thought she meant to kill him, and hardly ventured to take anything brought him. She ordered every ray of light to be shut out of his room; but by means of this he got a little used to the darkness. She would take one of his arrows and now tickle him with the feather end of it, now prick him with the point till the blood ran down. What she meant finally I cannot tell, but she brought Photogen speedily to the determination of making his escape from the castle: what he should do then he would think afterwards. Who could tell but he might find his mother somewhere beyond the forest! If it were not for the broad patches of darkness that divided day from day, he would fear nothing!

But now as he lay helpless in the dark, ever and anon would come dawning through it the face of the lovely creature who on

that first awful night nursed him so sweetly: was he never to see her again? If she was as he had concluded, the nymph of the river, why had she not reappeared? She might have taught him not to fear the night, for plainly she had no fear of it herself! But then, when the day came, she did seem frightened: why was that, seeing there was nothing to be afraid of then? Perhaps one so much at home in the darkness was correspondingly afraid of the light! Then his selfish joy at the rising of the sun, blinding him to her condition, had made him behave to her, in ill return for her kindness, as cruelly as Watho behaved to him! How sweet and dear and lovely she was! If there were wild beasts that came out only at night and were afraid of the light, why should there not be girls, too, made the same way—who could not endure the light, as he could not bear the darkness? If only he could find her again! Ah, how differently he would behave to her! But alas! Perhaps the sun had killed her—melted her—burned her up—dried her up—that was it, if she was the nymph of the river!

WATHO'S WOLF

From that dreadful morning Nycteris had never got to be herself again. The sudden light had been almost death to her: and now she lay in the dark with the memory of a terrific sharpness—a something she dared scarcely recall, lest the very thought of it should sting her beyond endurance. But this was as nothing to the pain which the recollection of the rudeness of the shining creature whom she had nursed through his fear caused her; for the moment his suffering passed over to her, and he was free, the first use he made of this returning strength had been to scorn her! She wondered and wondered; it was all beyond her comprehension.

Before long, Watho was plotting evil against her. The witch was like a sick child weary of his toy: she would pull her to pieces and see how she liked it. She would set her in the sun and see her die, like a jelly from the salt ocean cast out on a hot rock. It would be a sight to soothe her wolf pain. One day, therefore, a little before noon, while Nycteris was in her deepest sleep, she had a darkened litter brought to the door, and in that she made two of her men carry her to the plain above. There they took her out, laid her on the grass, and left her.

Watho watched it all from the top of her high tower, through her telescope; and scarcely was Nycteris left, when she saw her sit up and the same moment cast herself down again with her face to the ground.

"She'll have a sunstroke," said Watho, "and that'll be the end of her."

Presently, tormented by a fly, a huge-humped buffalo, with great shaggy mane, came galloping along, straight for where she lay. At sight of the thing on the grass, he started, swerved yards aside, stopped dead, and then came slowly up, looking malicious. Nycteris lay quite still and never even saw the animal.

"Now she'll be trodden to death!" said Watho. "That's the way those creatures do."

When the buffalo reached her, he sniffed at her all over and went away; then came back and sniffed again: then all at once went off as if a demon had him by the tail.

Next came a gnu, a more dangerous animal still, and did much the same; then a gaunt wild boar. But no creature hurt her, and Watho was angry with the whole creation.

At length, in the shade of her hair, the blue eyes of Nycteris began to come to themselves a little, and the first thing they saw was a comfort. I have told already how she knew the night daisies, each a sharp-pointed little cone with a red tip; and once she had parted the rays of one of them, with trembling fingers, for she was afraid she was dreadfully rude and perhaps was hurting it; but she did want, she said to herself, to see what secret it carried so carefully hidden; and she found its golden heart. But now, right under her eyes, inside the veil of her hair, in the sweet twilight of whose blackness she could see it perfectly, stood a daisy with its red tip opened wide into a carmine ring, displaying its heart of gold on a platter of silver. She did not at first recognize it as one of those cones come awake, but a moment's notice revealed what it was. Who then could have been so cruel to the lovely little creature as to force it open like that, and spread it heart-bare to the terrible death lamp? Whoever it was, it must be the same that had thrown her out there to be burned to death in its fire! But she had her hair, and could hang her head, and make a small sweet night of her own about her! She tried to bend the daisy down and away from the sun, and to make its petals hang

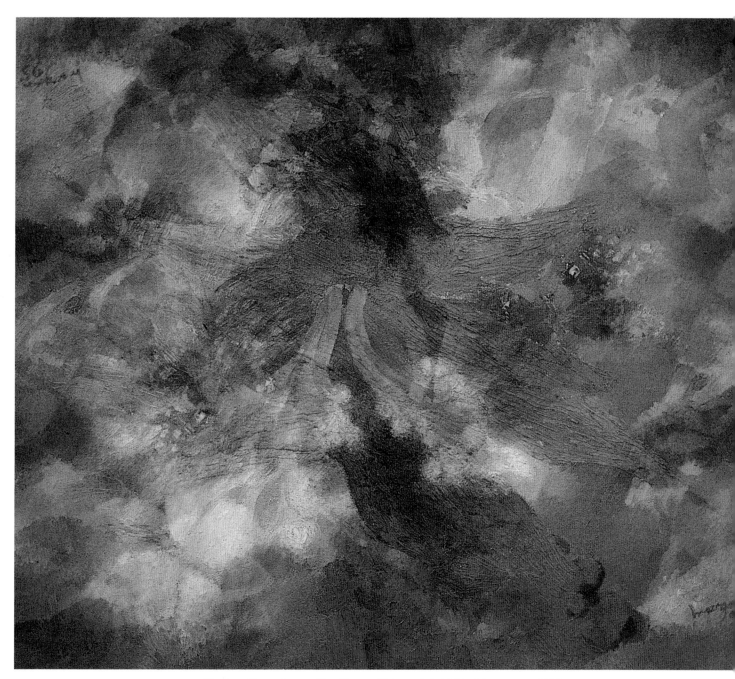

The Green Man in Summer, Glyn Morgan (living artist), Welsh. Oil on canvas, 1995.

about it like her hair, but she could not. Alas, it was burned and dead already! She did not know that it could not yield to her gentle force because it was drinking life, with all the eagerness of life, from what she called the death lamp. Oh, how the lamp burned her!

But she went on thinking—she did not know how—and by and by began to reflect that as there was no roof to the room except that in which the great fire went rolling about, the little Red-tip must have seen the lamp a thousand times, and must know it quite well; and it had not killed it! Nay, thinking about it farther, she began to ask the question whether this, in which she now saw it, might not be its more perfect condition. For not only now did the whole seem perfect, as indeed it did before, but every part showed its own individual perfection as well, which perfection made it capable of combining with the rest into the higher perfection as a whole. The flower was a lamp itself! The golden heart was the light, and the silver border was the alabaster globe, skillfully broken and spread wide to let out the glory. Yes: the radiant shape was plainly its perfection! If, then, it was the lamp which had opened it into that shape, the lamp could not be unfriendly to it but must be of its own kind, seeing it made it perfect! And again, when she thought of it, there was clearly no little resemblance between them. What if the flower, then, was the little great-grandchild of the lamp, and he was loving it all the time? And what if the lamp did not mean to hurt her, only could not help it? The red tips looked as if the flower had sometime or other been hurt: what if the lamp was making the best it could of her—opening her out somehow like the flower? She would bear it patiently and see. But how coarse the color of the grass was! Perhaps, however, her eyes not being made for the bright lamp, she did not see them as they were! Then she remembered how different were the eyes of the creature that was not a girl and was afraid of the darkness! Ah, if the darkness would only come again, all arms, friendly and soft everywhere about her! She would wait and wait, and bear, and be patient.

She lay so still that Watho did not doubt she had fainted. She was pretty sure she would be dead before the night came to revive her.

REFUGE

Fixing her telescope on the motionless form, that she might see it at once when the morning came, Watho went down from the tower to Photogen's room. He was much better by this time, and before she left him, he had resolved to leave the castle that very night. The darkness was terrible indeed, but Watho was worse than even the darkness, and he could not escape in the day. As soon, therefore, as the house seemed still, he tightened his belt, hung to it his hunting knife, put a flask of wine and some bread in his pocket, and took his bow and arrows. He got from the house and made his way at once up to the plain. But what with his illness, the terrors of the night, and his dread of the wild beasts, when he got to the level he could not walk a step farther and sat down, thinking it better to die than to live. In spite of his fears, however, sleep contrived to overcome him, and he fell at full length on the soft grass.

He had not slept long when he woke, with such a strange sense of comfort and security that he thought the dawn at least must have arrived. But it was dark night about him. And the sky—no, it was not the sky but the blue eyes of his naiad looking down upon him! Once more he lay with his head in her lap, and all was well, for plainly the girl feared the darkness as little as he the day.

"Thank you," he said. "You are like live armor to my heart; you keep the fear off me. I have been very ill since then. Did you come up out of the river when you saw me cross?"

"I don't live in the water," she answered. "I live under the pale lamp, and I die under the bright one."

"Ah, yes! I understand now," he returned. "I would not have behaved as I did last time if I had understood; but I thought you were mocking me; and I am so made that I cannot help being frightened at the darkness. I beg your pardon for leaving you as I did, for, as I say, I did not understand. Now I believe you were really frightened. Were you not?"

"I was indeed," answered Nycteris, "and shall be again. But why you should be, I cannot in the least understand. You must know how gently and sweet the darkness is, how kind and friendly, how soft and velvety! It holds you to its bosom and loves you. A little while ago, I lay faint and dying under your hot lamp. What is it you call it?"

"The sun," murmured Photogen. "How I wish he would make haste!"

"Ah! Do not wish that. Do not, for my sake, hurry him. I can take care of you from the darkness, but I have no one to take care of me from the light. As I was telling you, I lay dying in the sun. All at once I drew a deep breath. A cool wind came and ran over my face. I looked up. The torture was gone, for the death lamp itself was gone. I hope he does not die and grow brighter yet. My terrible headache was all gone, and my sight was come back. I felt as if I were new made. But I did not get up at once, for I was tired still. The grass grew cool about me and turned soft in color. Something wet came upon it, and it was now so pleasant to my feet that I rose and ran about. And when I had been running about a long time, all at once I found you lying, just as I had been lying a little while before. So I sat down beside you to take care of you, till your life—and my death—should come again."

"How good you are, you beautiful creature! Why, you forgave me before ever I asked you!" cried Photogen.

Thus they fell a-talking, and he told her what he knew of his history, and she told him what she knew of hers, and they agreed they must get away from Watho as far as ever they could.

"And we must set out at once," said Nycteris.

"The moment the morning comes," returned Photogen.

"We must not wait for the morning," said Nycteris, "for then I shall not be able to move, and what would you do the next night? Besides, Watho sees best in the daytime. Indeed, you must come now, Photogen. You must."

"I cannot; I dare not," said Photogen. "I cannot move. If I but lift my head from your lap, the very sickness of terror seizes me."

"I shall be with you," said Nycteris soothingly. "I will take care of you till your dreadful sun comes, and then you may leave me and go away as fast as you can. Only please put me in a dark place first, if there is one to be found."

"I will never leave you again, Nycteris," cried Photogen. "Only wait till the sun comes and brings me back my strength, and we will go away together and never, never part anymore."

"No, no," persisted Nycteris. "We must go now. And you must learn to be strong in the dark as well as in the day, else you

will always be only half brave. I have begun already: not to fight your sun but to try to get at peace with him and understand what he really is and what he means with me—whether to hurt me or to make the best of me. You must do the same with my darkness."

"But you don't know what mad animals there are away there towards the south," said Photogen. "They have huge green eyes, and they would eat you up like a bit of celery, you beautiful creature!"

"Come, come! You must," said Nycteris, "or I shall have to pretend to leave you, to make you come. I have seen the green eyes you speak of, and I will take care of you from them."

"You! How can you do that? If it were day now, I could take care of you from the worst of them. But as it is, I can't even see them for this abominable darkness. I could not see your lovely eyes but for the light that is in them; that lets me see straight into heaven through them. They are windows into the very heaven beyond the sky. I believe they are the very place where the stars are made."

"You come, then, or I shall shut them," said Nycteris, "and you shan't see them anymore till you are good. Come. If you can't see the wild beasts, I can."

"You can! And you ask me to come!" cried Photogen.

"Yes," answered Nycteris. "And more than that, I see them long before they can see me, so that I am able to take care of you."

"But how?" persisted Photogen. "You can't shoot with bow and arrow, or stab with a hunting knife."

"No, but I can keep out of the way of them all. Why, just when I found you, I was having a game with two or three of them at once. I see, and scent them too, long before they are near me—long before they can see or scent me."

"You don't see or scent any now, do you?" said Photogen uneasily, rising on his elbow.

"No—none at present. I will look," replied Nycteris, and sprang to her feet.

"Oh, oh! Do not leave me—not for a moment," cried Photogen, straining his eyes to keep her face in sight through the darkness.

"Be quiet, or they will hear you," she returned. "The wind is from the south, and they cannot scent us. I have found out all about that. Ever since the dear dark came, I have been amusing myself with them, getting every now and then just into the edge of the wind and letting one have a sniff of me."

"Oh, horrible!" cried Photogen. "I hope you will not insist on doing so anymore. What was the consequence?"

"Always, the very instant, he turned with flashing eyes and bounded towards me—only he could not see me, you must remember. But my eyes being so much better than his, I could see him perfectly well and would run away round him until I scented him, and then I knew he could not find me anyhow. If the wind were to turn and run the other way now, there might be a whole army of them down upon us, leaving no room to keep out of their way. You had better come."

She took him by the hand. He yielded and rose, and she led him away. But his steps were feeble, and as the night went on, he seemed more and more ready to sink.

"Oh, dear! I am so tired and so frightened!" he would say.

"Lean on me," Nycteris would return, putting her arm round him or patting his cheek. "Take a few steps more. Every step away from the castle is clear gain. Lean harder on me. I am quite strong and well now."

So they went on. The piercing night eyes of Nycteris descried not a few pairs of green ones gleaming like holes in the darkness, and many a round she made to keep far out of their way; but she never said to Photogen she saw them. Carefully she kept him off the uneven places, and on the softest and smoothest of the grass, talking to him gently all the way as they went—of the lovely flowers and the stars: how comfortable the flowers looked, down in their green beds, and how happy the stars up in their blue beds!

When the morning began to come, he began to grow better but was dreadfully tired with walking instead of sleeping, especially after being so long ill. Nycteris, too, what with supporting him, what with growing fear of the light, which was beginning to ooze out of the east, was very tired. At length, both equally exhausted, neither was able to help the other. As if by consent, they stopped. Embracing each the other, they stood in the midst

of the wide grassy land, neither of them able to move a step, each supported only by the leaning weakness of the other, each ready to fall if the other should move. But while the one grew weaker still, the other had begun to grow stronger. When the tide of the night began to ebb, the tide of the day began to flow; and now the sun was rushing to the horizon, borne upon its foaming billows. And ever as he came, Photogen revived. At last the sun shot up into the air, like a bird from the hand of the Father of Lights. Nycteris gave a cry of pain and hid her face in her hands.

"Oh, me!" she sighed. "I am so frightened! The terrible light stings so!"

But the same instant, through her blindness, she heard Photogen give a low exultant laugh, and the next felt herself caught up: she who all night long had tended and protected him like a child was now in his arms, borne along like a baby, with her head lying on his shoulder. But she was the greater, for suffering more, she feared nothing.

THE WEREWOLF

At the very moment when Photogen caught up Nycteris, the telescope of Watho was angrily sweeping the tableland. She swung it from her in rage and, running to her room, shut herself up. There she anointed herself from top to toe with a certain ointment; shook down her long red hair and tied it round her waist; then began to dance, whirling round and round and round faster and faster, growing angrier and angrier, until she was foaming at the mouth with fury. When Falca went looking for her, she could not find her anywhere.

As the sun rose, the wind slowly changed and went round, until it blew straight from the north. Photogen and Nycteris were drawing near the edge of the forest, Photogen still carrying Nycteris, when she moved a little on his shoulder uneasily, and murmured in his ear.

"I smell a wild beast—that way, the way the wind is coming."

Photogen turned, looked back towards the castle, and saw a dark speck on the plain. As he looked, it grew larger: it was coming across the grass with the speed of the wind. It came nearer and nearer. It looked long and low, but that might be

because it was running at a great stretch. He set Nycteris down under a tree, in the black shadow of its bole, strung his bow, and picked out his heaviest, longest, sharpest arrow. Just as he set the notch on the string, he saw that the creature was a trememdous wolf, rushing straight at him. He loosened his knife in its sheath, drew another arrow halfway from the quiver, lest the first should fail, and took his aim—at a good distance, to leave time for a second chance. He shot. The arrow rose, flew straight, descended, struck the beast, and started again into the air, doubled like a letter V. Quickly Photogen snatched the other, shot, cast his bow from him, and drew his knife. But the arrow was in the brute's chest, up to the feather; it tumbled heels over head with a great thud of its back on the earth, gave a groan, made a struggle or two, and lay stretched out motionless.

"I've killed it, Nycteris," cried Photogen. "It is a great red wolf."

"Oh, thank you!" answered Nycteris feebly from behind the tree. "I was sure you would. I was not a bit afraid."

Photogen went up to the wolf. It *was* a monster! But he was vexed that his first arrow had behaved so badly and was the less willing to lose the one that had done him such good service: with a long and a strong pull, he drew it from the brute's chest. Could he believe his eyes? There lay—no wolf, but Watho, with her hair tied round her waist! The foolish witch had made herself invulnerable, as she supposed, but had forgotten that to torment Photogen therewith, she had handled one of his arrows. He ran back to Nycteris and told her.

She shuddered and wept, and would not look.

ALL IS WELL

There was now no occasion to fly a step farther. Neither of them feared anyone but Watho. They left her there and went back. A great cloud came over the sun, and rain began to fall heavily, and Nycteris was much refreshed, grew able to see a little, and with Photogen's help walked gently over the cool wet grass.

They had not gone far before they met Fargu and the other huntsmen. Photogen told them he had killed a great red wolf, and it was Madam Watho. The huntsmen looked grave, but gladness shone through.

"Then," said Fargu, "I will go and bury my mistress."

But when they reached the place, they found she was already buried—in the maws of sundry birds and beasts which had made their breakfast of her.

Then Fargu, overtaking them, would, very wisely, have Photogen go to the king and tell him the whole story. But Photogen, yet wiser than Fargu, would not set out until he had married Nycteris: "for then," he said, "the king himself can't part us; and if ever two people couldn't do the one without the other, those two are Nycteris and I. She has got to teach me to be a brave man in the dark, and I have got to look after her until she can bear the heat of the sun and he helps her to see, instead of blinding her."

They were married that very day. And the next day they went together to the king and told him the whole story. But whom should they find at the court but the father and mother of Photogen, both in high favor with the king and queen. Aurora nearly died for joy and told them all how Watho had lied and made her believe her child was dead.

No one knew anything of the father or mother of Nycteris; but when Aurora saw in the lovely girl her own azure eyes shining through night and its clouds, it made her think strange things and wonder how even the wicked themselves may be a link to join together the good. Through Watho, the mothers, who had never seen each other, had changed eyes in their children.

The king gave them the castle and lands of Watho, and there they lived and taught each other for many years that were not long. But hardly had one of them passed, before Nycteris had come to love the day best, because it was the clothing and crown of Photogen, and she saw that the day was greater than the night, and the sun more lordly than the moon; and Photogen had come to love the night best, because it was the mother and home of Nycteris.

"But who knows," Nycteris would say to Photogen, "that when we go out, we shall not go into a day as much greater than your day as your day is greater than my night?"

PETUNIA
WALBERSWICK
1 9 1 4
C R M M M M

AUGURIES OF INNOCENCE

William Blake

English

To see a World in a Grain of Sand

And a Heaven in a Wild Flower,

Hold Infinity in the palm of your hand

And Eternity in an hour.

Petunia, Walberswick,
Charles Rennie Mackintosh
(1868–1928), Scottish.
Pencil and watercolor, 1914.

THE MIRACLE OF THE GARMENT THROWN OVER A SUNBEAM

COGITOSUS

Irish

Here, I think I ought to slip in for your Reverences this other miracle in which the pure mind of the virgin and God's cooperating hand clearly appear to combine. As she was grazing her sheep in the course of her work as a shepherdess on a level grassy plain, she was drenched by a very heavy downpour of rain and returned to the house with her clothes wet. There was a ray of sunshine coming into the house through an opening and, as a result, her eyes were dazzled and she took the sunbeam for a slanting tree growing there. So, she put her rainsoaked clothes on it and the clothes hung on the filmy sunbeam as if it were a big solid tree. And the occupants of the house and the neighbours, dumbfounded by this extraordinary miracle, began to extol this incomparable lady with fitting praise.

In the Realms of Light,
Tim Goulding
(living artist), Irish.
Oil on canvas, 1994.

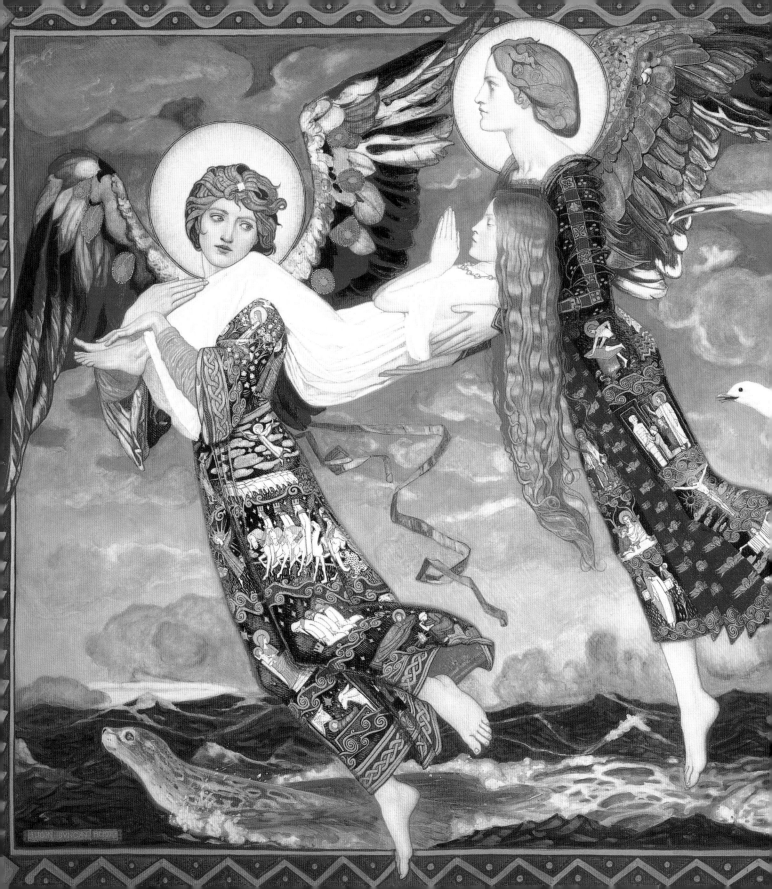

BLESSING OF PEACE-HEALING

Anonymous, 12th century

Irish, translated by Fiona MacLeod

Deep peace I breathe into you,
O weariness, here:
O ache, here!
Deep peace, a soft white dove to you;
Deep peace, a quiet rain to you;
Deep peace, an ebbing wave to you!
Deep peace, red wind of the east from you;
Deep peace, grey wind of the west to you;
Deep peace, dark wind of the north from you;
Deep peace, blue wind of the south to you!
Deep peace, pure red of the flame to you;
Deep peace, pure white of the moon to you;
Deep peace, pure green of the grass to you;
Deep peace, pure brown of the earth to you;
Deep peace, pure grey of the dew to you,
Deep peace, pure blue of the sky to you!
Deep peace of the running wave to you,
Deep peace of the flowing air to you,
Deep peace of the quiet earth to you,
Deep peace of the sleeping stones to you,
Deep peace of the Yellow Shepherd to you,
Deep peace of the Wandering Shepherdess to you,
Deep peace of the Flock of Stars to you,
Deep peace of the Son of Peace to you,
Deep peace from the heart of Mary to you,
And from Bridget of the Mantle,
Deep peace, deep peace!

St. Bride,
John McKirdy Duncan
(1866–1945), Irish.
Tempera on canvas, 1913.

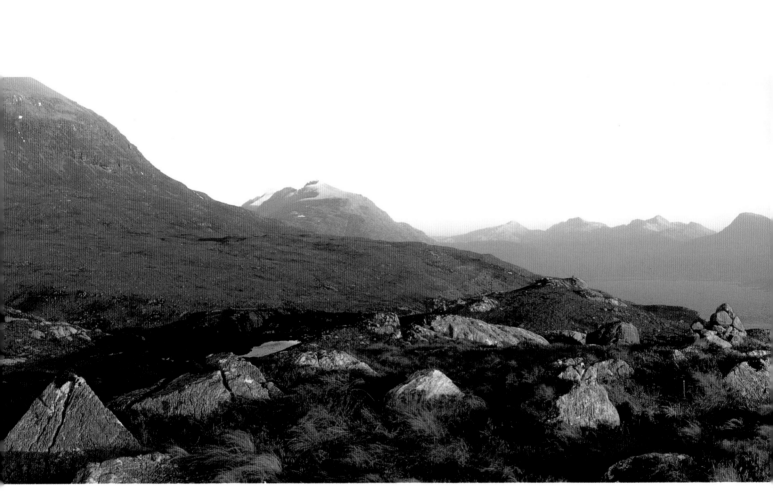

Loch Torridon and
Mountains, Scotland.

THE BLESSING OF THE ELEMENTS

SAINT PATRICK

Irish

I rise today
Through the strength of heaven:
Light of sun,
Radiance of moon,
Splendour of fire,
Speed of lightning,
Swiftness of wind,
Depth of sea,
Stability of earth,
Firmness of rock.

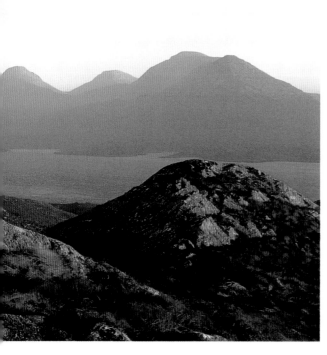

CRAZY JANE TALKS WITH THE BISHOP

William Butler Yeats

Irish

I met the Bishop on the road
And much said he and I.
"Those breasts are flat and fallen now,
Those veins must soon be dry;
Live in a heavenly mansion,
Not in some foul sty."

"Fair and foul are near of kin,
And fair needs foul," I cried.
"My friends are gone, but that's a truth
Nor grave nor bed denied,
Learned in bodily lowliness
And in the heart's pride.

"A woman can be proud and stiff
When on love intent;
But Love has pitched his mansion in
The place of excrement;
For nothing can be sole or whole
That has not been rent."

Hecate, William Blake (1757–1827),
English. Watercolor on paper, c. 1795.

214

ROCKS

Tim Goulding

Irish

For their patience

For their reach

For their silence

For their song

For their presence

For their promise

For their softness

For their strength

For their elevation

For their accuracy

For their imperceptible mutability

For their utter lack of opinion

Listen and watch.

Giant's Causeway,
Northern Ireland.

Young Woman with Geese,
William John Leech
(1881–1968), Irish.

THE OLD COUNTRY

Katharine Tynan

Irish

As I go home at end of day, the old road,
Through the enchanted country full of my dreams,
By the dim hills, under the pellucid o'er-arching sky,
Home to the West, full of great clouds and the sunset,
Past the cattle that stand in rich grass to the knees,
It is not I who go home: it is not I.

Here is the turn we took, going home with my father,
The little feet of the pony trotting fast,
Home by the winding lane full of music of water,
He and I, we were enough for each other;
Going home through the silver, the pearly twilight,
I content with my father, he with his daughter.

Magical country, full of memories and dreams,
My youth lies in the crevices of your hills;
Here in the silk of your grass by the edge of the meadows,
Every flower and leaf has its memories of you.
Home was home then and the people friendly,
And you and I going home in the lengthening shadows.

Now I go home no more, though the swift car glides,
Carries me fast through the dear, the heavenly country.
No one knows me, the cottages show strange faces,
They who were kindly, who bid me "God save You!" of yore,
They are gone, they are flown, and only the country's the same,
And you sleeping so quietly under the grass.

FIELD DAY

W. R. Rodgers

Irish

The old farmer, nearing death, asked
To be carried outside and set down
Where he could see a certain field
"And then I will cry my heart out," he said.

It troubles me, thinking about that man;
What shape was the field of his crying
In Donegal?

I remember a small field in Down, a field
Within fields, shaped like a triangle.
I could have stood there and looked at it
All day long.

And I remember crossing the frontier between
France and Spain at a forbidden point, and seeing
A small triangular field in Spain,
And stopping

Or walking in Ireland down any rutted by-road
To where it hit the highway, there was always
At this turning-point and abutment
A still centre, a V-shape of grass
Untouched by cornering traffic,
Where country lads larked at night.

I think I know what the shape of the field was
That made the old man weep.

Stobo Kirk,
James McIntosh Patrick
(living artist), Scottish.
Oil on canvas.

Portrait of a Bride,
Sir James Jebusa Shannon
(1862–1923), Irish.
Oil on canvas, 20th century.

LOVELIER THAN THE SUN

Anonymous, 17th century

Welsh, Kenneth Hurlestone Jackson

Lovely is the sun's smile as it rises in its full brilliance,

lovely are the moon's smiles at night,

more lovely is my darling's cheek.

The moon is pretty on the waves,

the stars are pretty on a bright night,

but neither stars nor moon are half so pretty as my darling.

THE SONG OF WANDERING AENGUS

William Butler Yeats

Irish

I went out to the hazel wood,
Because a fire was in my head,
And cut and peeled a hazel wand,
And hooked a berry to a thread;
And when white moths were on the wing,
And moth-like stars were flickering out,
I dropped the berry in a stream
And caught a little silver trout.

When I had laid it on the floor
I went to blow the fire aflame,
But something rustled on the floor,
And some one called me by my name:
It had become a glimmering girl
With apple blossom in her hair
Who called me by my name and ran
And faded through the brightening air.

Though I am old with wandering
Through hollow lands and hilly lands,
I will find out where she has gone,
And kiss her lips and take her hands;
And walk among long dappled grass,
And pluck till time and times are done
The silver apples of the moon,
The golden apples of the sun.

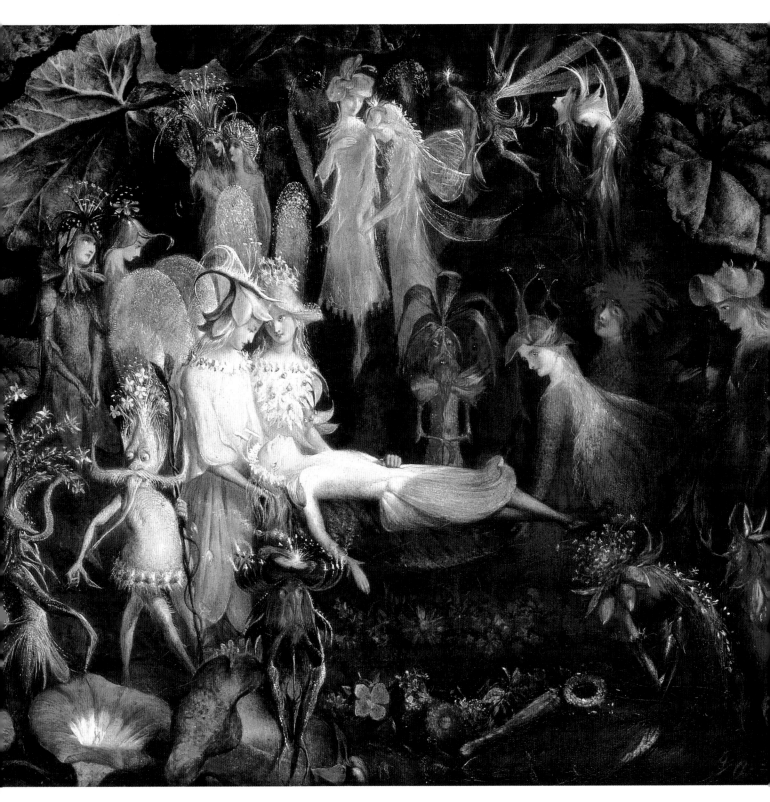

THE FAIRY RATH

Lady Francesca Speranza Wilde

Irish

The ancient rath, or fort, or liss, generally enclosed about half an acre, and had two or more ramparts, formed by the heads of the tribe for defence. But when the race of the chieftains died out, then the Sidhe crowded into the forts, and there held their councils and revels and dances; and if a man put his ear close to the ground at night he could hear the sweet fairy music rising up from under the earth.

The rath ever after is sacred to the fairies, and no mortal is allowed to cut down a tree that grows on it, or to carry away a stone. But dangerous above all would it be to build on a fairy rath. If a man attempted such a rash act, the fairies would put a blast on his eyes, or give him a crooked mouth; for no human hand should dare to touch their ancient dancing grounds.

It is not right, the people say, to sing or whistle at night that old air, "The pretty girl milking her cow;" for it is a fairy tune, and the fairies will not suffer a mortal to sing their music while they are dancing on the grass. But if a person sleeps on the rath the music will enter into his soul, and when he awakes he may sing the air he has heard in his dreams.

In this way the bards learned their songs, and they were skilled musicians, and touched the harp with a master hand, so that the fairies often gathered round to listen, though invisible to mortal eyes.

The Fairy's Funeral,
John Anster Fitzgerald
(1832–1906), English.
Oil on canvas, 19th century.

THE HAPPY MARCH

James Stephens

Irish

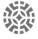

Caitilin Ni Murrachu sat alone in the Brugh of Angus much as she had sat on the hillside and in the cave of Pan, and again she was thinking. She was happy now. There was nothing more she could desire, for all that the earth contained or the mind could describe was hers. Her thoughts were no longer those shy, subterranean gropings which elude the hand and the understanding. Each thought was a thing or a person, visible in its own radiant personal life, and to be seen or felt, welcomed or repulsed as was its due. But she had discovered that happiness is not laughter or satisfaction, and that no person can be happy for himself alone. So she had come to understand the terrible sadness of the gods, and why Angus wept in secret; for often in the night she had heard him weeping, and she knew that his tears were for those others who were unhappy, and that he could not be comforted while there was a woeful person or an evil deed hiding in the world. Her own happiness also had become infected with this alien misery, until she knew that nothing was alien to her, and that in truth all persons and all things were her brothers and sisters and that they were living and dying in distress; and at the last she knew that there was not any man but mankind, nor any human being but only humanity. Never again could the gratification of a desire give her pleasure, for her sense of oneness was destroyed—she was not an individual only; she was also part of a mighty organism ordained, through whatever stress, to achieve its oneness, and this great being was threefold, comprising in its mighty units God and Man and Nature—the immortal trinity. The duty of life is the sacrifice of self: it is to renounce the little ego that the mighty ego may be freed; and, knowing this, she found at last that she knew Happiness, that divine discontent which cannot rest nor be at ease until its bourne is attained and the knowledge of a man is added to the gaiety of a child. Angus had told her that beyond this there lay the great ecstasy which is Love and God and the beginning and the end of all things: for everything must come from the Liberty into the Bondage that it may return again to the Liberty comprehending all things and fitted for that fiery enjoyment. This cannot be until there are no more fools living, for until the last fool has grown wise wisdom will totter and freedom will still be invisible. Growth is not by years but by multitudes, and until there is a common eye no one person can see God, for the eye of all nature will scarcely be great enough to look upon that majesty. We shall greet Happiness by multitudes, but we can only greet Him by starry systems and a universal love.

She was so thinking when Angus Óg came to her from the fields. The god was very radiant, smiling like the young morn when the buds awake, and to his lips song came instead of speech.

"My beloved," said he, "we will go on a journey to-day."

"My delight is where you go," said Caitilin.

"We will go down to the world of men. From our quiet dwelling among the hills to the noisy city and the multitude of

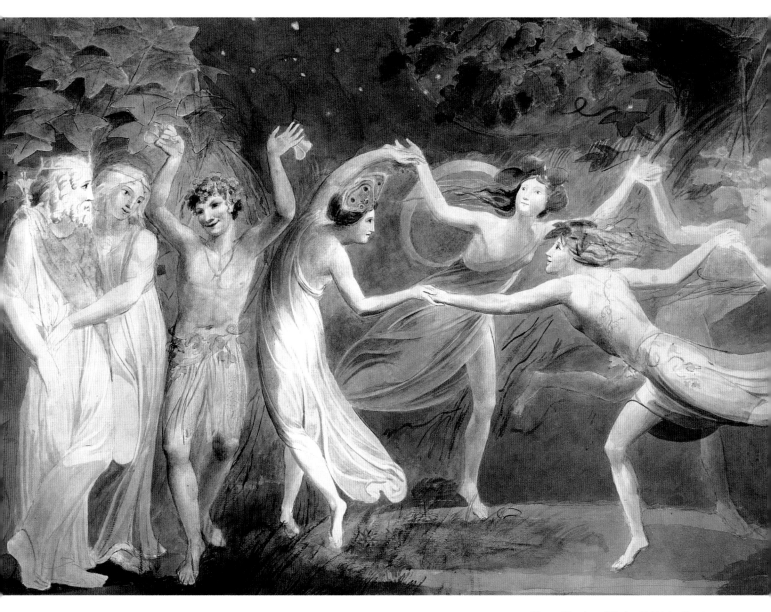

Oberon, Titania and Puck with Fairies Dancing,
William Blake (1757–1827), English.
Watercolor and pencil on paper, 1785.

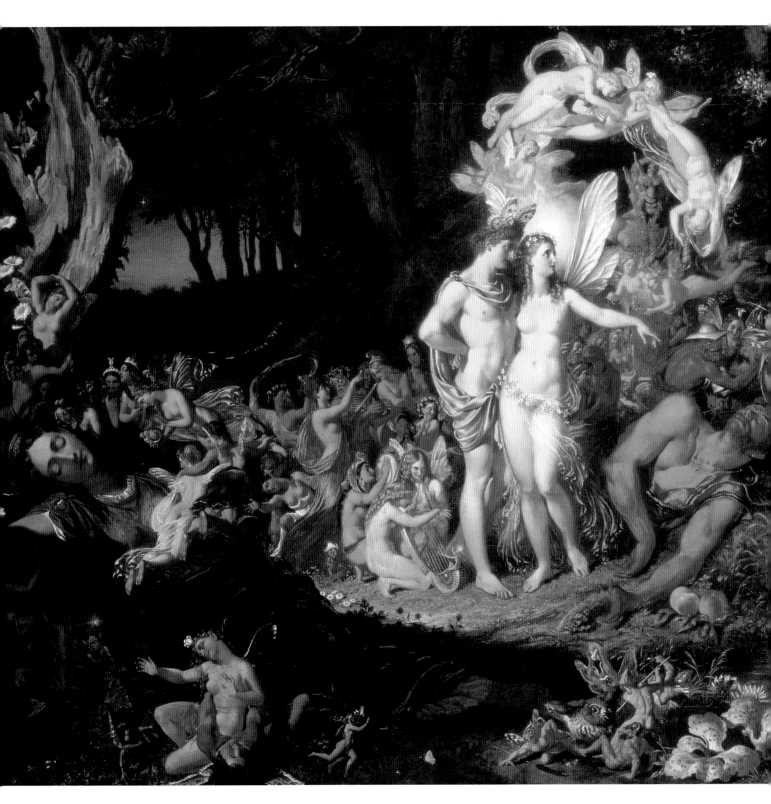

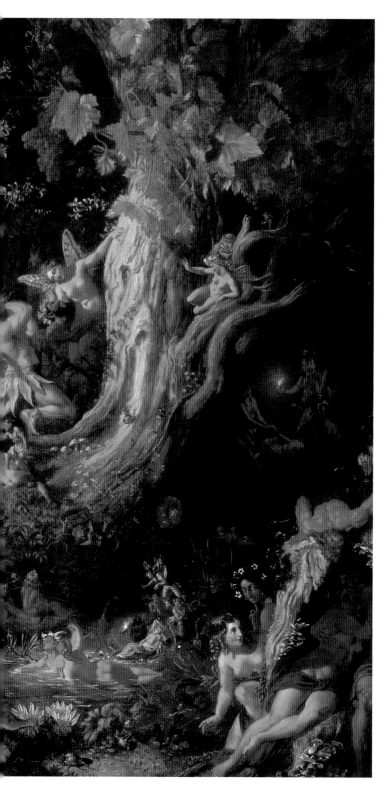

people. This will be our first journey, but on a time not distant we will go to them again, and we will not return from that journey, for we will live among our people and be at peace."

"May the day come soon," said she.

"When thy son is a man he will go before us on that journey," said Angus, and Caitilin shivered with a great delight, knowing that a son would be born to her.

Then Angus Óg put upon his bride glorious raiment, and they went out to the sunlight. It was the early morning, the sun had just risen and the dew was sparkling on the heather and the grass. There was a keen stir in the air that stung the blood to joy, so that Caitilin danced in uncontrollable gaiety, and Angus, with a merry voice, chanted to the sky and danced also. About his shining head the birds were flying; for every kiss he gave to Caitilin became a bird, the messengers of love and wisdom, and they also burst into triumphant melody, so that the quiet place rang with their glee. Constantly from the circling birds one would go flying with great speed to all quarters of space. These were his messengers flying to every fort and dún, every rath and glen and valley of Eiré to raise the Sluaige Shee (the Fairy Host). They were birds of love that flew, for this was a hosting of happiness, and, therefore, the Shee would not bring weapons with them.

It was towards Kilmasheogue their happy steps were directed, and soon they came to the mountain.

After the Thin Woman of Inis Magrath had left the god she visited all the fairy forts of Kilmasheogue, and directed the Shee who lived there to be in waiting at the dawn on the summit of the mountain; consequently, when Angus and Caitilin came up the hill, they found the six clanns coming to receive them, and with these were the people of the younger Shee, members of the Tuatha da Danaan, tall and beautiful men and women who had descended to the quiet underworld when the pressure of the sons of Milith forced them with their kind enchantments and invincible valour to the country of the gods.

The Reconciliation of Oberon and Titania, Sir Joseph Noel Paton (1821–1901), Scottish. Oil on canvas, 1847.

Of those who came was Aine Ni Eogáil of Cnoc Aine and Ívíl of Craglea, the queens of north and south Munster, and Una the queen of Ormond; these, with their hosts, sang upon the summit of the hill welcoming the god. There came the five guardians of Ulster, the fomenters of combat:—Brier Mac Belgan of Dromona-Breg, Redg Rotbill from the slopes of Magh-Itar, Tinnel the son of Boclacthna of Slieve Edlicon, Grici of Cruachan-Aigle, a goodly name, and Gulban Glas Mac Grici, whose dún is in the Ben of Gulban. These five, matchless in combat, marched up the hill with their tribes, shouting as they went. From north and south they came, and from east and west, bright and happy beings, a multitude, without fear, without distraction, so that soon the hill was gay with their voices and their noble raiment.

Amongst them came the people of the Lupra, the ancient Leprecauns of the world, leaping like goats among the knees of the heroes. They were headed by their king Udán Mac Audain and Beg Mac Beg his tanist and, following behind, was Glomhar O'Glomrach of the sea, the strongest man of their people, dressed in the skin of a weasel; and there were also the chief men of that clann, well known of old, Conán Mac Rihid, Gaerku Mac Gairid, Mether Mac Mintán and Esirt Mac Beg, the son of Bueyen, born in a victory. This king was that same Udán the chief of the Lupra who had been placed under bonds to taste the porridge in the great cauldron of Emania, into which pot he fell, and was taken captive with his wife, and held for five weary years, until he surrendered that which he most valued in the world, even his boots: the people of the hills laugh still at the story, and the Leprecauns may still be mortified by it.

There came Bove Derg, the Fiery, seldom seen, and his harper the son of Trogáin whose music heals the sick and makes the sad heart merry. Eochy Mac Elathán, the Dagda Mór, the Father of Stars, and his daughter from the Cave of Cruachán. Credh Mac Aedh of Raghery and Cas Corach son of the great Ollav. Mananaan Mac Lir came from his wide waters shouting louder than the wind, with his daughters Cliona and

Aoife and Etain Fair-Hair; and Coll and Cecht and Mac Greina, the Plough, the Hazel, and the Sun came with their wives, whose names are not forgotten, even Banba and Fodla and Eire, names of glory. Lugh of the Long-Hand, filled with mysterious wisdom, was not absent, whose father was sadly avenged on the sons of Turann—these with their hosts.

And one came also to whom the hosts shouted with mighty love, even the Serene One, Dana, the Mother of the gods, steadfast for ever. Her breath is on the morning, her smile is summer. From her hand the birds of the air take their food. The mild ox is her friend, and the wolf trots by her friendly side, at her voice the daisy peeps from her cave and the nettle couches his lance. The rose arrays herself in innocence scattering abroad her sweetness with the dew, and the oak tree laughs to her in the air. Thou beautiful! the lambs follow thy footsteps, they crop thy bounty in the meadows and are not thwarted: the weary men cling to thy bosom everlasting. Through thee all actions and the deeds of men, through thee all voices come to us, even the Divine Promise and the breath of the Almighty from afar laden with goodness.

With wonder, with delight, the daughter of Murrachu watched the hosting of the Shee. Sometimes her eyes were dazzled as a jewelled forehead blazed in the sun, or a shoulder-torque of broad gold flamed like a torch. On fair hair and dark the sun gleamed: white arms tossed and glanced a moment and sank and reappeared. The eyes of those who did not hesitate nor compute looked into her eyes, not appraising, not questioning, but mild and unafraid. The voices of free people spoke in her ears and the laughter of happy hearts, unthoughtful of sin or shame, released from the hard bondage of selfhood. For these people though many were one. Each spoke to the other as to himself, without reservation or subterfuge. They moved freely each in his personal whim and they moved also with the unity of one being: for when they shouted to the Mother of the gods they shouted with one voice, and they bowed to her as one man bows. Through

the many minds there went also one mind, correcting, commanding, so that in a moment the interchangeable and fluid became locked, and organic with a simultaneous understanding, a collective action—which was freedom.

While she looked the dancing ceased, and they turned their faces with one accord down the mountain. Those in the front leaped forward, and behind them the others went leaping in orderly progression.

Then Angus Óg ran to where she stood, his bride of beauty—

"Come, my beloved," said he, and hand in hand they raced among the others, laughing as they ran.

Here there was no green thing growing; a carpet of brown turf spread to the edge of sight on sloping plain and away to where another mountain soared in the air. They came to this and descended. In the distance, groves of trees could be seen, and, very far away, the roofs and towers and spires of the Town of the Ford of Hurdles, and the little roads that wandered everywhere; but on this height there was only prickly furze growing softly in the sunlight: the bee droned his loud song, the birds flew and sang occasional and the little streams grew heavy with their falling waters. A little further and the bushes were green and beautiful, waving their gentle leaves in the quietude, and beyond again, wrapped in sunshine and peace, the trees looked on the world from their calm heights having no complaint to make of anything.

In a little they reached the grass land and the dance began. Hand sought for hand, feet moved companionably as though they loved each other; quietly intimate they tripped without faltering, and, then, the loud song arose—They sang to the lovers of gaiety and peace, long defrauded—

"Come to us, ye who do not know where ye are. Ye who live among strangers in the houses of dismay and self-righteousness. Poor, awkward ones! How bewildered and bedevilled ye go! Amazed ye look and do not comprehend, for your eyes are set upon a star and your feet move in the blessed kingdoms of the Shee. Innocents! in what prisons are ye flung? To what lowliness are ye bowed? How are ye ground between the laws and customs? The dark people of the Fomor have ye in thrall; and upon your minds they have fastened a band of lead, your hearts are hung with iron, and about your loins a cincture of brass impressed, woeful! Believe it, that the sun does shine, the flowers grow, and the birds sing pleasantly in the trees. The free winds are everywhere, the water tumbles on the hills, the eagle calls aloud through the solitude, and his mate comes speedily. The bees are gathering honey in the sunlight, the midges dance together, and the great bull bellows across the river. The crow says a word to his brethren and the wren snuggles her young in the hedge. . . . Come to us, ye lovers of life and happiness. Hold out thy hand—a brother shall seize it from afar. Leave the plough and the cart for a little time: put aside the needle and the awl—Is leather thy brother, O man? . . . Come away! come away! from the loom and the desk, from the shop where the carcasses are hung, from the place where raiment is sold and the place where it is sewn in darkness: O bad treachery! Is it for joy you sit in the broker's den, thou pale man? Has the attorney enchanted thee? . . . Come away! for the dance has begun lightly, the wind is sounding over the hill, the sun laughs down into the valley, and the sea leaps upon the shingle panting for joy, dancing, dancing, dancing for joy. . . ."

They swept through the goat tracks and the little boreens and the curving roads. Down to the city they went dancing and singing; among the streets and the shops telling their sunny tale; not heeding the malignant eyes and the cold brows as the sons of Balor looked sidewards. And they took the Philosopher from his prison, even the Intellect of Man they took from the hands of the doctors and lawyers, from the sly priests, from the professors whose mouths are gorged with sawdust, and the merchants who sell blades of grass—the awful people of the Fomor...and then they returned again, dancing and singing to the country of the gods. . . .

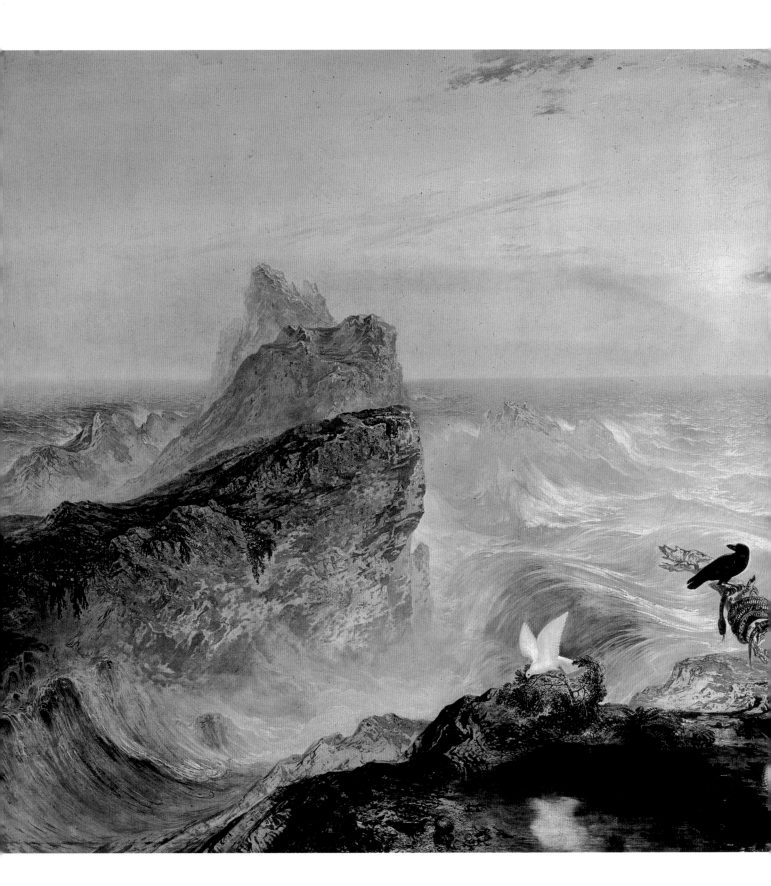

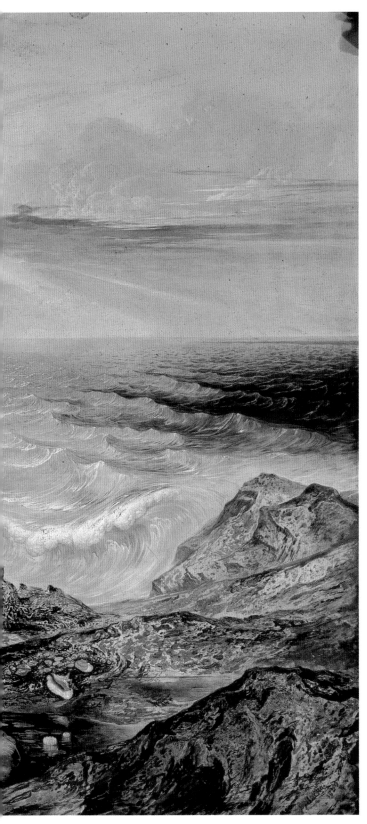

AFTER THE STORM

Eva Gore-Booth

Irish

Suddenly everywhere

 Clouds and waves are one,

The storm has cleared the air,

 The sea holds the sun

And the blue sky—

 There is no under, no above,

All is light, all is love—

 Is it like this when you die?

Assuaging of the Waters,
John Martin (1789–1854),
English. Oil on canvas,
19th century.

INTO THE MYSTIC

Van Morrison

Irish

We were born before the wind

Also younger than the sun

Ere the bonnie boat was won as we sailed into the mystic

Hark, now hear the sailors cry

Smell the sea and feel the sky

Let your soul and spirit fly into the mystic

Voyage, Tim Goulding
(living artist), Irish.
Oil on canvas, 1994.

CREDITS

Published in 2008 by Welcome Books®
An imprint of Welcome Enterprises, Inc.
6 West 18th Street, New York, NY 10011
(212) 989-3200; Fax (212) 989-3205
www.welcombooks.com

Publisher: Lena Tabori
Editor: Sara Baysinger
Art Director: Gregory Wakabayashi
Designer: Tsang/Seymour Design

Library of Congress Cataloging-in-Publication Data
on file

Printed in China
10 9 8 7 6 5 4 3 2 1

LITERATURE

"The Earth-Shapers" and "A Good Action" from *Celtic Wonder-Tales*, retold by Ella Young. First published by Maunsel & Company, Dublin, Ireland, 1910. Republished by Dover Publications, Inc., 1995.

"Fern Hill" and "And Death Shall Have No Dominion" from *The Poems of Dylan Thomas*. Copyright © 1945 by The Trustees for the Copyrights of Dylan Thomas. Reprinted by permission of New Directions Publishing Corp. and David Higham Associates.

Excerpt from "When the Moon Has Set" from *The Aran Islands and Other Writings of Synge*. Copyright © 1962 by Random House.

"Deirdre Remembers a Scottish Glen," "Suibhne the Wild Man in the Forest," excerpt from "How Trystan Won Esyllt," "Epigram," and "Lovelier than the Sun" from *A Celtic Miscellany*, selected and translated by Kenneth Hurlstone Jackson. Copyright © 1951, 1971 Kenneth Hurlstone Jackson.

"Milking Croon" from *Carmina Gadelica: Hymns & Incantations Collected in the Highlands and Islands of Scotland in the Last Century* by Alexander Carmichael. First published in 1992 by Lindisfarne Press. Reprinted with revisions, 1994 by Floris Books. Reprinted by permission of Floris Books.

"Windharp" from *John Montague: Collected Poems* (1995). Copyright © 1961, 1967 by John Montague. Reprinted by kind permission of the author, Wake Forest University Press, and The Gallery Press, Ireland.

"The Ram's Horn" from *The Collected Poems of John Hewitt* (1991), edited by Frank Ormsby. Published by The Blackstaff Press, Ltd. Reprinted by permission.

"The Lake Isle of Innisfree," "The Coming of Wisdom with Time," "Fergus and the Druid," and "The Song of Wandering Aengus" from *The Collected Poems of W. B. Yeats, Vol. 1: The Poems*, revised and edited by Richard J. Finneran (New York: Scribner, 1996).

"I Was Brought to my Senses," written and composed by Sting. Copyright © 1996 G. M. Sumner. Published by Magnetic Publishing Ltd. and Administered by EMI Blackwood Music Inc. in the U.S.A. and Canada. All Rights Reserved. International Copyright Secured. Used by Permission.

"Gift of Sight" and "Serpent's Tail" from *The Collected Poems 1975* by Robert Graves. Copyright © 1975, 1988 by Robert Graves. Reprinted by permission of Oxford University Press and Carcanet Press Limited.

"The Planter's Daughter" from *Collected Poems* (1974) by Arthur Clarke.

"To My Mountain, "Love Spell," and "Spell of Sleep" from *The Collected Poems of Kathleen Raine*. Copyright © 1956 Kathleen Raine.

"To Anybody at All" from *Origins and Elements* by Margaret Tait.

"Blessing for a Lover" from *Sian Bhuadha*, translated by Caitlin Matthews from Carmina Gadelica, vol. 3.

"The Philtre" from *The Romance of Tristan and Iseult*, retold by Joseph Bédier. Translation © 1945 by Pantheon Books, Inc.

"The Circle" from *The Stopped Landscape* by Alan Riddell, published by Hutchinson. Reprinted by permission.

"Country Girl" from *Selected Poems by George Mackay Brown*. Reprinted by permission of John Murray Publishers, Ltd.

"The Wooing of Etain" from *A Fair Stream of Silver: Love Tales from Celtic Lore*, collected and retold by Ann Moray. Copyright © 1965 by Ann Moray.

"Blessing of the Moon" from *The Silver Bough*, translated by F. Marian MacNeil. Translation copyright © 1956 by William MacClelland.

Excerpt from *Portrait of the Artist as a Young Man* by James Joyce. Copyright © 1916 by B.W. Huebsch. Copyright © 1994 by Nora Joyce. Copyright © 1964 by the Estate of James Joyce. Used by permission of Viking Penguin, a division of Penguin Putnam Inc.

"The Adventure of Conle" from *Early Irish Literature*, edited by Myles Dillon. Copyright © 1948 by The University of Chicago Press. Reprinted by permission.

Excerpt from "The Apple Trees" from *Merlin: Priest of Nature* by Jean Markale, published by Inner Traditions International, Rochester, VT 05767. English translation copyright © 1995 Inner Traditions International. Reprinted by permission.

"The Weakness of the Ulstermen" and "The Hound of Culann" from *The Cattle Raid of Cooley*. From J. J. Campbell's *Legends of Ireland*, published by B. T. Batsford Ltd., London.

"The White Stallion" by Pete Morgan from *Scottish Poetry, 4*. Reprinted by permission of Edinburgh University Press Ltd.

"The Reign of Conaire"and "King Cormac's Vision" from *Ancient Irish Tales*, edited by T. P. Cross and C. H. Slover. Copyright © 1936 by Henry Holt & Co., Inc.

ART

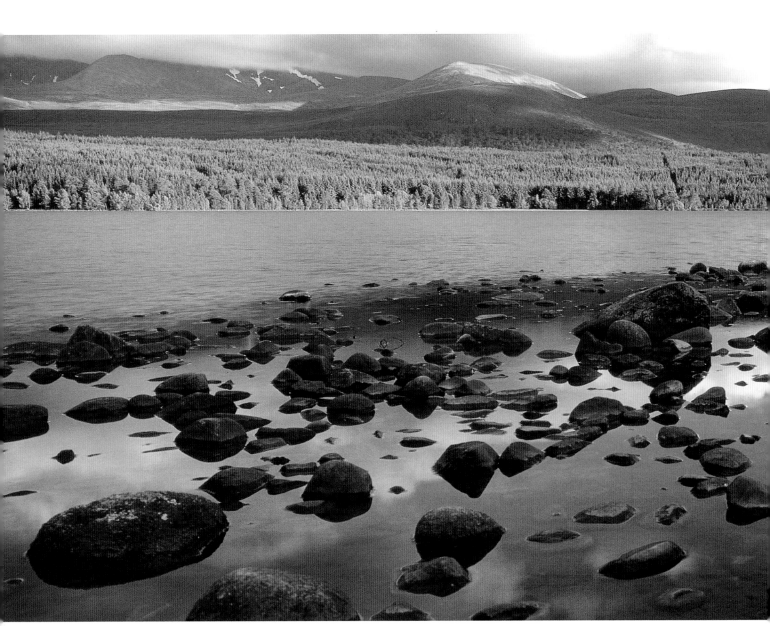

Loch Morlich, Scotland.

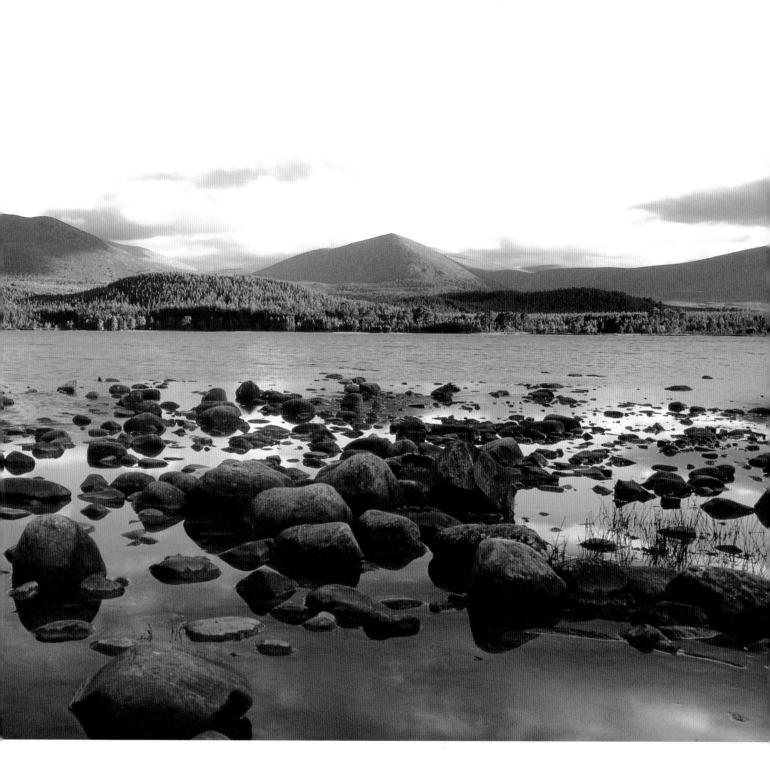

ACKNOWLEDGMENTS

I WOULD LIKE TO THANK the publishing "Dream Team" at Welcome Enterprises for their expert help crafting this volume. In a twenty-three year publishing career, this experience has been among the very best. This is due to the talent of Hiro Clark Wakabayashi who created the ideal working environment, which at times featured the soundtrack of *Braveheart*! Gregory Wakabayashi, an artistic director who can do the impossible through design— intensify the experience of a Yeats poem, or a Scottish landscape. His visual subtlty can increase the elegance of an already superb painting. Sara Baysinger who brought sound ideas and creativity to this book and was a total joy to work with. And, finally, Lena Tabori who gave me the opportunity to work with this wonderful material and this gifted team.

On the home front I would like to thank my husband, Sherman Crites who showed great support and patience through the lengthy process of creating this volume. My gratitude to my brother John Lahr and friend Peg Streep for their publishing savy. Both made a contribution to this volume by generously tolerated the early morning and late night calls as I obsessed and labored in this quest for things Celtic.

A special thank you to James Lipton for inspiring me with his great love for James Stephens.

And finally, my gratitude to The Bridgeman Art Library for superb help and exquisite quality of material.

— Jane Lahr